Sir John Boardman
was born in 1927, and educated at
Chigwell School and Magdalene College, Cambridge. He
spent several years in Greece, three of them as Assistant
Director of the British School of Archaeology at Athens,
and he has excavated in Smyrna, Crete, Chios and Libya.
For four years he was an Assistant Keeper in the Ashmolean
Museum, Oxford, and he subsequently became Reader in
Classical Archaeology and Fellow of Merton College,
Oxford. He is now Lincoln Professor Emeritus of Classical
Archaeology and Art in Oxford, and a Fellow of the British
Academy. Professor Boardman has written widely on the
art and archaeology of Ancient Greece. His other books in
the World of Art series include *Greek Art*; *Athenian Black
Figure Vases*; *Athenian Red Figure Vases* (volumes on the
Archaic and Classical periods) and three volumes on *Greek
Sculpture* covering the Archaic, Classical and
Late Classical periods.

WORLD OF ART

This famous series
provides the widest available
range of illustrated books on art in all its aspects.
If you would like to receive a complete list
of titles in print please write to:
THAMES AND HUDSON
30 Bloomsbury Street, London WC1B 3QP
In the United States please write to:
THAMES AND HUDSON INC.
500 Fifth Avenue, New York, New York 10110

Printed in Singapore

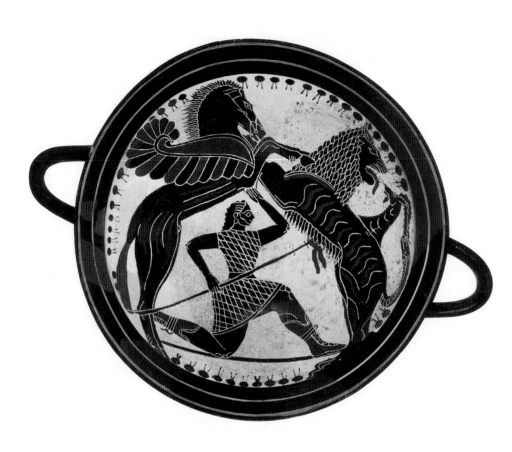

Laconian cup by the Boreads Painter. Pegasus, Bellerophon and the Chimaera. See [418]

JOHN BOARDMAN

EARLY GREEK VASE PAINTING

11TH–6TH CENTURIES BC

a handbook

588 illustrations

THAMES AND HUDSON

© 1998 Thames and Hudson Ltd, London

First published in the United States of America in 1998 by Thames and
Hudson Inc., 500 Fifth Avenue, New York, New York 10110

Library of Congress Catalog Card Number 97-61112
ISBN 0-500-20309-1

Printed and bound in Singapore

CONTENTS

Chapter One

INTRODUCTION

This is the first volume in terms of content, though the last to be published, of four in the World of Art series devoted to Greek vase painting (on Athenian pottery of the 6th to 4th centuries BC: my *Athenian Black Figure Vases* and *Athenian Red Figure Vases: Archaic Period* and ... : *Classical Period*). This book begins in Greece's so-called Dark Ages, after the decline of the Bronze Age cultures of the Minoans and Mycenaeans, proceeds through the Geometric and Orientalizing styles of Greek art (9th to 7th centuries BC), and ends in the 6th century BC with the non-Athenian schools of vase painting, plus a little about the slight non-Athenian production in Greece thereafter where a lingering archaic style can be detected. Vases made in Etruria are included when they are clearly from Greek hands. I include painted figure-vases and plaques, even some sarcophagi, since their figure decoration and technique relate them closely to the rest, but omit the unpainted relief vases. These are decorated from moulds, sometimes freehand or from stamps, and the latest of them relate more to metal vases.

The intention, as in the other volumes, is to provide the student and other interested readers with a fairly comprehensive illustrated guide to the craft, with such consideration of the choices of subject matter (iconography) and the function of the vases as can be included in the space available; these have also influenced my choice of pictures. The attempt is to present the vases in terms of the people by and for whom they were made, rather than placing them in some imaginary niche in the History of Man and his Arts. Some may deserve such a place but the exercise is too subjective for security. Suffice it to say that many are still valued by collectors and museums of art for more than their antiquarian interest. But the presentation here has to be by succession of styles and geography, to remain comprehensible.

This is, however, a period in which the evidence of painted pottery is of a historical value beyond its intrinsic interest, since we are at the dawn of the historic period in Greece, when texts are scarce and later records often unreliable, so that archaeology has to fill out the picture of what was happening in the Greek world. In excavations the principal source and medium for dating is pottery. Moreover, since this is also a time in which regional diversity flourishes, the pottery may have much to say about identity of peoples and trade. This same diversity also makes it more difficult to present neat characterizations of styles

and there is a good deal more variety, sometimes bewildering, than in the books devoted to the later Athenian or South Italian pottery alone. Now too painters began to perfect their techniques of figure drawing and narrative, no little helped by contact with the arts of the near east, mainly Cyprus and Syria. In this relatively humble craft we can read, in more detail than in the major arts of sculpture and architecture, the origins of those styles of figure composition and narrative art which, in the full Classical period of the 5th century BC, were to create an idiom destined to determine the future of the arts in the Greek and Roman world, and ultimately in much of the western world to the present day.

These origins might seem unpromising, indeed quite alien to what was to come, and in early days of scholarship it seemed difficult to believe that Greek Geometric art could have anything to do with what was to be achieved in the Classical period; it was deemed foreign, Phoenician or Egyptian. Excavation and shrewd scholarship of the last 150 years have demonstrated the continuity and gone far to explain how the changes took place. What to many has seemed crude or even primitive is seen to conceal subtleties that would do credit to much later and more sophisticated work; the best of these early vases are no more the works of primitives than are the poems of their contemporaries, Homer and Sappho.

Whether what is presented here is Art in the modern sense is irrelevant. The craftsmen obviously responded to the needs of the society they served, élite as well as poor, and could be called upon to demonstrate status, accommodate funeral ritual as well as domestic needs or to serve a foreign market. But it was up to the craftsman to decide how this was done and the development of means of expression was in his hands, conditioned by technique as well as imagination and aesthetic sensitivity; to this extent the potter/painters' products are Art. The vast differences in this period in the styles affected by some contemporary centres probably depended more, or as much, on craftsmen's choice as on any special requirements of different societies. In no case can we detect any state-imposed styles or subjects such as are the common stock of major and many minor arts of the early empires of the east and Egypt. There are no 'Court Styles' in Greece; one of the advantages of being a small, poor and non-integrated country.

Background

Greece of the 11th century BC was a relatively poor place by comparison with its Mycenaean past when the fleets of its kings ranged the Mediterranean, the bureaucracy of their palace storerooms rivalled that of the far more extensive kingdoms of the east and Egypt, and their arts were no less accomplished, though somewhat less ambitious in terms of size than those of their non-Greek neighbours. What brought an end to the palaces and their literacy is not clear and at any rate not our concern. The regeneration of Greece took a long time. The small country, much subdivided by mountains and rivers, was one of village communities wholly dependent on the land they controlled, and in merely geo-

graphical terms quite unlike the lands of the east and Egypt, even of Cyprus. Greeks were still hardy seafarers, but yet to harvest again the goods of distant shores, though there were Greeks in Cyprus, and links with the island were never severed. The empires of Assyria and Egypt ignored the Aegean coasts, but Greeks were soon to visit foreign shores with more purpose and, themselves, to receive the ships of easterners. The east Mediterranean was reawakening. In Euboea, at Lefkandi, a ruler built a massive apsidal structure, forty-five metres long, showing that monumental aspirations could still be cherished. His tomb and those of some successors contained eastern exotica, and we may imagine a society including élite travellers and skilled seamen. Finds in the near east show that there was some exchange of goods, while the sailors of Euboea were soon to explore the coast of Syria with more intent, and set free that flow of eastern goods that created Greece's Orientalizing Revolution. In the 8th century their eyes were cast again on the west, and the colonizing of south Italy and Sicily began, in step with Phoenician exploration farther west and south. By the end of the century Greece had grown to a country of small cities, often at odds with each other, with rural territories and some also with merchant fleets, on which their prosperity depended. To the west their colonies waxed rich, while across the Aegean older settlements (Ionian and other) had to cope at closer quarters with eastern powers.

In all this story the evidence of pottery bulks large, but it is not an aspect to which this book can afford to devote much attention, although note will be taken of historical events and social requirements. If the pottery of a particular site tells us more about its local history than about the craft itself it is likely to be treated summarily, and can be studied more easily and in a specialist manner elsewhere.

Dates

Before the later 8th century BC dates depend wholly on associations with non-Greek objects or finds overseas in contexts for which local sources can provide a date. Sadly, there are virtually none, and we depend a great deal on simply observing the clear stylistic, and sometimes stratigraphic sequence of the major pottery series (in this case the Attic), assess the probable rate of change from style and quantity preserved, make correlations from find contexts, and spread the material accordingly in centuries and quarter centuries. The resultant dates are purely conventional and might easily be upset if clear contexts with foreign and dated events were to appear. A spurious air of precision is given by round centuries BC but it is likely that they are not too misleading, and where there are foreign contexts the conventional dates have at least proved very plausible.

With the 8th century there are dates for the foundation of various western Greek colonies in later writers who counted back by numbers of years or by generations. These need not be reliable, but where they agree about a sequence

of foundations, and the sequence seems borne out by the apparent stylistic sequence of earliest finds, and where there are finds in foreign contexts which have even a vague date, they make very good sense. Finds such as an Egyptian scarab for a Pharaoh (Bocchoris) who reigned 720–715 in a Late Geometric (in terms of pottery) Greek tomb on Ischia, are very reassuring. There are more foundation dates in the 7th century, and by its end and thereafter there are finds in sites destroyed at known (or roughly known) dates by easterners (Babylonians, Lydians, Persians), in Greece and the near east, as well as close stylistic parallels to be drawn with architectural sculpture which has a reliable literary date (the Siphnian Treasury at Delphi). Again, plausible correspondences repeatedly emerge from new finds and associations with historical events, and all attempts to upset the agreed sequence seriously have failed, however convenient some new equations might appear in particular cases and from a narrow viewpoint. But even the absolute dating proposed here and by others for pottery has to be taken cautiously since it indicates primarily what appears to be its relevant place in a sequence, and we must allow for, but cannot always identify, the avant-garde as well as the old-fashioned or backward. I suggest dates for the main styles and sequences in the chapters that follow and the Chronological Chart but do not give them in the captions (except where there could be serious confusion with adjacent pieces), to avoid any air of false confidence. The maps are an important aid in this volume.

It should be noted that the chapters below are not simply chronologically arranged, but by style, so that the Geometric in one place may be contemporary with the Orientalizing elsewhere, and so on.

Shapes and functions

One thing that differentiated Greeks from the non-Greek, both in the Bronze Age and later, was their enthusiasm for using pottery as a field for elaborate decoration, of figures and floral or abstract patterns. The regeneration of Greece was accompanied by growing sophistication in domestic crafts, not least those of the potter. Pots survive well, even in fragments, but they do not represent all the vessels and containers of early societies. Wood, skin, basketry, gourds and horn, which generally do not survive, were used, and the shapes appropriate to these other materials could be copied in clay. The technology of metals also meant that bronze or more precious vessels could suggest shapes and details. But clay was the most versatile of all materials, and the use of it represented, after stone tools, man's first major technology. A large number of the shapes we survey seem to have served eating and especially drinking: the cups, and the bigger bowls (*krateres*, craters) in which the wine and water were mixed. There were pouring jugs (*oinochoai*), and carriers of liquid (usually water) with side handles to which was added an upright handle to make the familiar later waterjar, the *hydria* or *kalpis*. Amphorae (plural of the Latin *amphora*, not Greek *amphoreus*) were for

storage of solids or liquids. Small, close-mouthed vessels (*lekythoi, aryballoi, alabastra*) held oil, plates and dishes were tableware, probably not used quite as today, and there were boxes (*pyxides*, named from their boxwood models). Some shapes may have been elaborated, miniaturized or enlarged for special purposes (small dedications to temple or grave, big grave-markers, status display), and some had particular cult functions. Greeks were inconsistent in their names for many shapes so we impose old or modern names as a matter of convenience, and not always correctly or consistently. Special cases will be noticed as we meet them, but we have to learn to accept that archaeologists call a shape a *kotyle* when it first appears, and a *skyphos* two centuries later; and a *skyphos* a cup or *kylix* two centuries later; while many a term (e.g., *olpe, kothon*) is known to have been used for shapes other than those so described nowadays.

Technique

Clay of some sort from which pottery can be made is available virtually all over Greece. Local sources were naturally exploited and the usual place for the kilns would be near them unless they were too far from the relative safety of a town. Some clays were better than others, and the red Attic and pale buff Corinthian were especially good. Clay could be moved about for special needs; for instance, overseas to a settlement, as at Naucratis in Egypt, where Greeks might have wanted to make pots but the local clay was inadequate. A very fine clay like Corinthian could be in demand for architectural and large figure terracottas elsewhere. It was, after all, the same or similar potters, painters and kilns which made the highly decorative clay revetments for Archaic buildings. Identity of pottery origin from chemical analysis of clays has progressed far in recent years, after a shaky start when there were too few *comparanda* available from either certainly located wares or clay beds. This has been important for the early pottery, especially since scholars were reluctant to attribute to unexcavated but historically important towns pottery found elsewhere. We are dealing with a period in which we may normally assume that pottery was made where most of it has been found, but the importance of minor, and eventually major export markets is but one of the historical benefits which stylistic and now scientific attribution of sources has given us.

Decorated pottery was made on the fast wheel and the quality of Greek clay allowed the production of very fine-walled wares, some almost eggshell thin; most, however, were as stout and practical as was required by their function. The black or brownish paint resulted from the careful firing, in two stages, of the same clay, a finer slip producing the black contrast to the pale body. The technique had been practised by the Mycenaeans, and by the 6th century had been perfected to produce the fine Greek 'black glaze' (really a black gloss). If the clay was gritty or dark a finer, pale surface could be added with a thinner slip, or sometimes (as in Chios) by using a white primary clay (like kaolin for porcelain,

not the buff, brown or ruddy sedimentary clays). Then there could be problems resulting from different degrees of shrinkage, and the white slip can sometimes peel off rather easily. Other colours for details might be white (primary clay) or red/purple (from red oxide *miltos*). Various shades of brown and red could be achieved from mixes of the basic clay but nothing more colourful; most Greek pottery decoration is essentially bichrome and the few early exceptions appear in the 7th-century islands and Corinth. In our period all the painting is fired on, so very durable, and conservators who fuss over temperature and humidity are being over-anxious. There are two basic methods of decoration, especially of figure work: silhouette, eventually with incised detail (the black figure technique) from the 7th century on, and, in the same century, outline drawing often with washes of colour. There is little of mixed technique (Corinth, the islands and East Greece).

Free-flowing pottery forms such as the modern potter seeks are the exception. Shapes are generally taut and seem almost mathematically inspired, and details are often most carefully tooled, the unfired pot being 'turned' and trimmed as on a wood-lathe. Its appeal today is very different indeed from that of the best periods of, say, Chinese pottery.

I ignore in this book kitchen wares, which are generally undecorated and many of them not made on a wheel (these do better on the fire or in the oven), and plain storage/carriage vessels which were mainly for liquids (wine, oil), and various unpainted ('monochrome') but fineware small pots made in different parts of Greece from the 9th to 6th century with impressed decoration.

Much of the material illustrated here is from excavations in Greek lands, where complete vases are less often found than they are, for later periods, in tombs in Italy. This is particularly true of those illustrating Chapters 2–5. Many are incomplete and look the less interesting as a result, meat for the archaeologist rather than art historian. Some are better shown in drawing, which is adequate for shape and simple decoration, or to show the restored pattern of decoration over a whole vase. And since the figure decoration is often the most important element and can best be shown in drawings, these will often appear. I have done my best to avoid the less palatable archaeological drawings which are designed to show sections as well as decoration.

The subject matter of the figure decoration, the iconography, is one of the major appeals of the subject. It will not be ignored in the following chapters but it cannot be pretended that the vase scenes give an adequate view of all Greek iconography of the period, so I dwell on local preferences, interactions, whence they are derived and what they may mean. Later Athenian pottery is more plentiful and varied, and so in its way more comprehensive as a guide to the way Greeks expected to see themselves and their myths depicted. Relationships to literature, our most familiar source for things Greek, are a problem, but the vase scenes were no more designed to illustrate Homer than was the alphabet to write him down.

Chapter Two

THE PROTOGEOMETRIC STYLE

The 11th century BC saw the twilight of the Mycenaean world. The palaces and the luxury arts they sustained had passed. Many of the major centres of power either declined dramatically or had been abandoned. In most of the towns and villages of Greece there was continuity of population and general behaviour; no obvious or drastic changes of population except in size and way of life, possibly more local independence, and a degree of relative isolation from what had been the major concerns of the Bronze Age masters. Pottery, of course, was still to be made, though many of the more ambitious earlier shapes and some of the more specialized and exotic ones, such as the stirrup jar for perfumed oil, had virtually disappeared (except in Crete) together with the need for their service or content. The new Protogeometric (PG) style emerges from the latest sub-Mycenaean styles, and it flourished to around 900 BC or later, when a broader range of shapes and patterns heralded the full Geometric style. Influence from Cyprus, which was by now partly Greek-speaking, may have played its part, as well as some passive interest in conservation of the (not so) recent past. Its appearance marks one of the rare occasions in Greek archaeology when we may justifiably feel that the work of the potter is reflecting something more profound than just new pots and patterns, and something that in the long term means more than any new social order that might be deduced from it or from any other archaeological source.

Athens presents the fullest sequence of Protogeometric pottery and the most accomplished work, which need not mean that it invented the style, but at least means that it came to set the pace for change and quality. But I shall use the term Attica/Attic hereafter, since it seems clear that the villages of the Attic country-side were busy pottery-producers, and not everything need be attributed to the town. It is a moot point, to which we shall return briefly, whether shared pottery styles need imply close political affiliations. Athens seems to have been the first Greek town to regain some sort of cultural identity in the aftermath of the Bronze Age, and the new pottery style goes with other indications of probable social significance, such as the adoption of cremation.

PG is divided by scholars into three phases, mainly ignored for our present purposes. The style is evinced in both potting and painting. The pots, made perhaps now on a faster wheel, are better proportioned and more crisply finished than hitherto. The painting is, to our eyes, more thoughtfully suited to the

shape, helping articulate it, with broad bands and areas of sheer black, and rhythms of thick and thin lines, or triple lines. There is a tendency in late PG for more of the vase to be painted black. Motifs are few – wavy lines left over from the past, zigzags, cross-hatched triangles and, importantly, concentric circles and semicircles executed by a multiple brush fitted to a compass. This device created patterns in which we see geometricized versions of the old Mycenaean florals (lily heads and the like) which had themselves become highly stylized in the late period but were still hand-drawn as concentric arcs, as on the stirrup vase [1]. The compass technique was not a new one (except in Greece) and might have been suggested from Cyprus, possibly even from the north, but the way it was used to create the major elements of new schemes of decoration was quite new. The placing of the circles, whole or half, also helped articulate the shapes: rising on shoulders [2, 3, 5–7], hanging from lips [16, 17], pairs like eyes or breasts on bodies [19, 22]. The use of these English terms for parts of a vase calls to mind how Greek potters too tended to anthropomorphize the vessels, as heads, masks or bodies, a recurrent feature as we shall see, and later made much more explicit. This was not a Bronze Age trait, and if we are trying, as many do, to discern in PG elements of design, architectonic and compositional, which will recur throughout the history of Greek art, yet were little apparent in Greece's Bronze Age, then these are certainly relevant features. The planned simplicity of the best PG produced results in which the crafts of potter and painter seem to us to have been most successfully wedded; it appears almost as though thereafter Greek vase-decoration and potting lost their innocence; but they offer many other rewards.

The repertory of principal shapes in Attic PG are: the neck amphora (neck set off from body and with vertical handles) [2], the belly-handled amphora (often with black neck) [3] and the shoulder-handled [4] with a smaller version (amphoriskos); the hydria waterjar with one upright and two horizontal handles (still a rare shape) [5]. Replacing the stirrup jar are small round-bodied, thin-necked jugs (lekythoi) [6] and broader versions with round or trefoil lips [7], for pouring various liquids (wine is generally assumed, whence called oinochoai); globular boxes without handles (pyxides) [8] which are long popular, but there are also some more ambitious shapes [12]; deep bowls (skyphoi) with two horizontal handles [9], and cups with one upright handle [10], or two (kantharoi); the bowls and cups sometimes have conical feet. A few bigger craters (krateres, wine-mixing bowls) [11], are like large skyphoi or with vertical strap handles to the rim. Basket-shaped vases (kalathoi) reveal their origin in wicker shapes (see the later [35]). Exotics like duck vases (see [25]) may derive from Cyprus. We shall find virtually all these forms and variants upon them persisting in use throughout the history of Greek vase painting, but they will be added to as a result of inspiration from overseas or to meet special needs of life or cult.

The Attic sequence is best read in the rich finds from the Kerameikos cemetery in Athens, outside the major NW gate and near the potters quarter (whence

its name). The clays probably came from farther off, perhaps Amarousi where the beds are still in use and yield a fine reddish clay which, in the early period, was fired lighter than it was later (from the 6th century on). Beside the abstract decoration on the vases there is minimal figure work (a modest silhouette horse [*13*]) though the potters also made figure-vases (a stag: *GSAP* fig.3) with wheel-made bodies decorated like the vases, or toy horses on wheels for a child's grave. That these vases travelled in Greece is shown by their obvious influence on other wares rather than from the few identified exports.

The island of EUBOEA lies off the east coast of Attica. Of its major historic seafaring cities Eretria was not settled until the 8th century and Chalcis remains little known. The main source for us is Lefkandi, between these two cities, which British excavations of the last thirty years have revealed as the richest site in Greece of this period for both its architecture (the palatial '*heroon*' some forty-five metres long) and eastern imports. In late PG, from around 950 on, the potters began to import and take closer note of Attic forms but also to innovate with a disposition of patterns unthought-of in Attica [*14*]. There is some preco-cious figure work [*15*] but not, it seems, locally made. The multiple brush and compass were wielded with enthusiasm. In the skyphos with pairs of pendent semicircles (PSC) on each side, the Euboean potter created what was to be the prime indicator of Greek presence (in person or pot) in both the eastern and, to a lesser degree because later, western Mediterranean [*16*]. The distinctive decora-tion and its associations with wide-ranging seafarers may have prompted its retention to at least as late as the mid-8th century. This gives Euboea a sub-Protogeometric phase (SPG) contemporary with the Early and some of the Middle Geometric of Attica. SPG also produces some early figure work, and some handled open dishes with PSC decoration [*17*] as on the skyphoi, which look like export models for Cyprus where the shape is at home. The PSC cups were also current, and some made, to the north in Thessaly and imitated yet farther north, and in the Cyclades islands, several of which seem to have been within Euboea's sphere of influence. The historical value of the identification of this pottery cannot be overestimated, and its sources are confirmed by clay analy-sis. The cups are found in quantity in Syria and could only have come with Greeks, and perhaps only to be used by them since eastern drinking habits favour handle- and foot-less small cups rather than vessels of Greek shape. Lefkandi also yields a painted clay man-horse (*GSAP* fig.4), the significance of which is obscure: either the earliest myth figure (Chiron with a wound in his leg) of Iron Age Greece, or a nod to Cyprus.

In THESSALY (a major site at Marmariani), there are PSC cups, evidence of Attic influence, and some fine craters [*18*] as well as a local fondness for jugs with cutaway necks which were to be taken up in Euboea. Here too PG lingers well into the 9th century. Farther off, in MACEDONIA, PG is intrusive on a mainly non-Greek culture and the products mostly imitative though impressive, and these northern shores were being much visited, eventually colonized.

To the south, the local schools of the Peloponnese can be distinguished mainly in terms of their copying or deviation from what we take to be the Attic norm. Connoisseurship of their production is of more value for the history of the people than of pots. Migrations east across the Aegean to what became known as Aeolis, Ionia and the Dorian Dodecanese, what we call 'East Greece', left many settlements, at this date hardly more than coastal footholds, well aware of the homeland PG styles in pottery. There are good Atticizing works, recalling Athens' alleged role as springboard of the Ionian Migration, from sub-Mycenaean on. Given the apparently slower tempo of life in Greece after the Bronze Age hurly-burly and probable decline in interest in neighbours, one might have expected less homogeneity of pottery styles and less readiness to imitate leaders in the craft. But new finds constantly remind us of how much Greece of this period has been underestimated. These are not altogether Dark Ages.

CRETE deserves special attention. The Bronze Age Minoan tradition in pottery was as influential as the Mycenaean had been on the mainland of Greece, though in its later years Crete too had fallen under Mycenaean control. There seems to have been less disruption of population, while the passage of people to and from Cyprus may have helped retain much more continuity of practice in the more modest crafts. The former Minoan centres at Knossos, Phaistos and Gortyn remain important although habitation had shifted away from the palaces. Awareness of mainland Greek PG is obvious [19, 20] but did not inhibit continued use of the stirrup jar [24] for oil, of straight-sided pyxides and of wide craters (bell-craters). The Dark Age interest in duck vases is well attested [25] but Crete will have a long record in creation of such figure-vases. More importantly, Cretan vase painters had not eschewed figure decoration for their pots and allowed it to dominate some vessels. Early examples have mainly silhouette figures: boats and goats [21] or something more lively [22]. Later, though, there are monsters that hark back to Bronze Age types – sphinxes, and lions attacking a warrior, an Orientalizing motif probably introduced long before [23]. These figures do not represent a unified Cretan style, some are silhouette, some quite elaborately patterned, but they do make one wonder more at the fact that the rest of Greek pottery of the period remained virtually figure-free. The Cretans must have been very different people in their attitudes to their crafts, and the figures on pottery suggest that similar decoration may have been admitted in other media.

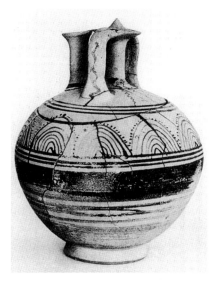

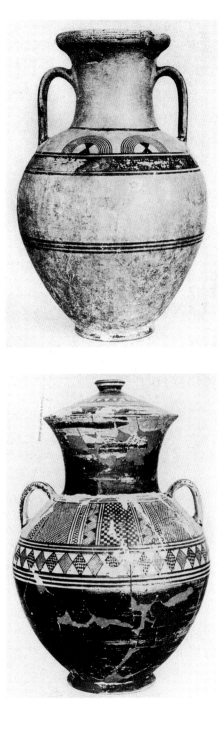

1 Attic sub-Mycenaean stirrup vase. (Ker. 498; H. 20.6)

2 Attic PG neck amphora. (Ker. 575; H. 41)

3 Attic PG belly-handled amphora. (Ker. 560; H. 47.2)

4 Attic PG shoulder-handled amphora. (Ker. 2131)

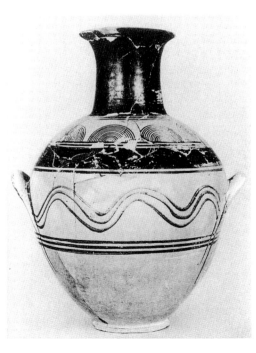

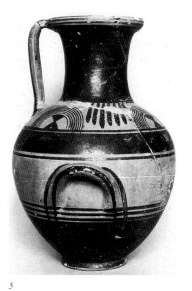
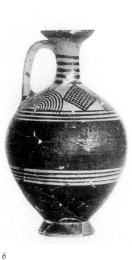
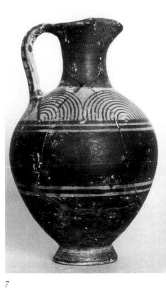

5 6 7

5 Attic PG hydria from Peristeri (Attica). (Athens 195; H. 34)

6 Attic PG oinochoe jug. (Ker. 2022; H. 29)

7 Attic PG oinochoe. (Athens)

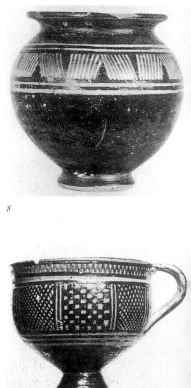

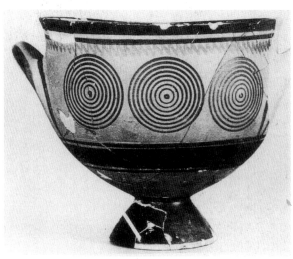

9

8 Attic PG globular pyxis. (Ker. 912; H. 13.1)

9 Attic PG skyphos. (Ker. 547; H. 15.5)

10 Attic PG cup. (Munich 6213; H. 9.6) 10

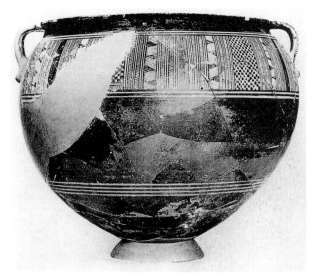

11 Attic PG crater from Nea Ionia (Attica). (Athens 18114; H. 47)

12 Attic PG tall pyxis. (London 1950.2-28.3; H. 48.2)

13 Attic PG belly-handled amphora detail. (Ker. 1260)

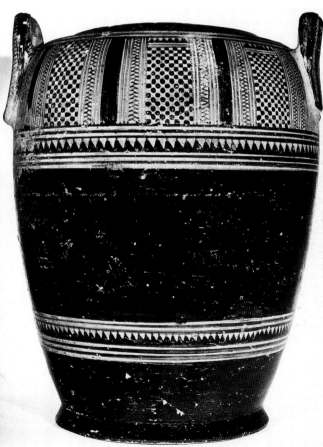

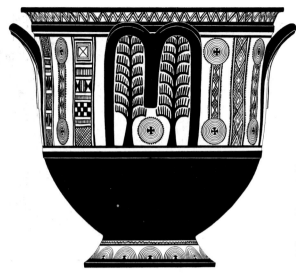

14 Euboean MPG crater from Lefkandi (floor of 'heroon'). (Eretria; H. c.80)

15 Euboean MPG hydria fr. detail from Lefkandi. (Eretria, Lefk S51/2)

16 Euboean SPG pendent-semicircle skyphos from Lefkandi. (Eretria, Lefk S59/2; H. 6.7)

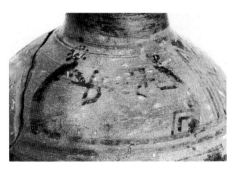

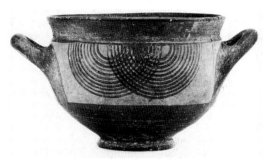

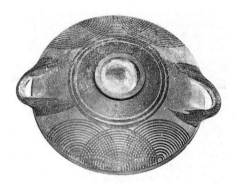

17 Euboean SPG pendent-semicircle dish from Lefkandi. (Eretria, Lefk T 42/8; W. 17.7)

18 Thessalian LPG crater from Marmariani. (Athens; H. 39)

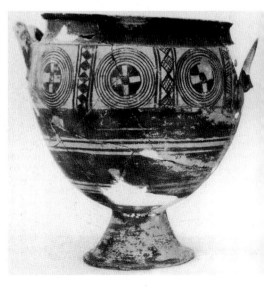

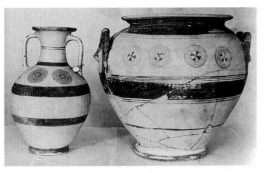

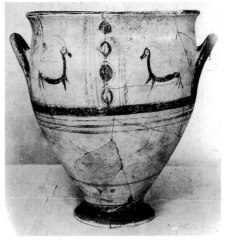

19, 20 Knossian EPG neck amphora. (Heraklion, Fortetsa 226; H. 35.5). (Right) Knossian EPG crater. (Heraklion, Fortetsa 222; H. 39)

21 Knossian EPG crater. (Heraklion, Fortetsa 45; H. 40.5)

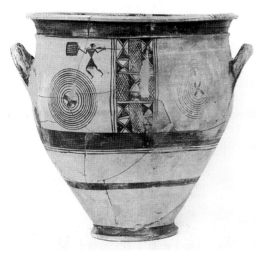

22.1,2 Knossian EPG crater from Teke, Knossos. Warrior and hunter. (Heraklion, Teke Tomb F)

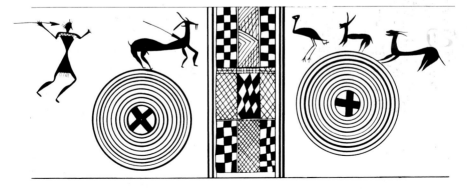

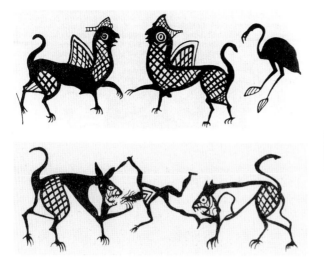
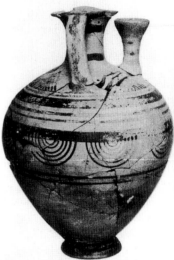

23.1,2 Knossian LPG crater. (Heraklion; H. 31.4)

24 Knossian EPG stirrup jar. (Heraklion, Fortetsa 141; H. 25.5)

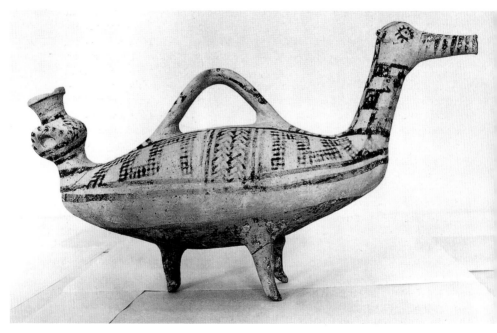

25 Knossian LPG duck vase. (Heraklion, Fortetsa 277; L. 31)

Chapter Three

THE GEOMETRIC STYLE

The making of definable Attic Geometric pottery begins around 900 BC and goes on until around 700, the latter date being only slightly more precise than the former. Stylistically it divides into Early (say, 900–850), Middle (850–760) and Late (760–700), abbreviated as EG, MG, LG, each being subdivided as EG I and II, etc., and some further as LG IIa and b. Such apparent precision depends on observation of decoration and shape more than stratigraphy or absolute dates, although towards the end there are contexts with Egyptian objects and the evidence of earliest finds in colonies whose foundation dates are deduced with some optimism from later literature (see Chapter 1).

Classification of non-Attic wares does not exactly follow the Attic in dates and style although Attica still sets the pace. What happens is a growing diversity of geometric patterning which comes to cover more and more of the vase surface, eventually displacing the nice black, and hardly helping to articulate the shape. The compass is not forgotten but is less important. The decoration is disposed in friezes, a natural way for a potter, but these come to be subdivided, sometimes in very complex rhythms of vertical strips and panels, and the last may be further subdivided horizontally. Some scholars have likened this complicated new rhythm to that of an epic hexameter, as Homer's. The analogy is not altogether meaningless and this is the first intimation of the Greek artist's interest in the almost mathematical disposition of complex patterns and images, but the effect is more like that of a carpet, or patchwork. Figure decoration, highly stylized, assumes some importance, at first isolated or repetitive in friezes, then in major panels. Many of the new patterns seem probably derived from those natural to weaving or basketry, and there are some basketry forms copied (kalathos-baskets [*35*], round box-pyxides [*37–8*]). These are crafts for women in many early societies, as often was potting, so the overall effect may owe something to women's treatment of other media, and although women could hardly have handled some of the very heavy potting which was involved, their possible role as decorators cannot be ignored.

The development of a Geometric figure style was not internally generated. Much seems so close to styles current at the end of the Bronze Age, often in trivial detail like filling patterns, that there must be some connection, more probably through chance finds copied than from any continuity, but we cannot be sure about what might have continued to be made in other materials. Some use

of repeated-animal friezes seems to have derived from the near east, but we should not call Geometric 'Orientalizing' because the conventions that governed the construction of individual figures, as of patterns, do seem to have been developed independently. There is a puzzling, almost universal popularity for Geometric decoration on pottery at about this time, from Persia (Sialk, in the eastern desert) through parts of Anatolia. It would probably be wrong to make too much of this since there are no other apparent associations, and many of the patterns appear also at widely different periods and places simply because they derive from common techniques (weaving and wickerwork) where the material does much to determine pattern. So we find many tapestry or weaving patterns, with tassels and fringes. Some Argive Geometric vases [*123*] look most like patchwork quilts.

This is a period whose art is best studied in its pottery, and the way it is treated explains much of what comes after: a growing interest in figure decoration to set a scene and eventually tell a story; a very strong architectonic sense in the use of pattern; and experiment with some patterns which will remain quintessentially Greek, notably the maeander – 'Greek key'. The ability to differentiate regional styles is important. Some, like Attic and Argive, are shared by whole districts (Attica, the Argolid) with different centres sometimes producing pots discernibly different from their neighbours although sharing a common syntax of decoration. *Faute de mieux* this has been used to try to distinguish political groupings; much might be due to the observation of neighbouring fashions by individual potters, and the location of market towns, but we make the most we can of archaeological evidence for history where texts fail us. Identification of source as an aid to identifying trade and settlement overseas is crucial historically, and the compliment paid by copying the familiar styles of others, in pottery or anything else, may well conceal other associations, commercial or social.

Attic

In Attica the EG vases tend to retain the mainly black surface cover of late PG. The compass patterns are almost abandoned, however, in favour of grouped zigzags and obliques, and the simple key or battlement pattern, as well as real maeanders [*29*]. Where appropriate, between handles or on the neck of a vase, the pattern may be presented in a panel [*26–9*]. Shapes are much as before, the round-lipped lekythos acquiring a trefoil lip to pour from, and oinochoai a broader base [*28*]. Craters commonly have a high stand (see [*34*]), but the skyphoi have lost their conical feet [*29*]. Pyxides with pointed bases remind us that we shall meet a number of shapes that were intended for suspension, from wall or wrist. This is a type yet more popular in the following period [*36*].

In Attic MG the surface decoration further disintegrates into strips and narrower bands of triple lines and pattern, and there are new string patterns of linked circles or lozenges, and opposed triangles, often helped out with dots, as

well as the old multiple zigzags. Rows of verticals are punctuated by half-filled crosses, like butterflies or double axes (they are of course neither). Complexity of pattern and panel is most highly developed on the vessels made to mark graves, of traditional shape but immense: neck amphorae and standed craters for men, belly-handled amphorae for women. On these the multiple-brush circles return with patterns at their centres and disposed in pairs of panels, recalling wheels or eyes or breasts [33]. The triple-loop feet of [32] are borrowed from Cyprus and will recur on other Greek Geometric vases (Argive, Cretan). On craters the horizontal handles may be reinforced by a strap running up to the rim [34], a feature which will be developed in various ways in later years ('stirrup crater'). The flat pyxis emerges as an important shape [38], sometimes with a horse or horses (one to four) as a handle on the flat lid, suggesting a mount or chariot team. There are also larger deep pyxides [40], and more cups with high-swung vertical handles (kantharoi) [39]. Stray examples of figure decoration present status/wealth animals – horses, a stag, pigs [40], fowl, and once a female mourner; and on a skyphos [41] we see our first major action scene of fighting on land and sea, with rather fluid Geometric figures. Some MG pottery seems almost to qualify as luxury ware, or at least to demonstrate wealth: the extraordinary combination of treasure chest and model granaries of [30] comes from the grave of a wealthy woman dressed in Orientalizing gold jewellery.

LG is a boom period for Attica, not only in its pottery. There are clear indications of a growth in wealth and population while awareness and use of foreign wealth and art grows apace. Much attention seems to be paid to modes of burial, well served by pottery, and graves are still our prime source. There were important cemeteries in the Attic countryside, as at Thorikos and Eleusis (which seems very likely, on other grounds, *not* to be in any real way under Athenian control, and might caution us against using such evidence too freely to identify political affiliations). In vase painting the changes are mainly internally generated to meet new needs, not least those of an élite who demonstrate status by show, usually in other materials than pottery except when it came to grave marking. We can also begin to identify the hands, and so the influence, of individual painters, sometimes even two hands on one vase. The exercise is made easier by the increased use of figure decoration, and from observation of casual detail as well as overall composition – a criterion successfully employed on later Attic pottery (black and red figure). We have of course no names for these artists – Greece is barely literate as yet – only invented sobriquets. But decorated-pottery production is now a growth industry.

The Dipylon Painter, working mid-century, seems to have canonized the geometricization of human and animal figures, which hitherto had been rather more loosely drawn. We observe them best on the grave-marking vases decorated by him [44] and his followers which carry large panels with funeral scenes on their bodies [45–7]. These are often referred to as Dipylon vases, from the cemetery by the Dipylon Gate where many were first found, but they were not

confined to it. We may note in passing, perhaps with some surprise, that many of the big grave-marking vases have survived complete, but many others only in isolated fragments. This suggests that, once broken, some were soon effectively covered, but it is possible that they had differing fortunes after the burial, possibly not unrelated to the identity of the buried. Later large vases that have survived well were generally buried and did not stand above ground.

The compositions on the vases are geometrically arranged in symmetrical areas of verticals and horizontals which, when more closely inspected, resolve themselves into figures setting a scene. To the repertory of patterns is added chequer, various diamond 'tapestry' patterns, leaves (some formed into rosettes, as on pyxis bases) and more developed maeanders. What look like pattern friezes may be composed of repeated animal figures [44, 48], reclining or grazing quadrupeds and birds, possibly inspired by near eastern bronzes or weaving. Newly important shapes for LG I are the pitcher and tankard [51–5], bowls (sometimes lidded) with vertical sides [56–7], while oinochoai sport necks of varying height [58–61]. There are generally more bigger vases, and a growing assortment of odd shapes, such as the pomegranate vases [62], offerings for the grave that reflect the multi-pipped fruit's fertility/death symbolism.

The stick figures of LG observe a strict discipline and economy of construction. The important features are emphasized: broad shoulders, strong thighs. Women are given blip breasts and dress; men do not generally show a penis but are deemed naked, with sword and knife at waist and/or two spears, and a crest to indicate a helmet. The curvaceous 'Dipylon shield' [49, 50, 59, 60] is a geometricized version of the large but light hide shields which had a long history in Greece. In LG II round shields appear as well, harbingers of Greece's new hoplite armour, and some of these are decorated. Sometimes Dipylon shield fights round shield, and the latter of course wins. The artist shows what he knows to be there in a fully conceptual manner. Although a four-horse team seen in profile may economize with a single body, all heads, legs and tails are shown. Similar experiments to show two men side by side have little success because the human body is upright, not horizontal like a horse; the result is odd-looking twins (at the right on [46.2]) which do not survive the LG style which created them and are no more likely to have any mythical identity than the horses are to be judged multi-headed and -limbed. A charioteer may be shown standing on, rather than behind, the chariot rail, while an ordinary rider may look more like part of a circus act. Filling ornament is a variety of zigzags, diamonds and stars, which again recall tapestry.

The Dipylon Painter's best preserved work [44] stands 1.55 m high and shows well the symmetrical pattern of the laying out of a body (*prothesis*; notice the female, with skirt) between the handles, with pattern friezes which include grazing and reclining animals, and multiple maeanders. The Hirschfeld Painter offers a crater 1.23 m high [45] with the male dead laid on his bier on a cart for the procession to the grave (*ekphora*) accompanied by mourners in two tiers to

fill the height of the field, and a chariot procession which might hint at funeral games (on some other vases they race). On both, the shroud is lifted and cut away by the painter so that the body is visible. Mourners raise their hands to their heads (tearing hair), and on one vase mourners may be seen carrying food offerings to the dead [46] while a small figure under the shroud seems to try to feed him. By showing seated figures beneath the bier the painter is not attempting a composition in which spatial relationships are meant to represent reality. There is, however, much more sophisticated detail of action and intimation of purpose than might appear at first sight.

There is more animation in the fighting scenes which are seen on some of the grave-markers, often on ships [49, 50]: a reflection, it may be, on Attic 'trading' methods and piracy rather than the hazards of colonization, which Athens did not face. Some elements of the fighting groups may reflect the conventions of near eastern art, but rather, perhaps, knowledge of battlefields. Other funeral scenes appear on smaller vases – seated figures with clappers or rattles [51, 61], perhaps to deter malign intervention at an important ritual occasion between life and death, and there are more specific scenes of duels and dances which could refer to games or cult [65]. The man savaged by two lions on this vase is an old eastern motif picked up elsewhere in Attic and other Geometric art [23]. But the dominant themes in Attic LG are death, horses and warfare.

By the end of LG the figures show rather more fluidity, not so much an attempt at realism as an indication of careless or at least rapid execution, although now a two-wheeled chariot in profile may be shown properly with just one wheel [69, 70]. Silhouette is still the rule, but relaxing, a woman's dress may be crosshatched and there is an occasional patterned or white shield blazon [68, 70–1]. Subsidiary friezes of animals, now also of dogs, persist, and the near east introduces the lion, locally geometricized with proper emphasis, however, on jaws and paws [66, 74–5]. The effect of the east is more apparent in other media, less traditionally established than pottery. Funeral amphorae and hydriae get slimmer; there is a general tendency for ritual vases to adopt less practical proportions. Their function is also sometimes indicated by the applied (or painted, dotted) snakes on rims, handles and shoulders [68].

Some open, conical cups [72–3] have decoration within, perhaps inspired by Syrian bronze bowls which usually show rows of animals. [72] carries early sphinxes which seem to have horse-legs like centaurs and so are by no means a simple copy of the eastern monster. Elsewhere we find winged goats which may be a Greek fantasy. Dishes, decorated outside, survive from LG I [63] as does a good range of skyphoi and kantharoi with metopal decoration (i.e. patterns in square panels between verticals) [64]. Some of the kantharoi and occasionally other shapes have vertical ribbing on the body, appropriately decorated with tall tongues, either just painted or in relief; these look as though they might imitate metal although the motif is easier done in clay. While the compass was not forgotten for isolated wheel patterns, the multiple brush found a new use, freehand.

It proved to be a ready method for the rapid, and usually fairly slovenly, production of zigzags, chevrons and small diamond patterns, both in friezes and as fill [68–70]. Lavish use of the device does little credit to the painter and is a sign of the exhaustion of the Geometric painting technique. Multiple brushes of twelve or more members can be detected. This freehand usage in Greece began a century before, and was more carefully applied in Corinth. Corinth also begins to offer Attic some shapes and decoration in LG IIb, such as the kotyle and broad bands of parallel stripes [75]. We shall find that this exhaustion of the Geometric style in Athens seems associated with other indications of some sort of decline or contraction in Attic society, but it is a phenomenon shared by other parts of Greece except, it seems, Corinth.

Euboean

Euboea remains in a SPG mode, still producing pendent-semicircle cups [16], through the period of Attic MG, of which it takes some note. Lefkandi declines in importance, but settlement at the grander site of Eretria begins (the other great city, Chalcis, remains little explored). Around 750 an important artist, the Cesnola Painter, introduced a robust Geometric figure style, possibly from Naxos. His name vase is a high crater found in Cyprus [76] which displays his innovations – the goats at a tree (an eastern theme) and the rows of linked blobs or concentric circles (hand-drawn). His followers adjust the style in interesting ways, sometimes using a deliberate contrast of thin and thick paint; and they use a compass for the rows of concentric circles. Figure work is mainly men and horses [77], but a variety of angular-winged bird [79] seems a Euboean trait and persists well into the 7th century. Oinochoai may have cutaway necks by the handle [78], a feature borrowed from Thessaly to the north. The LG II cups are most characteristic of the ware, although the least spectacular. There are high-rimmed skyphoi with rows of concentric circles or stripes on the rim, and metopal patterns on the body comprising groups of verticals enclosing simple zigzag or diamond patterns, all executed with a multiple brush [80]. Others have simply striped rims but the circles appear on mugs too [81]. Some open, conical cups (compare the Attic [73]) carry simple Geometric patterns drawn in outline and filled, not with the usual hatching, but with white paint, which can also appear on the rims [82]. This is unique for the period. There are copies of Protocorinthian kotylai (tall cups) decorated with stripes and wire-birds (see the colonial copy [160]), or in white and often with white stripes within, and aryballoi [83]. All these are styles well represented in Euboea, but also in Syria, where they were taken by Euboean merchants, and in the western Euboean settlement on Ischia where there was local production in the same style (see below), also introduced to Etruria in these years. The simple metopal skyphoi keep up the tradition of the pendent semicircles, and get imitated in Cyprus and in the Phoenician west.

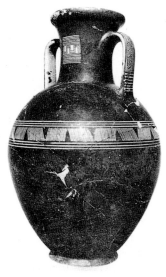

28 Attic EG jug. (Ker. 1253;
H. 23.7)

26 Attic EG shoulder-handled amphora.
(Ker. 412; H. 37.5)

27 Attic EG neck amphora. (Athens,
Agora P20177; H. 52)

29 Attic EG skyphos. (Ker. 251; H. 8)

30 Attic MGI chest with model granaries.
(Athens, Agora P27646; L. 44.5)

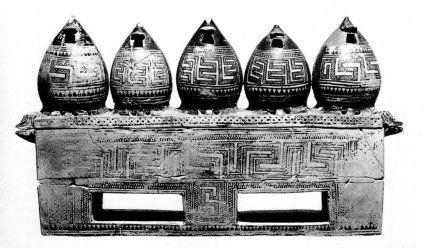

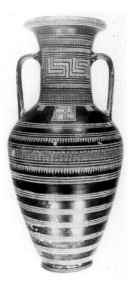

31 Attic MGII neck amphora. (Tübingen 1245; H. 51.5)

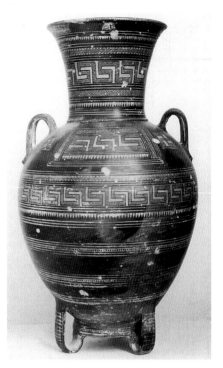

32 Attic MGII shoulder-handled amphora from Athens. (Athens 218; H. 73)

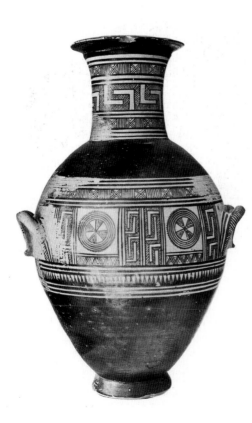

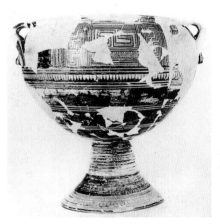

34 Attic MGII standed crater. (Ker. 290; H. 52.5)

33 Attic MGII belly-handled amphora. from Eleusis. (Eleusis)

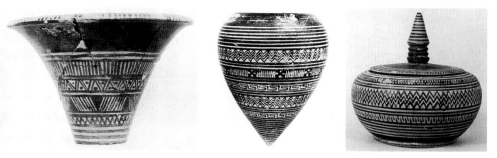

35 Attic MGI kalathos from Eleusis. (Eleusis 397)

36 Attic MGI pyxis. (Acropolis 1961–NAK299; H. 15.5)

37 Attic MGI pyxis. (Eleusis 800)

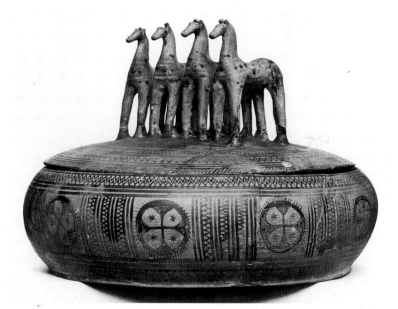

38 Attic MGII pyxis. (London 1910.11–21.2; H. 24.3)

39 Attic MGII kantharos. (Ker. 258; H. 11.5)

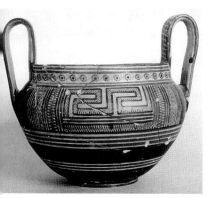

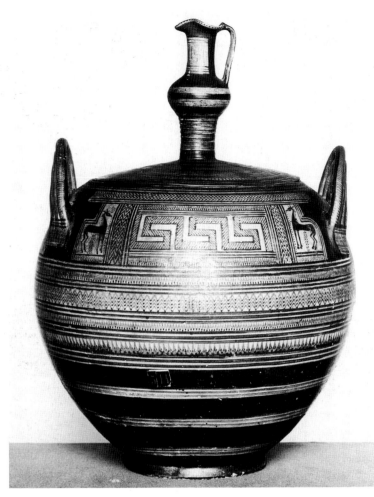

40.1,2 Attic MGII pyxis, and figure details. (Louvre A514; H. 33)

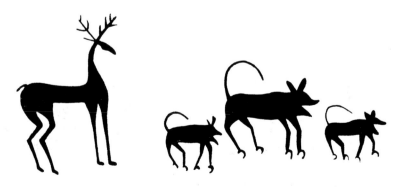

41.1,2 Attic MGII skyphos from Eleusis. (Eleusis 741; H. 6.4)

2,43 (Left) Attic MG skyphos. (H. 7.5). (Right) Attic MG skyphos. (H. 5)

44 Attic LGIa amphora by the Dipylon P. *Prothesis*. (Athens 804; H. 1.55m)

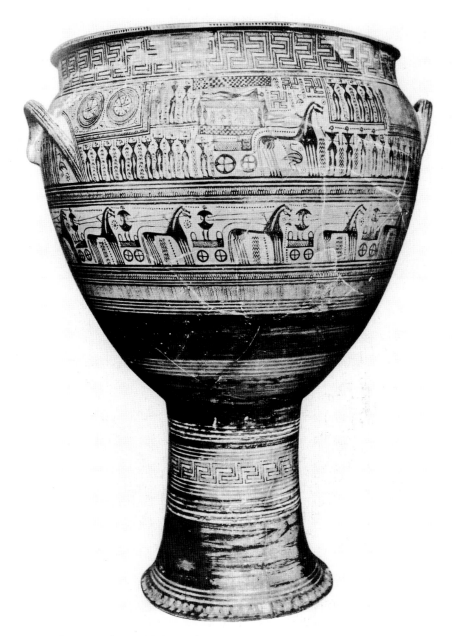

45 Attic LGIb crater by the Hirschfeld P. *Ekphora.* (Athens 990; H. 1.23m)

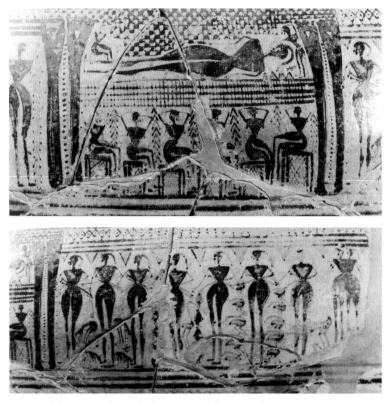

46.1,2 Attic LGI crater details. *Prothesis.* (New York 14.130.15)

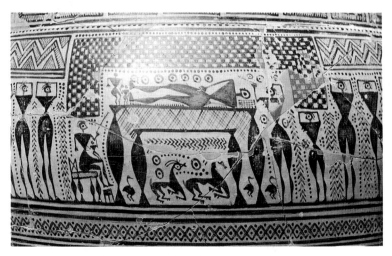

47 Attic LGIb crater detail. Late Hirschfeld P.(?) *Prothesis.* (New York 14.130.14)

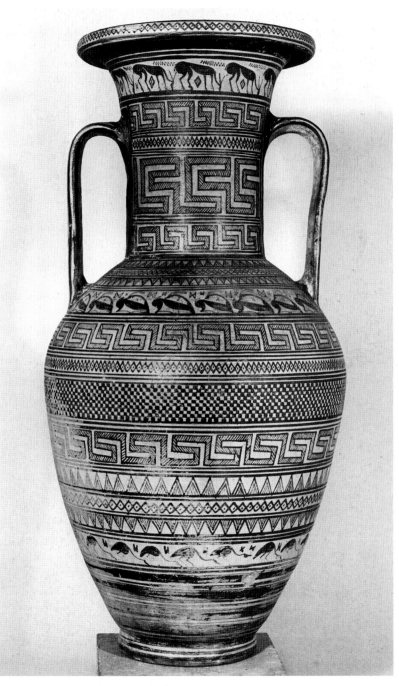

48 Attic LGI neck amphora, Dipylon workshop. (Munich 6080; H. 51)

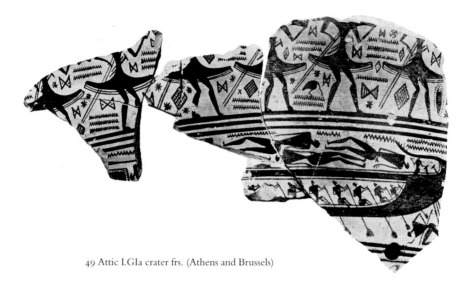

49 Attic LGIa crater frs. (Athens and Brussels)

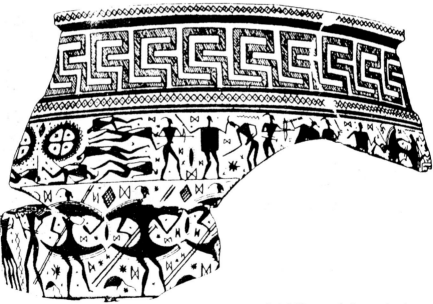

50 Attic LGIa crater fr. (Louvre A519)

51 Attic LGII pitcher. Cult scene. (Athens)

52 Attic LGI pitcher. (London 1878.8-12.8; H. 21.5)

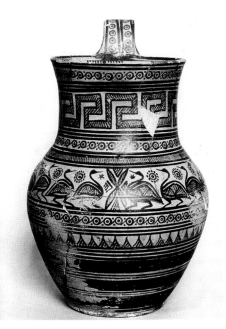

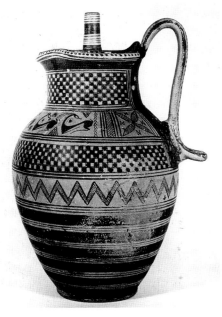

53 Attic LGIb pitcher. (Athens 858; H. 28)

54 Attic LGI jug. (Tübingen 2657; H. 32.5)

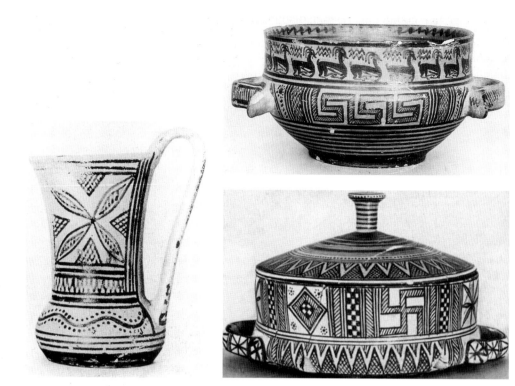

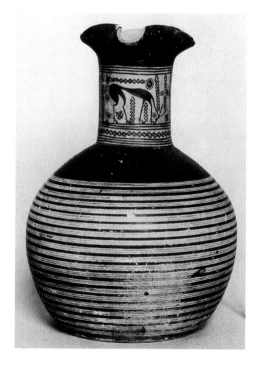

55 Attic LGIb tankard. (Ker. 1303)

56 Attic LGIb bowl. (Athens 166; H. 10)

57 Attic LGIb lidded bowl. Workshop of Athens 706. (Ker. 345; H. 7.5)

58 Attic LGIb oinochoe. Dipylon workshop. (Athens 152; H. 21)

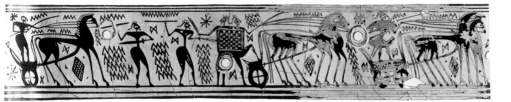

59.1

59.1,2 Attic LGIIb oinochoe with wall pierced by tube (magic?) (Athens, Agora P4885; H. 22.8)

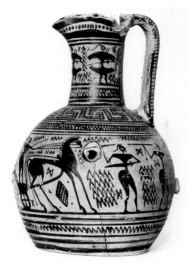

59.2

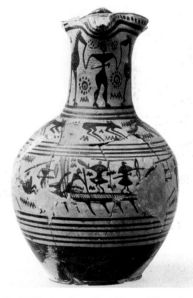

61.1

60 Attic LGIIa oinochoe. Hunt Group. (Copenhagen NM 1628; H. 23.4)

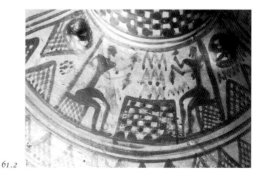

61.2

61.1,2 Attic LGIIa oinochoe, and detail. Cult scene at an altar (?) (Liverpool, once Danson; H. 44)

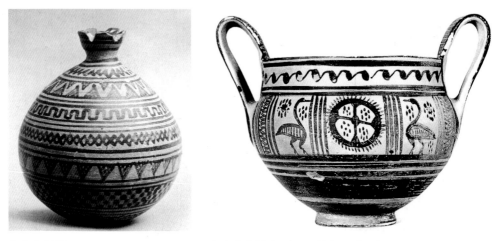

62 Attic LGII pomegranate vase.
(New York 12.229.8; H. 10.2)

64 Attic LGIb kantharos. (Athens 18422)

63 Attic LGII dish. (Ker. 800)

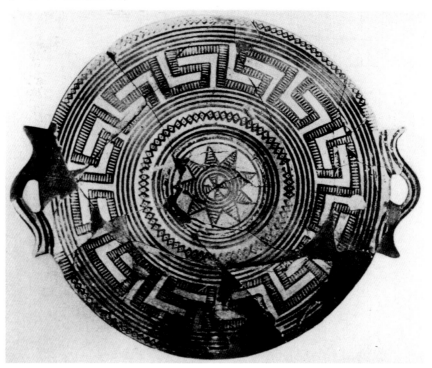

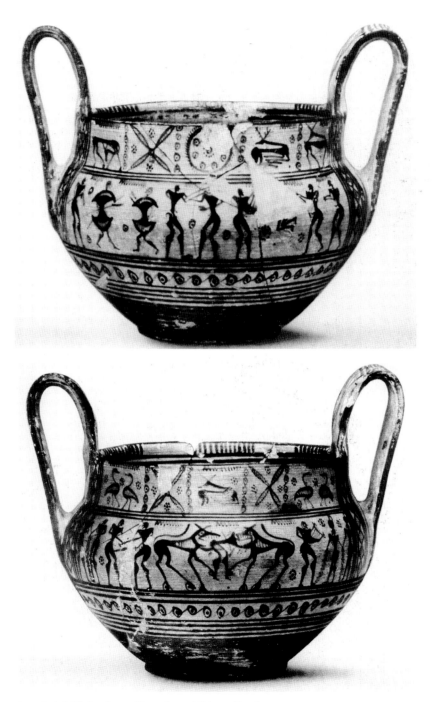

65.1,2 Attic LGIb kantharos. (Copenhagen NM 727; H. 17)

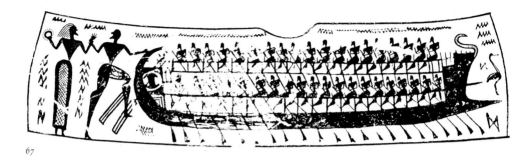

67

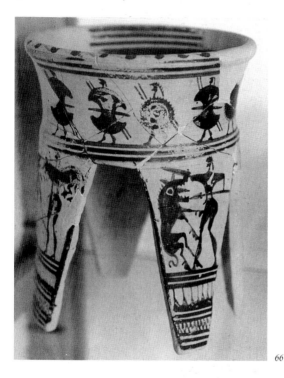

66 Attic LGII tetrapod stand. Lion fighter. (Ker. 407)

67 Attic LGIIa spouted crater from Thebes. (London 1899.2-19.1)

68 Attic LGIIb neck amphora by the Benaki P. (Athens, Benaki 7655)

69 Attic LGIIb amphora detail. (Athens 894)

66

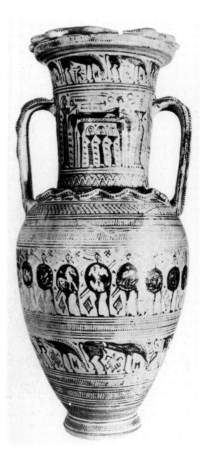

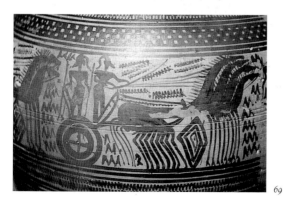

69

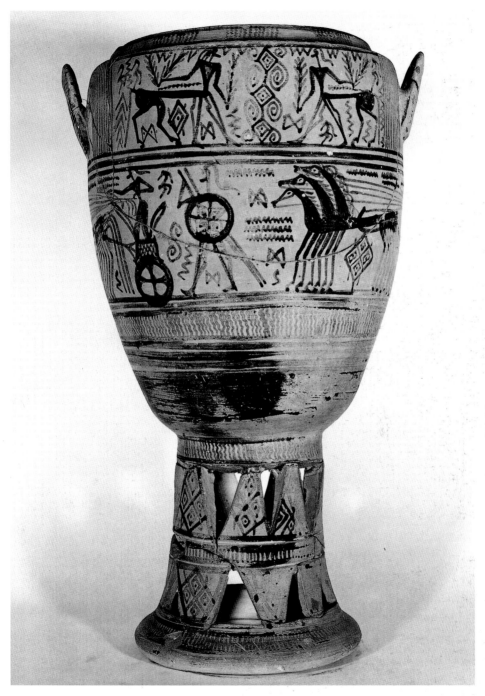

70 Attic LGIIb standed crater. Workshop of Athens 894. (Louvre CA3256; H. 46.7)

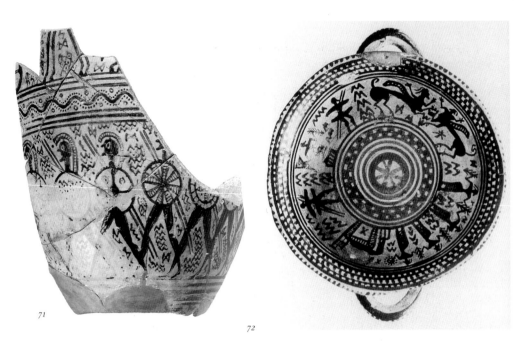

71

72

71 Attic LGIIb frs. (Athens, once Vlasto)

72 Attic LGIIb cup interior. Two sphinxes(?); women approach a seated goddess; warriors flank a lyre-player. (Athens 784; Diam. 12.5)

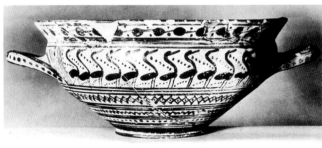

73

73 Attic LGIIb cup. Birdseed Group. (Munich 6220; H. 8.5)

74 Attic LGIIb kantharos. (Athens, once Vlasto)

75 Attic LGIIb kotyle by the Lion P. (Athens, once Vlasto)

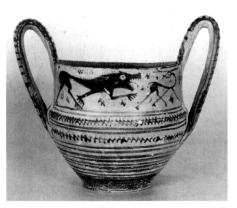

74

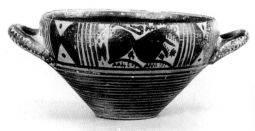

75

Euboean Geometric lingers into the 7th century, though not at Lefkandi, but internal strife diminishes Euboean enterprise and thereafter the pottery record is impoverished. A characteristic shape which begins in LG II is the tall-necked amphora, seldom figure-decorated [84] but usually with thick wavy lines up its neck and simple metopal patterns on the body [85]. This remains an important shape in Euboea, Boeotia and the islands.

To the north the potters of THESSALY continued their idiosyncratic course in shapes and decoration without wandering far from the basic Geometric patterns [86]. In non-Greek MACEDONIA farther north there is some surprisingly early use of concentric circles.

Cycladic

In the islands of the Cyclades the potters kept their eyes on Attic and Euboean until LG, when they also had a shared interest in tall-necked grave amphorae. The central sanctuary island of Delos attracted many offerings and some classes of pottery are still known by the letter titles assigned them by the French excavators there. The sacred island was purified in the 6th and 5th centuries, and the contents of graves, mainly pottery, reburied in pits on the adjacent island of Rheneia (so I say 'from Delos' for them; the vases are in Mykonos Museum). This has proved an important source but, of course, the original grave groups are lost.

MELOS makes some conventional standed craters and more individual open-work stands [87]. NAXOS, has fine large MG amphorae, some with three circle-panels [88], and a figure and pattern style which may have inspired earliest Euboean LG; later, some neat slim amphorae with striped bodies [89](Delos Bb). Naxian clay is red, Parian more sandy, both of them micaceous from the islands' volcanic origins. PAROS (Delos Aa,c,e) favours the multiple-brush metopal patterns for cups and kantharoi [90] and on broad amphorae, some with metopal Geometric decoration [91], some of the 'Wheel Group' [92]; these surely run on well into the 7th century. A speciality are dishes of Attic type. Late too are the heavy amphorae of THERA with their fairly sparse but careful Geometric patterns, including the last of the big Geometric circle motifs [93–4]. In all islands there is production in shapes and decoration which mainly reflects Attic, but I have picked out whatever is more distinctive of each and displays its individuality. Some vases which include Orientalizing detail must be quite late and for these Subgeometric is a fair description, although this is sometimes too readily applied to any otherwise nondescript ware.

Boeotian

Boeotia, a broad and fertile tract of land in central Greece across the straits from Euboea, had several major sites, the most important of which in most periods

was Thebes. The area was relatively unimportant for its pottery before LG when some very distinctive styles and shapes are developed which persist well into the first half of the 7th century. Hallmarks are stout triple zigzags (vertical), eight-legged swastikas (some are seen in Attic), linked dashes and rows of concentric circles, probably borrowed from Euboea. Some big oinochoai seem to have been made in Thebes [95–6], and there are both plump and tall pyxides [97–8], round-bodied kantharoi [99, 100] – always a favourite Boeotian shape, and bell-idols [101]. Decoration is neatly applied; beside it the figure work is often crude, but includes some unusual animal life, including a shaggy boar being hunted [100], and the small-headed humans on this and other vases have a certain style.

The tall-necked amphorae carry a pale slip as do most of the later vases [102–3]. They share Euboean liking for wavy lines on the neck and occasional use of white. Some show ambitious outline drawing which is eastern in theme though with a local identity (the Artemis-like mistress of animals on [102]) but not style. The Boeotian version of a Geometric *prothesis* on [106] is on a tall thin hydria and must be fairly late. The composition is chaotic. At about this time there is comparable figure work incised on the bows and catch-plates of big bronze fibulae (safety-pins) from Boeotia, including some certain myth scenes, and these probably also run well into the 7th century. The different pottery-producing centres of Boeotia will be identified only through clay analysis but Thebes is commonly quoted as a provenance and must be a major centre; the various styles seem more differentiated than the Attic though still recognizably 'Boeotian'.

Corinth

The Peloponnese has a far more interesting record. Corinth stood at the land bridge between central and south Greece, and commanded the passage to and along its gulf, towards the Adriatic and Italy. Later there was a haulage way (*diolkos*) for shipping east-west across the isthmus, but this must have been passable in some way from an early period. An important source is the port and sanctuaries at Perachora, on a promontory opposite Corinth, where shipping might pause en route east or west. The town's cemeteries and a Potters Quarter have been excavated, and it will play an important part in this volume, but its start is muted. Its Geometric pottery depended very much on Attic, with a preference for maintaining a dark aspect to the vases and a restricted range of pattern – maeander, zigzags, rows of chevrons [107–9]. But the quality of painting was high, and even the multiple brush was wielded with special care; this finesse will long remain a Corinthian merit.

The 'chevron skyphoi' [109] are among the earliest Greek vases to travel west, where Corinthian pottery in particular was in general demand in South Italy and Sicily regardless of origin of colonists (only Syracuse was Corinthian but they had been busy on the Adriatic approaches) – an unusual tribute to its quality and

to the mercantile status and position of Corinth itself. It was copied too, notably by Euboeans, at home and in their colonies. Characteristic of LG I decoration is the use of close-set bands of stripes decorating the lower part of vases or in broad bands, carefully spaced, executed on the wheel. Other Geometric patterns are restricted and simple. The only figure work is 'wire-birds', painted, like much else, with a multiple brush, except when in separate pairs [*112*]. Important shapes are a broad deep cup with short vertical rim, and a tall cup (*kotyle*) with relatively straight walls. Early versions of this are also early travellers west ('Aetos 666' kotylai, named from a site in Ithaca). The shape will have a long history. [*110*] shows a basic type, and [*111*] one on which the painter has practised with his multiple brush. There are also conical oinochoai [*113*], a peculiarly Corinthian adaptation of the earlier form which bulged towards the base; and pyxides, either broad cylindrical, or tall with domed lids [*115*]. In the period of Attic LG II most Corinthian pottery was essentially Orientalizing, and so is dealt with in the next chapter, but the new style retained many elements of the old in both decoration and shapes.

Thapsos Group

One other class must be mentioned here since it is normally classed with Corinthian, named from the Sicilian site where examples were found. It is mainly LG in Attic terms and a little later [*116–20*]. The shapes are like Corinthian, mainly cups, oinochoai and broad craters (complete drinking sets!). The clay looks Corinthian, but there the resemblance ends. The ware is virtually unknown in Corinth itself but well distributed in central Greece (Delphi, Thebes), the NW Peloponnese and on some western sites where the pattern of distribution does not truly match Corinthian LG. The potting and firing are different, producing a softer heavier effect; decoration includes figures [*118–9*], notably ships, which are almost unknown in the otherwise prolific Corinthian LG, but late examples [*120*] are not unrelated to the Orientalizing figures of Protocorinthian which we have yet to meet. There are running spirals (unknown in Corinth) and more maeander (black and hatched) than in Corinth at this date, together with some motifs best matched in Boeotia. If Corinthian, it is decidedly out-of-town and Megara as a source might be taken seriously; it was an important colonizer in the west (the group is barely represented beside the Corinthian that travelled *east*), its colonies an important source of the class, and, although the site has yielded little, what seems a good example has been found near by. Many scholars, however, still hold the Thapsos Group to be off-beat Corinthian, despite the high originality which it maintained for over half a century in the face of Corinth's dominant production which declined to share any of its most characteristic motifs. Its geographical relationship to Corinth's Potters Quarter is unknown, but its stylistic distance is obvious. It did, however, use clay indistinguishable (so far) from Corinth's.

Argive

In the NW Peloponnese, Achaea and Elis, and on the western islands (Ithaca), Geometric styles are broadly Corinthian (and of the Thapsos Group), but, south of Corinth, the potters of the Argolid go their own way. In EG and MG they have an eye to Corinth and Attica but begin to affect motifs and shapes that will characterize LG [121–2]. Big ovoid lidded pyxides in particular will have a distinguished following [123]. The Argolid was a rich and influential area, seat of Mycenaean kings (Mycenae, Tiryns), and in LG there are various vigorous centres apart from Argos itself, with its big extra-mural sanctuary at the Heraion (whence a clay house or temple model [130]), especially at the old Mycenaean cities. Regional variations are apparent but slight; an attempt has been made to make similarities/dissimilarities reflect political affiliations.

The characteristic LG grave vases of Argos are ovoid pithoi, enlargements of the old pyxides, sometimes with tall necks (thus resembling the grave amphorae of Euboea and the islands; modern nomenclature of vase shapes comes adrift here, as often) and with triple loop feet. There are also craters more like Corinthian in shape [127–8]. The pithoi can be smothered in frieze and panel sometimes with slightest regard to symmetry; the craters and other shapes are more metopal in composition of pattern. There is something rather watery about the decoration – bands of multiple and triple zigzags (in Egypt the water sign, but obvious anywhere), but zigzags also disposed vertically, and all-over mazy maeander patterns. Nymphs with long girdle ends dance in a cloud of zigzags [126]. The other commonest figures are men leading horses, to a manger or a watery panel [128]. Groups are compartmentalized in the Geometric manner, sometimes with boxes of birds or zigzags set at the top corners of scenes; once an artist puts all his symbols together in one frame – horse-trainer, water, fish and waterbirds, dancers – and makes a unified picture of what is otherwise presented piecemeal [129], a unique composition for Geometric art. Filling patterns include many fish, and geometric objects which surely represent carthorse yokes [127], and perhaps other equipment or structures which we cannot readily identify since our eyes are not trained to this form of abstraction. In all the effect is totally unlike that of Attic LG, yet Argives and Athenians cannot have been that unalike in their social and religious behaviour, so this is decidedly the expression of a different artisan approach to the function of decoration on pottery, no doubt still serving comparable needs. Argos, Homer reminds us, was horse-rearing country, also 'thirsty' and the daughters of Danaos were the water-nymphs of the Argolid. The vase painters have these social/religious themes in mind rather than warrior status and death ritual.

Argive styles are influential to the south, in Arcadia and at SPARTA and its territory of Laconia. I show one piece with a figure scene [131].

East Greek

In the East Greek world it is again only LG that attracts attention. In the south, RHODES has been a prolific source and as a result has been credited often with work that really belongs elsewhere. EG [*132*] and MG styles depend much on Attic example, but in LG the local style is clear. The island was on an important east-west route, which explains some local copying of Cypriot and Phoenician flasks. [*133*] is an example of a copy of Cypriot with 'spaghetti' decoration – the multiple brush used in one stroke on and off the compass. The same decoration could be promoted onto a LG crater. On other shapes a number of foreign or locally devised patterns appear, some of them vaguely Orientalizing: trees, cable and hooked diamonds [*134*]. Kantharoi, large globular flasks and footed craters are specialities [*135–6*].

The North Ionian 'bird bowls' are more conventional but form an important series which can be traced, retaining their geometricity, into the 6th century. They start as deep cups with four panels – diamonds outside a hooked triangle and a bird – over a pattern frieze [*137*]; in the 7th century there are three panels – diamonds and bird [*138*]; the frieze below atrophies and the centre panel elongates as the shape gets lower and lower. The decoration of the Geometric examples is seen also on oinochoai [*139*].

The bird bowl is an interesting example of a LG form which is retained, although gradually updated, despite the many other drastic innovations in vase decoration. There is another in Ionia to the north, in CHIOS, where the main sources are temple sites at Emporio and Phanai at the south rather than the main town. Here LG evolves a skyphos type with fairly high, striped rim and metopal pattern between the handles. The latter remains in this position on the shape through the 6th century, with the bowl shallower while the rim becomes higher and higher, attracting Orientalizing and then black figure decoration in the classic 'chalice' shape [*310, 319, 322*]. The sequence in the shape and persistence of pattern from the 8th to 5th centuries is shown in [*140*]. Otherwise Chios has standed craters with some interesting panel schemes [*141–2*] and a full range of mainly striped cups and jugs. There is a little LG figure work, including a ship and a lion fight [*143*]. The Geometric vases run on well into the 7th century. There is hardly more on Chios' neighbour and rival, SAMOS which offers a *prothesis* scene on a kantharos, recalling Attic, and some equally distinctive panel schemes on craters [*144*] and large kantharoi. Finds are mainly from the sanctuary of Hera, away from the town.

In East Greece we are very much at the mercy of the opportunities of excavation. The early pottery of major cities such as Miletus and Ephesus is little more than glimpsed so far; it is clearly rich but probably predictable. That from Old Smyrna is unpublished, but there is an intriguing study of a lyre on [*145*]. Farther north, in Greek Aeolis (Lesbos and parts of the mainland opposite), there has been little decorated ware found, but much of a plain, pale grey bucchero,

copying non-Greek mainland types, while up in Troy and the NE generally there are strange small Subgeometric vases with very sparse Geometric patterning (G 2–3 ware). Apart from the bucchero there seems no influence from the Phrygians and Lydians of the mainland (although this comes later) and the south seems open to more direct influence from the east. On the other hand Caria adopts a very Greek LG style. There seems a general tendency to retain Geometric forms and patterns down to at least the mid-7th century.

Cretan

Crete has a pottery record all her own. Minoan and sub-Minoan shapes survived, even stirrup vases and Bronze Age forms of open craters, large and small. Of closed vases the neck amphora and hydria are common shapes. While Attic EG was observed, most patterns derived also from the past and formed a restricted repertoire which admitted the use of the multiple brush compass and was essentially PG. The main sites are the old ones – KNOSSOS especially. Old burial customs of using (or re-using) family vaults (chamber tombs) for multiple burials have made it more difficult to identify clusters of vases that belong to single burials and so to one occasion. A strange style occupies roughly the period of Attic MG I (down to around 800) and has been called, rather misleadingly, Protogeometric B (PGB) [146–51]. It is in fact a form of proto-Orientalizing, since its most important characteristic is the admission of near eastern patterns – cables, spirals, arcs and scales. Although relations between Crete and Cyprus seem to have been maintained, this new style owes more to the inspiration of Syrian metalwork, both imported and apparently practised on the island by immigrant craftsmen. There is figure work too, outline drawn but decidedly not orientally inspired [146–8]. Important shapes are the straight-sided pithos and globular hydria. [150] is a model decorated as a vase, variously interpreted as a shrine or as the discovery of a tomb, taken to be divinely occupied.

Oddly enough, the new patterns proved to have a short vogue. After PGB it seems hardly worth distinguishing an EG and MG at Knossos in a half century, but there is important innovation: big ovoid pithoi are used as grave vases [152–3]. The Attic crater shape, with or without stand, is copied, and a variety of other foreign shapes, including some imitation of Cypriot flasks. The pithoi are generally four-handled and with conical lids, decorated with standard Attic MG patterns covering the upper half, or more, of the body, some of them somewhat exuberant [152]. By contrast, the LG pithoi are more modestly decorated, the lids sometimes now shield-shaped and some feet are triple-looped. Birds, with raised wings and some multi-headed ([155] a flock) are favourite subjects and a Bird Workshop is distinguished [154]. The Cypriot flask shape continues, with the eastern pattern of circles on the sides (a late example [156]). One innovation which will linger is the occasional rendering of pattern in white paint laid over the black. Apart from some elegant LG birds there is rather less figure decora-

tion on 8th-century Cretan vases than before, but [157] may show a god, perhaps Zeus with thunderbolt and eagle.

Other areas of Crete, perhaps no less important than Knossos in political terms, yield distinctive variants. In the south, from Prinias (with some versions of PGB), Phaistos and Afrati (Arkades), there are vases which could compete with Knossos for interest but so far are less numerous. In East Crete an assumed pre-Greek population (Eteocretan) used vases, some even handmade, decorated with debased versions of the PGB and LG patterns seen elsewhere in the island.

West Greek

The early Greek colonies in South Italy and Sicily begin to be settled around 750 BC, using essentially LG pots, although there was earlier arrival of Greek pottery (and surely Greeks) in the form of the Euboean PSC and Corinthian cups (chevron skyphoi). With Euboeans established on ISCHIA (Bay of Naples; the site is Pithekoussai), and then on the mainland opposite at Cumae, there is brisk local production of typical Euboean LG forms with more attention to Corinthian fashions than at home, on conical oinochoai [158] (but note the Euboean birds, as [79]), kotylai [160] and aryballoi. Some of the figure work is ambitious, both familiar Euboean [159] and more, including a shipwreck [161] and part of a potter's signature '...inos' [162]. The styles permeate the mainland (Campania and Etruria) where there are both imports and the production of local (and Phoenician) shapes carrying Greek Geometric decoration (Italo-Geometric), possibly by Greeks. There is some comparable colonial imitative activity to the south and in Sicily, while in the Phoenician west (Spain) there are even copies being made of Greek cups, while Euboean vases made in Ischia also reach Phoenician (Punic) sites, including Carthage; indeed they are among the earliest vases there. All this is only to be expected. Colonists will wish to continue being served with wares they were used to at home, and connections of a sort were maintained with mother cities; whence the massive import, especially of fine wares, and, where possible, local derivatives, not always simply imitative. The way Greek pots and styles infiltrate native Italian and even colonial Phoenician areas says something about the novelty value of the decorated pottery for the mass of the population, their seniors being served also by more valuable orientalia.

The Greek Geometric style is an important phase in the history of Greek art, and all subsequent development can be seen to stem from it, however much affected by foreign fashions and changes in social attitudes, and however much an obsession with realism comes to demand. It is most familiar to us in pottery, and it may not be wrong to judge that the potter/painter was in early days a leader in defining pattern and the use of figurative art. Much, as we have

observed, might have been derived from lost media such as basketry and weaving, and woodwork was surely decorated in a similar fashion, by carving or paint. Metalwork, in the round and in plaques or vessels, seems less sophisticated in its decoration until LG, or involves works which depend more on near eastern crafts or craftsmen. It is easy to decry our material as mere pots but they deserve the attention they have received as indicators both of a developing mode in expression and of much else of social significance.

The figure work in particular is suggestive and was clearly used to help define the function of the pots involved and sometimes the status or sex of their owners [44–7]. This is most obvious on the big Attic grave markers which declared both cult and rank with scenes appropriate to the social role of their owners. There is also differentiation of shape for the sexes, determining some differences in decoration too. Display to the living was already as important, or more so, as lavish provision for the dead. On most vases, where there is figure decoration not obviously related to particular purposes of cult, we find images of status, animal wealth, horses, chariots; and, outside Athens, perhaps only in Crete, the occasional depiction of a deity, not always easily identified. Any reluctance to represent a god or goddess, at a time when cult statues must have been present in some form in temples, seems to require explanation. It would not, after all, have presented the problems of narrative scenes. Archaeologists are not always quick to provide explanations for or even identify what is missing in Greek iconography, perhaps because it seems otherwise so rich.

It has been easy for some scholars, no little influenced by Homer, to detect heroic events or motifs on the vases. But the 'Dipylon shield' cannot be heroic when it is so often defeated and is at any rate a plausible contemporary weapon; and the 'Siamese twins' [46] cannot easily sustain any heroic identity as the relatively unimportant Aktorione or Molione just for the long period of LG only, with no other identifiably heroic kin, and disappearing with Geometric art. At best they might reflect on the common pairing of heroes in life and the battlefield, or of hero and charioteer [59], which is clearly the case where two such pairs appear on adjacent chariots in a frieze.

The scenes, as so often later in Greek art, are generalized, almost idealized, and contemporary. The Geometric idiom could not sustain true narrative, having no means to identify individuals, but the formulae for narrative were being developed, especially from observation of near eastern art. Thus, on [66], the eastern hero fighting a lion is copied, and a contemporary might have shared our feeling that this could represent Heracles, especially since, on another leg of the same vessel, the hero is shown rescuing a sheep, and he was supposed to have been safeguarding the flocks of Nemea. A sailor's farewell [67] perhaps says as little and as much to us as it did to its ancient viewers about whether this might be Theseus and Ariadne, or Paris and Helen, or just a farewell or abduction. But Greek art is well on the way to making this sort of narrative message clear. While Athens might seem to have set the standards for such work it would be wrong

not to observe that the Argives used the figure work on their vases for subtly different purposes, while other Greeks seem to have had different priorities, and many did without, at least on pottery. There seems to have been a universal interest in fowl.

The geometricization of the main repertoire of pattern, inherited from the past or derived from other media, is a phenomenon familiar in other periods and places. The meticulous application of brush and compass on the best Geometric vases makes the Greek usage exceptional. It could also bear meaning, and we have seen that pattern, as on the Argive vases, might easily stand for realia. It has been suggested that the maeander and zigzag bands reflect the leafy wreaths that pots might carry, or at least bear the implication of 'live' decoration. By the same token the rows of animals seem to energize the vase, although we should probably stop short of thinking that they positively added any magic or protective value. The pattern use of animals might have been a gift from the east. The same source suggested monster imagery, including the lion (no longer visible in central Greece). Much of this repertory had been familiar, mainly from the same source, in the Bronze Age, but Greek artists are to put it to use for narrative in the following period, while on Geometric vases it served much as it did in the east, for statements of supernatural power or threat. Both the figures and the patterns bear promise of far greater subtleties in their use, possibly beyond our ready comprehension. More of this will become apparent in the next chapter.

76 Euboean LG crater from Cyprus by the Cesnola P. (New York 1874.51.965; H. 1.15m)

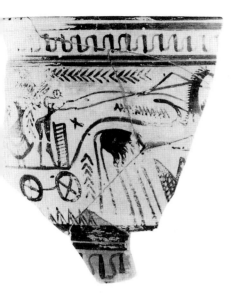

Euboean LG crater fr. from Chania, Crete. (Heraklion)

78 Euboean LG oinochoe from Lefkandi.
(Eretria; H. 18.6)

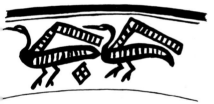

79 Euboean LG fr. detail. (Eretria)

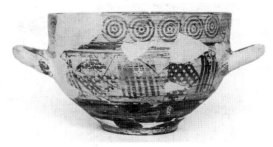

80 Euboean LGII skyphos from Lefkandi. (Eretria; H. 9.2)

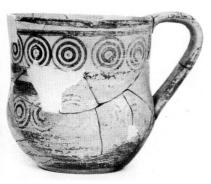

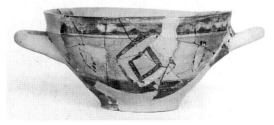

82 Euboean LGII cup from Lefkandi. (Eretria; H. 6.5)

81 Euboean LGII mug from Lefkandi.
(Eretria; H. 8.9)

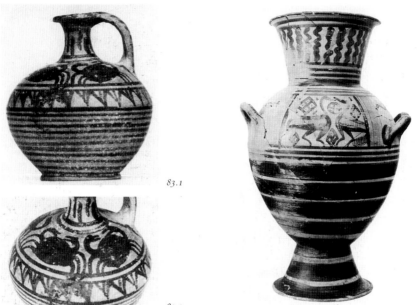

83.1

83.2

85

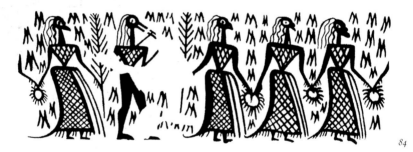

84

83.1,2 Euboean LGII aryballos from
Eretria. (Eretria FKH668.2; H. 8.5)

84 Euboean LGII amphora neck
from Eretria. (Eretria 3275)

85 Euboean LGII amphora. (Athens
12856)

86 Thessalian LG crater from
Marmariani. (Athens; H. 36.5)

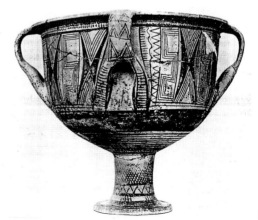

86

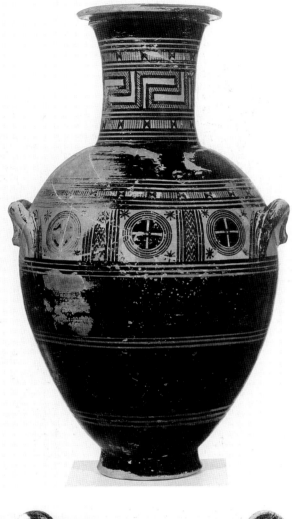

87 Melian LG stand. (Louvre A491; H. 20)

88 Naxian MG amphora. (Munich 6166; H. 73)

89 Naxian amphora from Rheneia. (Delos Bb6; H. 41.7)

90 Parian LG kantharos from Rheneia. (Delos Ae74; H. 13)

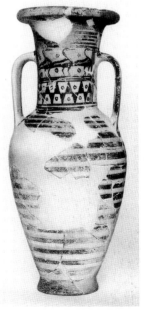

88

89 90

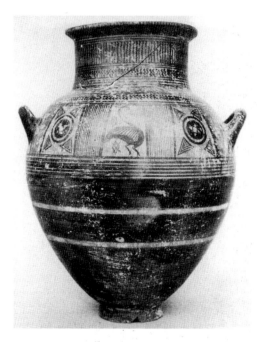

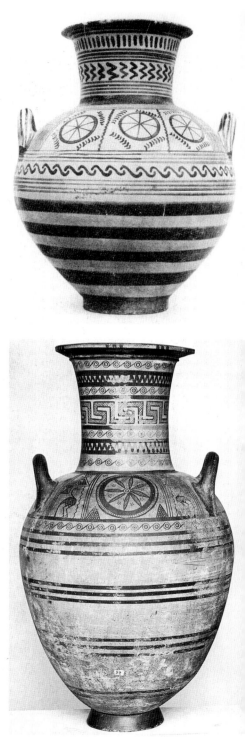

91 Parian LG amphora. (Athens, British School; H. 50)

92 Parian LG amphora from Thera. (Thera; H. 42)

93 Theran LG amphora. (Paris, Cab. Med.22; H. 80)

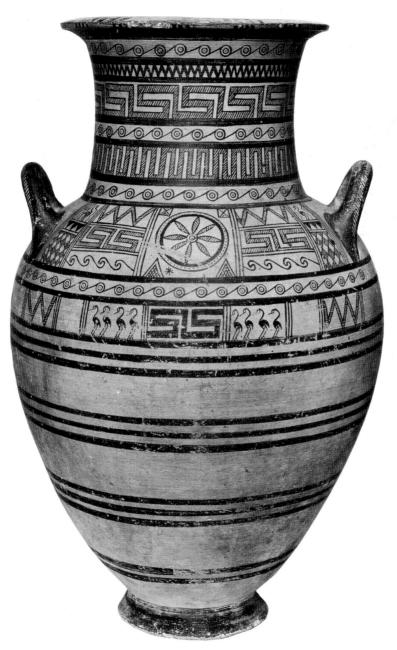

94 Theran LG amphora. (Copenhagen NM VIII.324)

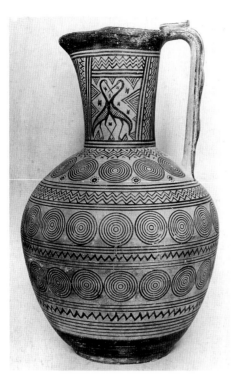

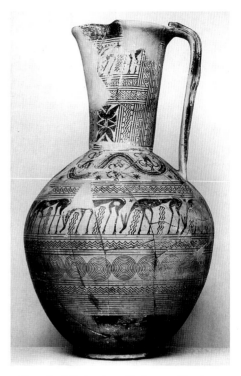

95 Boeotian LG oinochoe. (Athens 12573; H. 48)

96 Boeotian LG oinochoe. (Berlin 3310; H. 70)

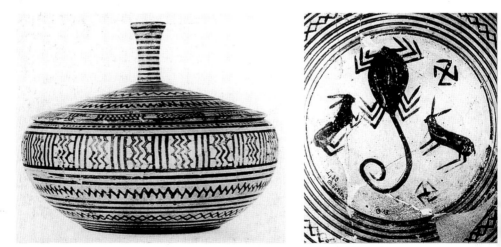

97.1,2 Boeotian LG pyxis, and detail. (Heidelberg G19; H. 16.1)

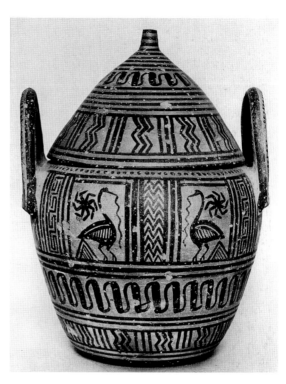

98 Boeotian LG pyxis. (Athens 11795; H. 25)

99 Boeotian LG kantharos. (Dresden ZV 1699; H. 20.5)

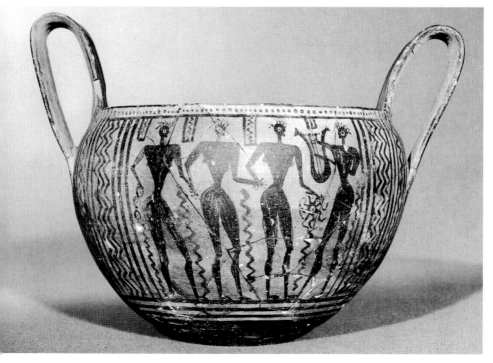

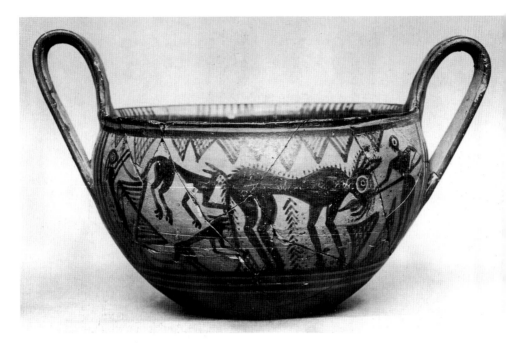

100 Boeotian LG kantharos.
(London 1910.10-13.1; H. 13.2)

101 Boeotian LG bell-idol.
(Boston 98.891; H. 30)

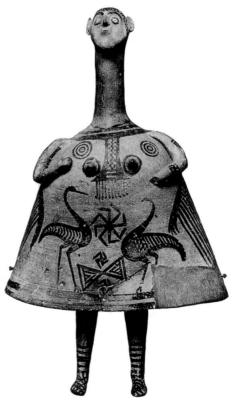

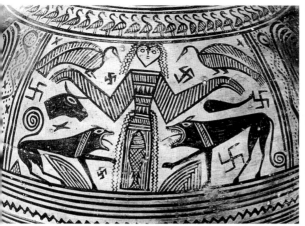

102.1,2 Boeotian LG amphora, and detail. (Athens 220; H. 86.5)

103 Boeotian LG amphora. (Madison, Elvehjem 68.19.1; H. 91)

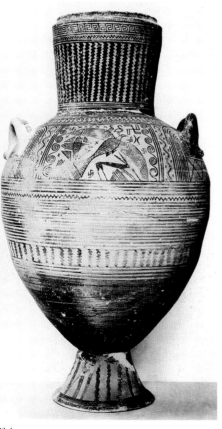

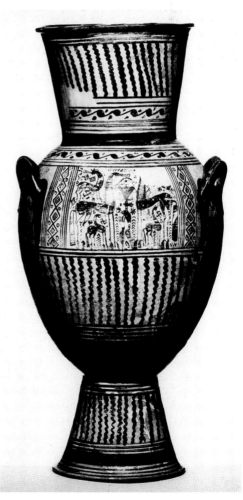

102.1

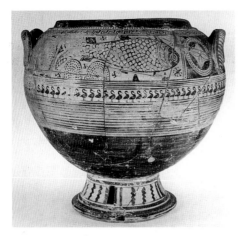

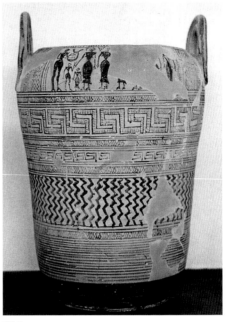

104 Boeotian LG crater. (Athens 237; H. 39)

105.1,2 Boeotian LG pithoid jar, and detail.
(Thebes BE469; H. 66.5)

106.1,2 Boeotian LG hydria, and detail.
(Louvre CA639; H. 45)

105.1

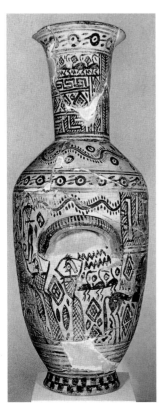

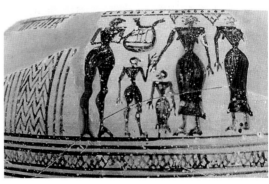

105.2

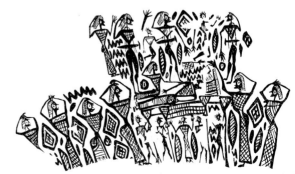

106.1

10

107 Corinthian EG oinochoe. (Corinth CP863; H. 29.4)

108 Corinthian MG crater. (Corinth C-37-1; H. 49.5)

109 Corinthian MGII chevron skyphos. (Corinth; H. 12)

110 Corinthian LG kotyle. (Corinth KP184; H. 12.8)

111 Corinthian LG kotyle displaying multiple brush. (Corinth KP182; H. 13)

112 Corinthian LG kotyle. (Athens, once Vlasto)

113 Corinthian LG conical oinochoe. (London market 1987)

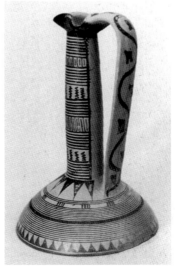

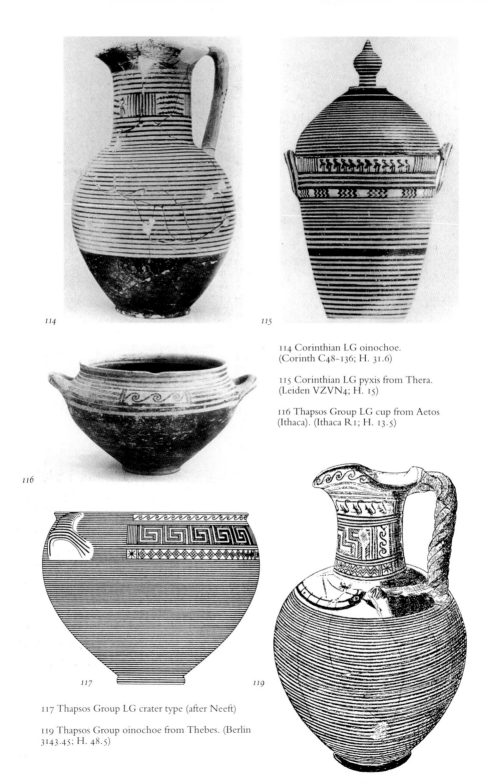

114 Corinthian LG oinochoe.
(Corinth C48–136; H. 31.6)

115 Corinthian LG pyxis from Thera.
(Leiden VZVN4; H. 15)

116 Thapsos Group LG cup from Aetos
(Ithaca). (Ithaca R1; H. 13.5)

117 Thapsos Group LG crater type (after Neeft)

119 Thapsos Group oinochoe from Thebes. (Berlin
3143.45; H. 48.5)

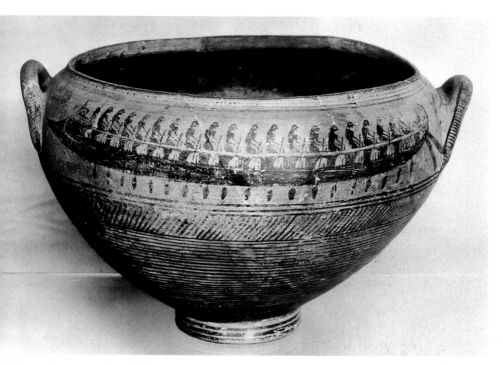

:8 Thapsos Group crater from Thebes. (Toronto 919.5.18; H. 22.8)

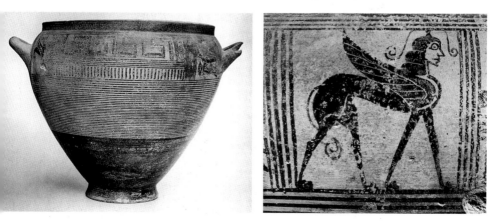

120.1,2 Thapsos Group crater from Aigion, and detail. (Aigion 2; H. 28.3)

121 Argive MGII neck amphora.
(Argos C28; H. 31.8)

122 Argive MGII pyxis.
(Argos C43; H. 43.3)

123 Argive LGI pithos.
(Argos C209; H. 1.04m)

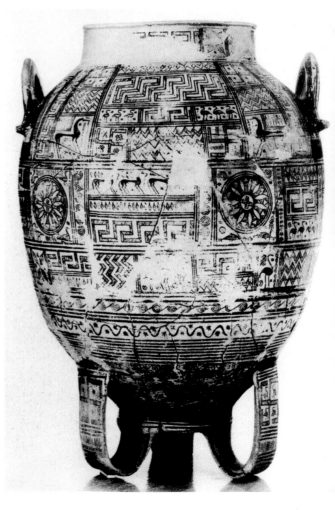

124

126

124 Argive LG oinochoe from Mycenae.
(Nauplion, Myc.53-339; H. 29)

125 Argive LGII pyxis. (Nauplion; H. 25)

126 Argive LGII crater frs. from Tiryns

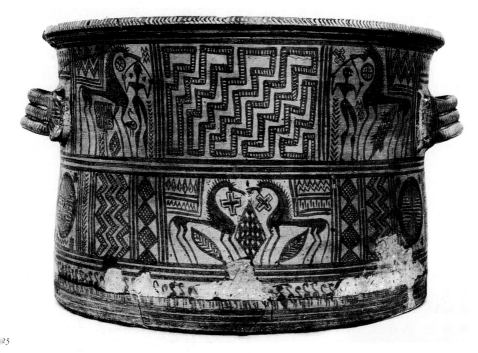

125

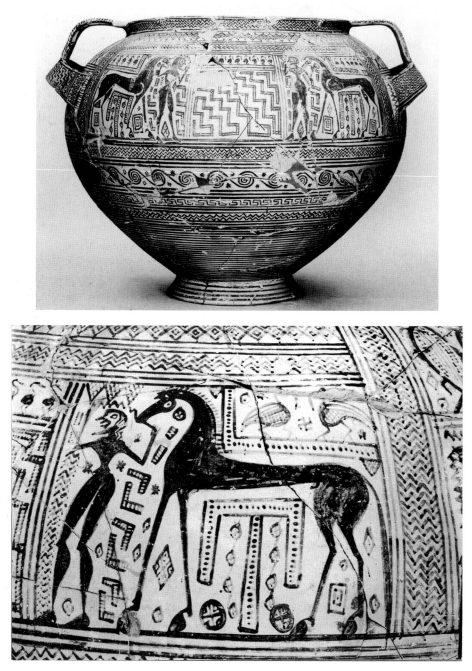

127.1,2 Argive LGII crater, and detail. (Argos C201; H. 47.3)

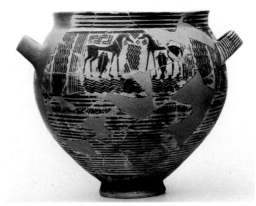

128 Argive LGII crater. (Argos C645; H. 31)

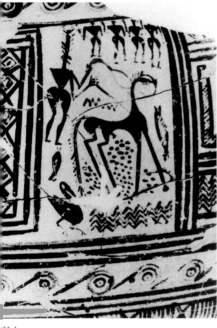

29.1

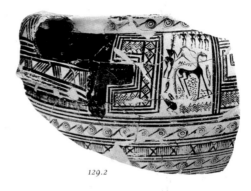

129.2

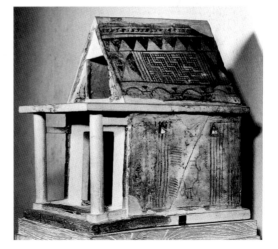

29.1,2 Argive LGII crater fr. and detail.
Argos C240)

30 Argive LGII house or temple model from the
Jeraion. (Athens; L.37.5)

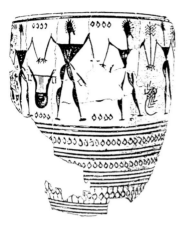

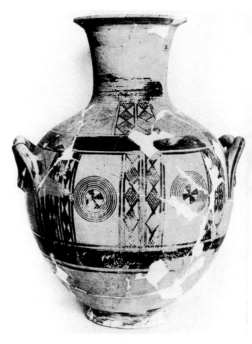

131 Laconian LG fr. from Amyklai. (Athens 234; H. 22)

132 Rhodian EG belly-handled amphora. (Rhodes 15533; H. 56)

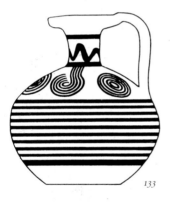

133

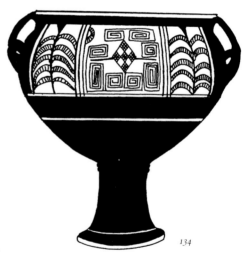

134

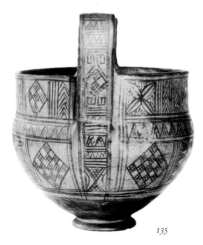

135

133 Rhodian LG imitation of a Cypriot flask ('spaghetti flask'). Ischia 159/5. H. 8.5)

134 Rhodian LG crater from Exochi (Rhodes). (Copenhagen NM 12432; H. 45)

135 Rhodian LG kantharos. (Liverpool, once Danson; H. 21.5)

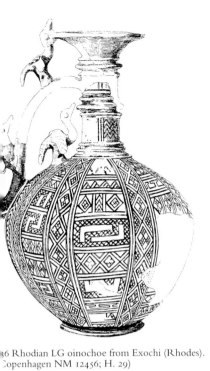

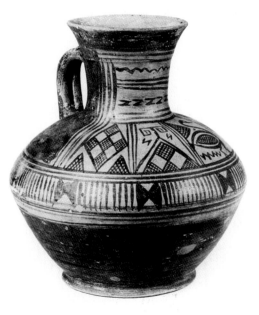

137 N. Ionian LG bird bowl from Delos. (Mykonos geom.rhod.14; H. 10.5)

136 Rhodian LG oinochoe from Exochi (Rhodes). Copenhagen NM 12456; H. 29)

139 N. Ionian bird oinochoe from Crete. Early 7th century. (Munich 455; H. 22)

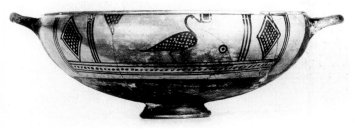

138 N. Ionian bird bowl. About 625 BC. (Oxford 1928.313; W. 14)

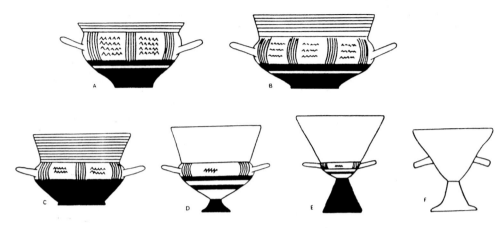

140 The development of the Chian chalice: **a**, LG; **b**, early 7th cent.; **c**, mid-7th cent.; **d**, late 7th cent.; **e**, 6th cent.; **f**, 5th cent.

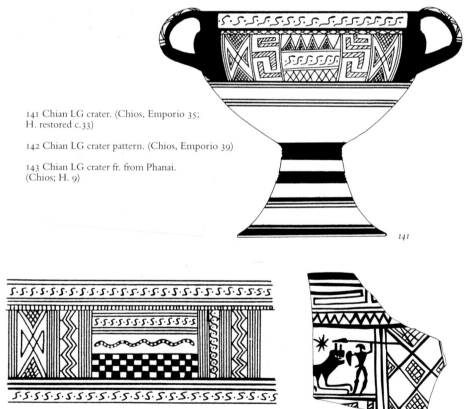

141 Chian LG crater. (Chios, Emporio 35; H. restored c.33)

142 Chian LG crater pattern. (Chios, Emporio 39)

143 Chian LG crater fr. from Phanai. (Chios; H. 9)

141

142

143

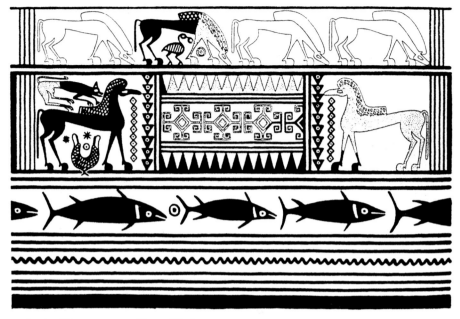

144 Samian LG crater pattern. (Samos K805)

145 LG dinos fr. from Smyrna. (Izmir)

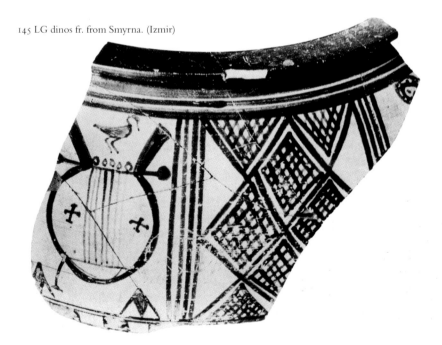

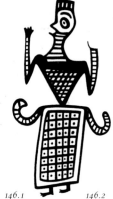

146.1,2 Knossian PGB pithos, and detail. (Heraklion, Fortetsa 1440; H. 41)

147 Knossian PGB pithos. (Heraklion KMF 292.144; H. 46)

148 Knossian PGB decoration from amphora (Heraklion, Fortetsa 339)

149 Knossian PGB hydria. (Heraklion, Fortetsa 493; H. 27.7)

146.1 146.2

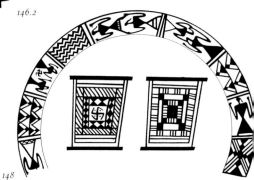

148

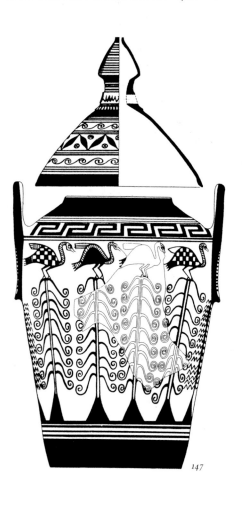

147

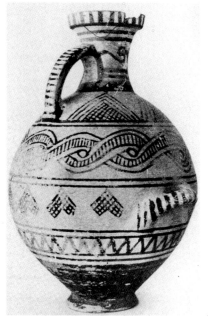

149

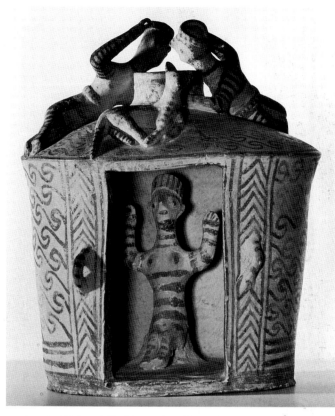

150 Knossian PGB model building with goddess and intruders from Archanes. (Heraklion; H. 22)

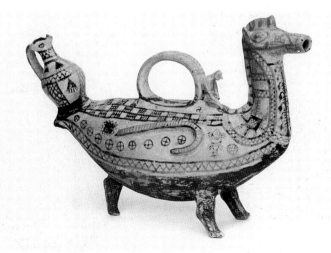

151 Knossian PGB figure vase. Winged? horse rider. (Heraklion, Teke Tomb Q)

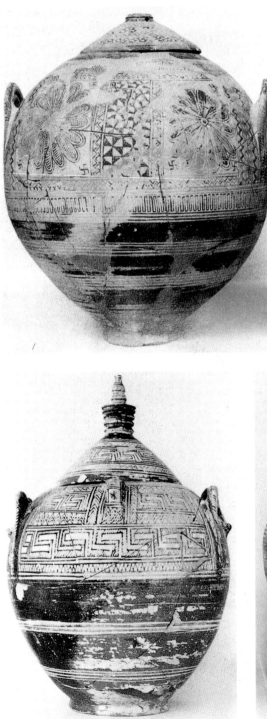

152 Knossian EG pithos from Teke. (Heraklion 12076; H. 62)

153 Knossian MG pithos. (Heraklion 530/1; H. 42)

154 Knossian LG pithos. (Heraklion, Fortetsa 988; H. 50)

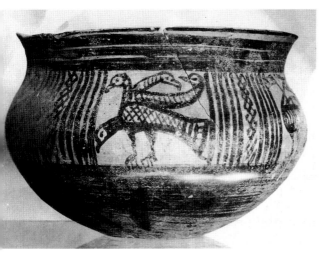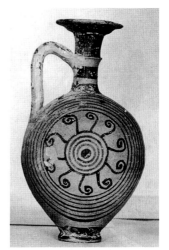

155 Knossian LG cup. (Heraklion, Fortetsa 1369; H. 10)

156 Knossian LG flask. (Heraklion, Fortetsa 1048; H. 9.5)

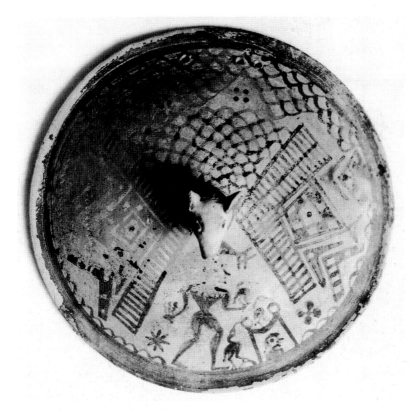

157 Knossian LG lid. (Heraklion, Fortetsa 1414; W. 17.4)

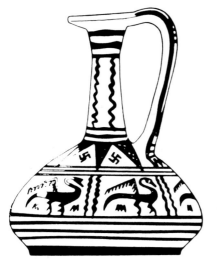

158 Ischian LG conical oinochoe.
(Ischia 355/3; H. 12.3)

159 Ischian LGI lekythos base.
(Ischia gr.967)

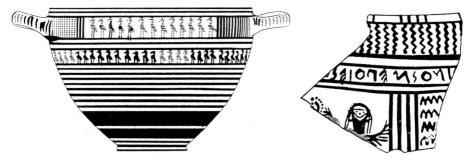

160 Ischian LG kotyle. (Ischia Sp.5/23; H. 9.7)

162 Ischian LG fr. with potter's signature. (Ischia)

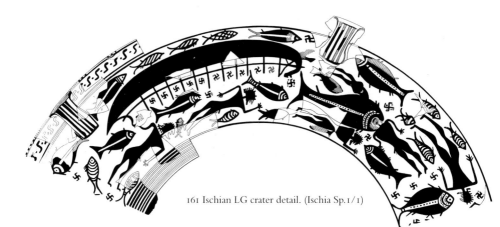

161 Ischian LG crater detail. (Ischia Sp.1/1)

Chapter Four

THE ORIENTALIZING STYLE

The Geometric Greek world had never lost contact with Greek-speaking Cyprus and became, not least through its own efforts but also from the influence of immigrant craftsmen, increasingly aware of the arts of the lands beyond. The most influential were those of Syria and Assyria, to which Euboean Greeks sought access at the mouth of the River Orontes, at Al Mina and through the inland cities such as Tell Tayinat on which the port depended. These have yielded copious Euboean Geometric pottery. Carriers west were Greeks but also surely Syrians, and Phoenicians from along the coast to the south (modern Lebanon), who were at the same time prospecting west and visiting Greece (notably Crete). They were also exploring the western Mediterranean, more at first for trade than for land as the Greeks did, in the same years as Greeks began busy colonization there. Phoenician arts were heavily Egyptianizing and had little effect in Greece although objects were imported. But Greeks had direct dealings with Egypt too, leading in time to a Greek trading town in the Nile delta, at Naucratis. That they were less impressed by Egyptian/Phoenician art than by Syrian must have been a matter partly of opportunity, partly of choice.

The immigrant craftsmen were, it seems, jewellers and other metalworkers who had most effect in central Greece and Crete. Their techniques, and imported works of metal and ivory and, no doubt, textiles, introduced new styles of figure and floral decoration, quite unlike the Geometric but by no means foreign to Greece's Bronze Age past, which was not totally inaccessible to later generations through standing monuments and casual finds. They also introduced new object types, including vessels, which the Greeks copied in metal and clay when they found them useful – the big round-bottomed cauldrons on conical or rod-stands, for example, and various shapes of shallow dish.

The Syrians did not decorate their pottery, and the Cypriots were on the whole more modest than the late Geometric Greeks in this matter. They had retained a figure style not unlike Greek Geometric, and in the 7th century one school perfected a wonderfully colourful and imaginative style in animal drawing on vases, perhaps too advanced or outlandish to be copied by homeland Greeks. In Greece the Orientalizing patterns and figures had to be translated by the potter/painter into a different medium. Human and animal figures rendered in incision or low relief on near eastern metalwork and ivories encouraged more outline drawing in Greece, with painted linear detail indicating features, muscles,

ribs, flowers. Incising techniques suggested similar treatment of silhouette figures on vases, giving rise to the black figure technique, a Greek pottery invention to answer eastern incising in other media. As a result, figures are fuller and more naturalistic than the Geometric although not much affected by close observation of live forms, and the Greeks were especially taken by the opportunities offered to introduce pure pattern in the decoration of bodies, much as it appeared on their eastern models. Of the subject matter, animal friezes were important, including monsters which the Greeks soon accommodated and hellenized (sphinxes, sirens, griffins) by identifying them with creatures in their existing corpus of myth – sphinxes for Oedipus, sirens for Odysseus and funeral imagery, griffins for Arimasps, and all for general decorative purposes. They adjusted others to serve other Greek mythical identities (gorgons, the chimaera). Thus, on [173] a form for the chimaera is devised by adapting the eastern winged lion type, putting a goat's head on its wing and a snake's head on the tail (where the easterner commonly put a bird's head). A similar vase has a lion with a man's head on its back, distorting the common Syrian monster which is a sphinx with a lion's head at its chest. Eastern florals, chains of lotus flowers and buds and palmettes, are readily given the place formerly occupied by Geometric pattern without ever entirely displacing it, and the eastern Tree of Life is adopted, without its religious significance, as a centrepiece to symmetrical, heraldic compositions, of the type already familiar in Geometric art, but now with animals at the flanks [166, 175]. The eastern forms are for the most part reinterpreted and we can never be sure that any in Greek guise are merely decorative.

We shall see that the Greek vase painter almost never copied an eastern metal vessel or its decoration directly, and the new forms were introduced piecemeal, assimilated and rapidly adjusted to serve their new functions, which must have been basically the same as those of Geometric art. But Greek Geometric society was changing too. Centralized power laid some towns more under the control of rich or forceful families and rulers (the so-called tyrants), but also dependent on the loyalty of citizen armies (hoplites), and there seems to have been a growing sense of statehood, with the neighbourly rivalries that this created. Status and the expression of status through display in life remained important, though status display at death did not quite match that of the Athenian Geometric cemeteries. The new possibilities of narrative and scene-setting given by Orientalizing art meant that the decoration of a vase could play a more explicit part in rendering any messages of status or function, but the new narrative came but slowly and was neither the reason for adopting near eastern forms nor an inevitable result of so doing.

Greek potteries did not all respond to Orientalizing art in the same way, indeed few seem to have responded to it directly – mainly Corinth, East Greece (in the Wild Goat style, considered in the next chapter), Crete and to a lesser degree Athens. Regional variety is even stronger than it had been, and only in the cases just cited was this due to a differing response to eastern example. The

individual local styles of the 7th and 6th centuries are explained by a variety of causes: the differing way in which influence, Greek or non-Greek, worked on what had been already established as a local tradition in Late Geometric; the taste of influential potter/painters; mindless copying; eventually a profit motive, once trade in pottery became of notable importance. Much Orientalizing was simply learnt from other Greeks. Only rarely could seriously different social requirements have been influential, and Corinthian pottery of the 7th century looks so unlike Attic for the reasons already given, not because Corinthians and Athenians were radically different Greeks.

Protocorinthian

Corinth's LG record of fine potting and delicate painting, but without any strong interest in figure work except in the possibly alien Thapsos Group, seems to explain why her potters and painters adopted near eastern forms and patterns in a meticulous and almost miniaturist form, and copied eastern figure types more wholeheartedly than did Athens, where there was a very strong Geometric figure tradition. Corinthian Orientalizing is known as Protocorinthian: Early (720–690 BC), Middle (690–650, subdivided I and II) and Late (650–630) – EPC, MPC, LPC – followed by a short Transitional style before the full Corinthian black figure series. Most Protocorinthian is in fact in black figure (that is to say, silhouette with incised detail) except for the filling ornament and on the earliest vases (Outline Groups). Corinth itself is a major source, not just tombs but its Potters Quarter which has been excavated. The vases also travelled and most shown here were exports. There is much from the port and sanctuaries of Perachora, on the promontory just north of Corinth, which we have noted already as the vestibule to routes west. Western colonial sites are otherwise our major source for Protocorinthian vases although they were well distributed through the Greek homeland and, eastwards, to Rhodes rather than Ionia.

In EPC the style and shapes of Geometric continue but there is one important new shape, the globular aryballos with a narrow round lip [163–6]. This was probably inspired by eastern flasks which are longer-necked, and was used for the same purpose, to carry perfumed oil, a luxury product for which Corinthians seem to have been the first of the Greeks to corner a home market. The cosmetic use of oil by both sexes, especially male athletes, was important, and the aryballos became an essential piece of equipment. Greek Geometric oil flasks were bigger; Corinth added a measure of refinement that suited the value and status of the contents. Oil was used in funeral rites too and the aryballoi are found in very many Greek graves. Many of the early examples carry only the close-set parallel stripes introduced in LG [163] but there are also many now with figure friezes added, with flowers and animals [164–6], the latter mainly drawn in outline (whole or part) although incision for detail is beginning. Most backgrounds are filled with a variety of small geometric or floral devices. The animals

still look somewhat Geometric but there are new ones (cocks [165]; the bird itself is also a newcomer to Greece), and monsters like griffin-birds, interspersed with florals. The last are at their most florid on some oinochoai (the Cumae Group) where they may fly free in the field having abandoned all the rooted logic of the eastern friezes and trees which inspired them [167]. Kotylai [168–9] get taller and more elegant and some colour is added (on [169] the leaves are pink) while the traditional animals find a new lease of life. The new-found exuberance does not last long. Upright rays begin to appear at vase bases [169], probably inspired by the pointed lotus petals of blooms that decorate Egyptian flasks; sometimes they are in two rows, realistically overlapping. The motif will survive on Greek vases for centuries and serves to articulate the rising conical form of the body.

In MPC the aryballos slims to an ovoid shape [172], with a narrow foot, soon too top-heavy to stand securely on its own [171–6]; it was carried (as we see from later representations; *ARFH* I fig.24.3) slung from the wrist. Many of these are tiny vases, five to eight cm high. The miniaturist style of the best is barely equalled in later Greek vase painting (some Attic black figure) and attribution to anonymous artists' hands is possible. Action scenes may still be generalized [171] but there is much more imaginative gesture and individual pose in the figures and they interact more naturally than did the Geometric. The animals are more realistically proportioned now and the incised detail is delicate and intricate. Lions copy the Syrian/neo-Hittite square-muzzled type [172–3, cf. 176], the filling ornament is more restrained, often just dot-wheels, and omitted on the more elaborate figured pieces. Red is used to pick out manes, bellies and wing feathers. Floral bands are imaginatively and carefully composed in interlaces. It is on these small vases that the full richness of Orientalizing imagery can be best grasped, yet the figures are already yielding to the Greek desire to tell a story from their own myth repertory: Bellerophon with the Chimaera [173], a 'centaur' (but perhaps at this stage no more than a Giant or Titan) confronting a god [174]; and odder creatures to which it is not easy to give a name, Greek or eastern [175]. Where these vases are enhanced by the skills of the clay modeller and have a lion or human head as mouth [176], they touch one of the high points of Greek pottery as more than a simple craft (see also *GSAP* fig. 41).

In the second quarter and middle of the century explicit mythological scenes appear in some numbers, the identities made clear by details of dress and action. Some offer colour contrast on the figures through the use of reds and yellows or dilute brown paint. The narrow friezes have something of the monumental to them, and it is a comparable technique that we see on larger clay slabs made in Corinth or by Corinthians for the upperworks (metopes) of temples in central Greece (at Thermon). It is by no means necessary to think that the larger figures inspired the smaller, given the continuous tradition in vase painting which evolved this style, but the new polychromy is surprising, and short-lived. It was, however, being practised, although not in black figure, elsewhere in Greece, as we shall see.

The same style appears on larger vases. A new shape is what we call an *olpe*, an oinochoe with a baggy outline probably derived from vessels of skin, but given a round flaring neck, perhaps originally a horn. The best preserved is the Chigi Vase [*178*] which comes late in MPC, near 650 or later. This offers a whole hoplite battle, the ranks closing to the sound of a piper. (On the aryballos by the same hand [*176*] the ranks have broken up into duels.) Another frieze has a mixture of scenes, not separated, including heraldic sphinxes, a vivid lion hunt in which the beasts have adopted the pointed-nose Assyrian type which replaced the Syrian, and a confrontation of men and women which, from the inscriptions, we can recognize as a Judgement of Paris. Even the black zones on the vase carry animal scenes and hunts in white and red.

Other shapes admit rather larger animal friezes, no less carefully executed [*177*]. Throughout the period there is brisk production of simpler aryballoi still with animal friezes of Subgeometric type, feeding a growing export market to the west. Plainer kotylai and low cups flaunt their rays and stripes, as still do many other shapes, but some kotylai ([*179*] note the double row of rays at the base), large oinochoai and cylindrical pyxides may also admit ambitious animals or figure friezes. On [*180*] the dog's neck is painted half yellow, half red. The rather poor pyxis [*181*] has the dubious merit of carrying what seems to be the earliest representation of Heracles fighting the triple-bodied warrior Geryon in a frieze composed partly of Geryon's cattle (for the subject see [*468*]), partly of indifferent lions. It reminds us that narrative aspirations and fine draughtsmanship need not go hand in hand. Another new shape is the *alabastron*, an oil flask with a long baggy shape deriving from skin flasks, a round lip and small side handle [*182*]. The name we use for it is from the Egyptian stone shape which is in fact different, slimmer and with side lugs, copied much later in Attic (*ABFH* fig.79).

In LPC the animal friezes begin to lose what life and originality they had. The Orientalizing idiom had, as might easily happen with a device copied rather than invented, become stereotyped – a phenomenon we observe in other Orientalizing arts such as sculpture. The old Geometric figure friezes of animals had a pattern quality of their own, but the more realistic animals of PC have lost much of this and seem to have nothing to do. The drawing becomes mannered, the lion turns his head to the viewer in despair, pacing as if in a modern zoo (and gets called by us conventionally a panther, but is properly also sometimes spotted). The animals do not interact but face or turn their backs on each other impassively. Filling is virtually all dot-wheels, and these lose their spokes in the final Transitional period. Some novelty is introduced in vases painted all or part black, decorated with small compass-incised scales picked out in red, yellow and white, or occasionally with colour or incised figures [*183*]. Aryballos feet become almost pointed [*184*], and there is lingering mass-produced decoration of silhouette (mis-called Subgeometric) animals on the shape. The new round (spherical) aryballos is introduced; the alabastra get slimmer necks.

One special product of late MPC and LPC potters is the figure-vase (unfor-

tunately often still called a 'plastic' vase): lions (recall [*176*]), but mainly fowl – pigeons, owls [*185*], a partridge [*186*]. All are oil vases, like the aryballoi, with the orifice cut discreetly, usually in the head (contrast the East Greek [*358–9*]).

The Protocorinthian style and technique were copied only sporadically in other Greek towns, except on the routes west, as on the island of Ithaca [*187*], and contributed to the latest of the Thapsos Group [*120*]. Few painters could cope with the demands of the finest miniaturist painting, and it may be that Corinth's grip on some areas of the trade in perfumed oil guaranteed a responsive and ready market for those who made the comparably luxurious containers. We know that the same flask shapes were made in metal, but none surviving are figure-decorated. This proves to be a common difference between metal and clay versions of the same shape. What Protocorinthian potters had achieved was an acclimatizing of near eastern patterns and figures to a different medium and to some of the needs of Greek art, and the production of a luxury ware. There was, however, a down side. Animal friezes, for all the animation that they added to a plain or functional shape, were to haunt Greek vases for another hundred years, while the future lay with the exploitation of the new freedom of drawing possible for figure scenes and narrative. Although the incising technique of black figure had given the opportunity to define and decorate figures with considerable elaboration, as a drawing technique it led nowhere. Nevertheless, in time it won over other wares, such as Attic, which had stayed with silhouette and outline drawing through most of the 7th century. Only at the end of the 6th century could the brush take over again from the graver, and give the possibility of fuller expression of linear detail in figure drawing in the red figure technique.

The rest of this chapter is devoted to 7th-century wares which were still going their own way or reacting to foreign models or the work of their neighbours.

Protoattic

7th-century Attica seems a marginally less active place than it had been, and various factors, social, climatic and medical, have been called upon to explain this. Or it may be that we know less than we should about Athens' cemeteries. The apparently more modest approach to burial practice has resulted in the survival of fewer and different types of finds, and may in antiquity have accounted for a changed attitude to some pottery production. The discipline of Attic LG pottery dissolves and after a first phase of loosely Geometric pattern and figures is replaced by lively, large forms executed with a certain panache that contrasts strongly with contemporary Corinth. What survives from LG is a readiness to cope with bigness, in pots and figures, beside which Corinth's miniaturism might seem fussy. The period is divided into three: EPA (700–675 BC), MPA (675–650) and LPA running seamlessly into early black figure, described elsewhere (*ABFH* ch.2).

There is much residually Geometric in Early Protoattic (EPA) from the filling

ornament to the still mainly silhouette figures. A major artist, the Analatos Painter [*188–93*], gives his figures more definition than appeared in the latest LG, and his women have dotted skirts, but although many of the friezes on his slim amphorae and hydriae are still LG in content, the backs of his vases are devoted to animals and dotted florals which recall without copying those employed in Corinth (E-MPC). He had a long career and on a larger vase such as the crater in Munich [*190*] his Geometric chariot horses acquire permed manes, and the base rays grow hooks. On a lid [*191*] the grazing horses' manes fall realistically. The plaque fragment with marines [*192*] introduces a new product for potteries, of which there are also a few LG examples, a votive picture, probably more commonly executed in wood and hung on a wall; another by our painter, from Aegina [*193*], carries the earliest known painted inscription in Greek (and was picked up by the author on his honeymoon). A companion, the Mesogeia Painter, has a more bland style, but with more interesting Orientalizing monsters: on [*194*] the odd shape of the sphinxes' wings suggests one wing falling below the body, an eastern and occasional Greek fashion, and on the fragment [*195*] the male sphinxes have cross-barred Syrian wings. On [*194*] no less than six of the subsidiary friezes are done with a multiple brush.

Other EPA vases relate easily to the work of the painters named and offer figures which range from the fine fellow on [*196*], and the heavily patterned [*197*], to less disciplined assemblies [*198*]. There is also, as not always or in every period, some poorer but entertaining work, such as the surprised fairy and pigs of [*199*]. The vases and their themes, where explicit, are dominantly to do with death or related rites but these are not grave markers. Smaller vessels are LG shapes (kantharoi and tankards [*200*]), but Corinthian kotylai are also copied along with some Corinthian patterns – the steps and close-set stripes.

MPA introduces a surge of monumentality, or at least sheer size, and a greater variety of figure work in the Black and White Style, named for the way white is used to fill some figures or to create black/white patterns on wings, dress and in motifs such as cables and rows of triangles. The slim amphorae and hydriae give place to craters of various shapes as prime examples for the new technique. A favourite is the skyphos-crater, which is like a large broad kotyle, with domed lid and high conical base, a shape that will survive into black figure (*ABFH* figs.4,6). Finds are mainly from Athens' cemetery but there was a major find on nearby Aegina and some have thought that many of the Protoattic vases were made on the island. In most periods Aegina had no locally-made pottery, however, and fetched decorated pottery from Corinth and Athens. The use of areas of white also induces some use of white in a linear fashion, even an occasional touch of incision. Human and animal heads at last have real faces, and body proportions assume a closer grasp on reality.

We shall return to the craters. Some other pieces Orientalize in an almost Corinthian manner [*201*], but perhaps more directly inspired by eastern metalwork and these are not typical of the best of the period. Some funeral vases are

painted over a fugitive white slip which has not helped preservation; on [*202*] this is confined to a pattern frieze. There are some fairly exotic shapes for funeral use also, with floral and figure additions, as [*203*] where the bowl copies a Syrian bronze type with lotus handles. The *prothesis* scene is not forgotten, but now executed on smaller vases [*204*]. There is also a number of more trivial works, for example jugs of the so-called Phaleron Class [*205*] with more EPA traits.

We turn to the full Black and White Style and especially the finds on Aegina. The Ram Jug Painter's name vase has Odysseus' companions escaping from Polyphemus' cave [*206*] and introduces a subject of some interest to artists in various parts of the Greek world at this time, to which we shall return. His faces especially are unmistakable. The jug (a broad bodied oinochoe of East Greek type with high neck carrying black and white diamonds) is from Aegina town. The big find elsewhere in the island includes more of his work but better represents the Polyphemus Painter, as on the big stand with heroes [*207*], one named Menela[o]s (the husband of Helen of Troy). His name vase was used as a child's coffin at Eleusis [*208*]. This is Black and White at its most dramatic: on the neck Odysseus is picked out by his whitened body as leader of the group blinding the monocular giant, already rendered drunk (note the cup), while on the body gorgons pursue Perseus (mainly missing) with an Athena intervening and, behind the gorgons, their decapitated sister Medusa, recumbent on the sward, not hovering. The artist has created gorgon heads out of the forms of cauldrons with animal protomes (here lion-headed serpents), inspired by the appearance of Orientalizing metalwork. All the basic elements of Archaic narrative are by now in place, while even the lion on the shoulder seems positively aggressive. The back of the vase is covered with squiggles, the usual practice with these large vases, and not only in Attica.

The Oresteia Painter's name vase [*209*] shows how the strictly profile figures present problems when asked to do more than march or fight, and the difficulties we have in identification when there are no diagnostic details of dress or weapon, no inscriptions, and as yet no accepted formulae for one story or the other. So is this Aigisthos killing Agamemnon, or Orestes killing Aigisthos, which both involved the intervention of a woman, Clytemnestra or Electra? Notice how the murderer has to manage both sword and hair-pulling, the way the two men are contrasted, black and white, and the woman's (there was another at the left) restrained gesture of alarm. The New York Nessos Painter's name vase [*210*] employs more incision than most for detail, especially where figures are mainly silhouette. Heracles chastises Nessos while the rescued Deianeira waits sitting on the chariot. The viewer is not expected to compare the apparent relative heights of hero, lady and horses; the story and different roles of the figures are paramount. The same artist did a sacrifice of a woman (Iphigeneia or Polyxena; she is carried by the men and we have her feet only), with some original three-bodied sea-monsters below [*211*]. These are large vases; the Polyphemus vase is 1.42 m high; Menelaos stands nearly 35 cm.

53 Corinthian (EPC) aryballos. (Syracuse T.219)

54 Corinthian (EPC) aryballos. First Outline Group.
Boston 03.810; H. 5.5)

165.1,2 Corinthian (EPC) aryballos from Cumae.
First Outline Group. (Naples 128321; H. 6.5)

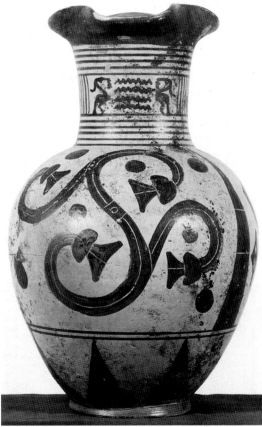

56.1,2 Corinthian (EPC) aryballos by the Evelyn P. (London 1969.12-15.1; H. 6.8)

57 Corinthian (EPC) oinochoe from Cumae. Cumae Group. (Naples 128193; H. 33.4)

168 Corinthian (EPC) kotyle from Almunecar (Spain). (Granada)

170 Corinthian (EPC) conical oinochoe, neck missing, from Cumae. Fox? and horse. (New York 23.160.16; H. 9.2)

169 Corinthian (EPC) kotyle. (Aegina; H. c.30)

170

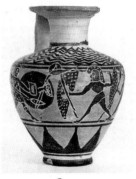

171.1

171.1,2 Corinthian (MPC) aryballos, and detail, from Lechaion (port of Corinth). Near the Huntsman P. (Corinth CP2096; H. 4.6)

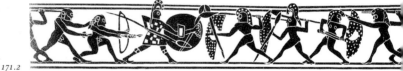

171.2

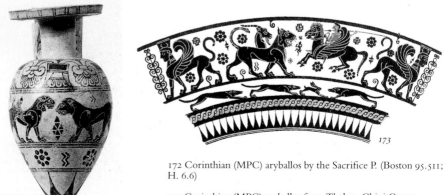

172 Corinthian (MPC) aryballos by the Sacrifice P. (Boston 95.511; H. 6.6)

173 Corinthian (MPC) aryballos from Thebes. Chigi Group. Bellerophon and Chimaera. (Boston 95.10; H. 6.8)

172

173

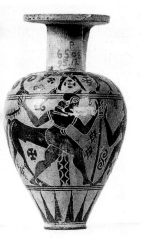

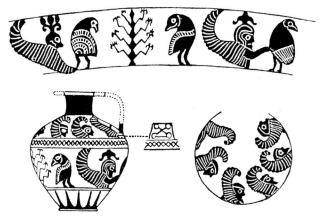

Corinthian (MPC) aryballos from
[Cor]inth by the Ajax P. God/hero and
[Cent]aur. (Boston 95.12; H. 7.4)

175 Corinthian (MPC) aryballos. (Once Branteghem Coll.)

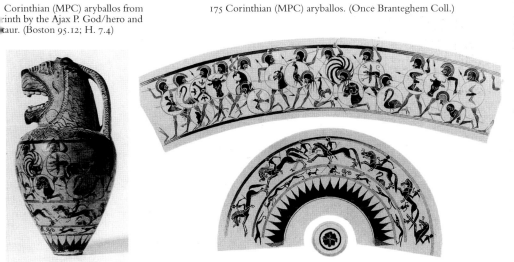

176.1,2 Corinthian (MPC) aryballos (Macmillan) from Thebes by the Chigi P.
(London 1889.4-18.1; H. 6.8)

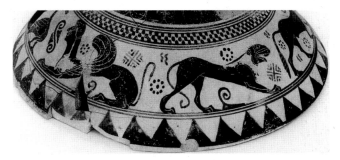

177 Corinthian (MPC) conical oinochoe, neck missing, from Tocra. (Tocra 1)

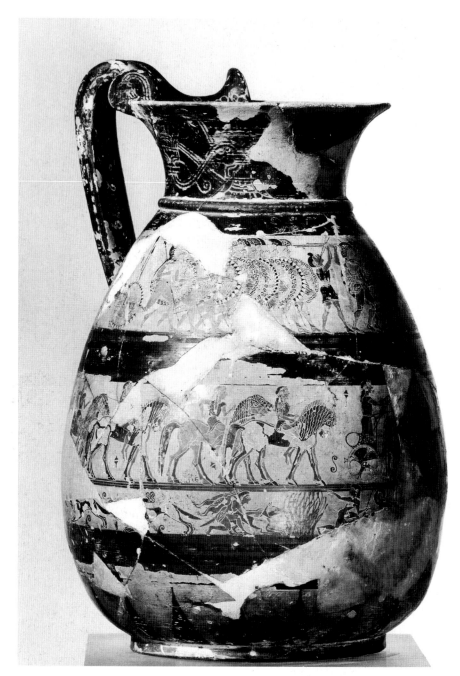

178.1,2,3 Corinthian (MPC) olpe (Chigi Vase) from Veii by the Chigi P. Details of hoplite battle and lion hunt. (Rome, VG 22679; H. 26.2)

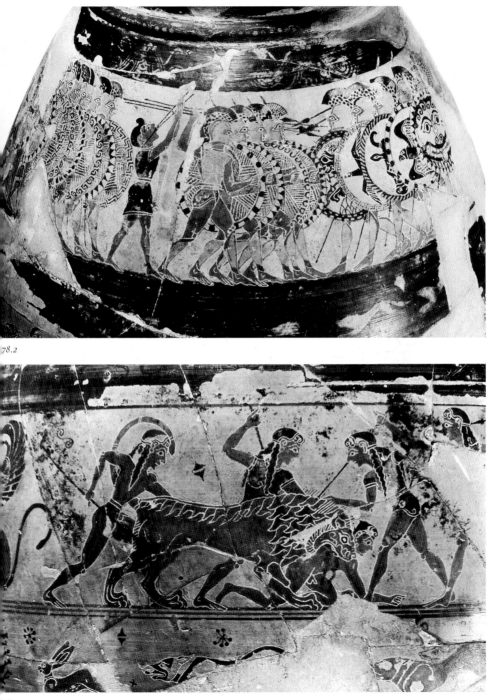

78.2

78.3

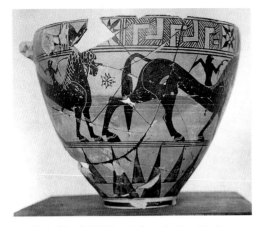

179 Corinthian (MPC) kotyle from Aegina. (Aegina; H. 20.5)

180 Corinthian (MPC) kotyle detail by the Hound P. (London 1860.4-4.18)

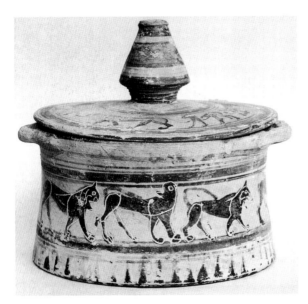

181.1,2 Corinthian (MPC) pyxis, and detail. Heracles and Geryon. (London 1865.7-20.17; H. 5.7)

182 Corinthian (MPC) alabastron from Camirus. (London 1860.2-1.30; H. 5.7)

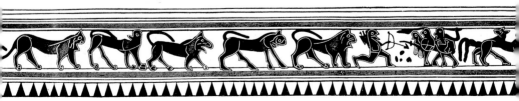

3 Corinthian (LPC) olpe from Camirus. Group of atican 69. (Oxford 1879.100; H. 27.5)

7 Ithakesian oinochoe. Mid-7th century. thaca 502; H. 15)

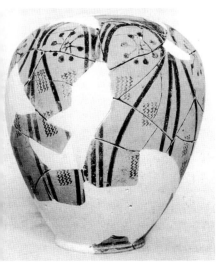

184 Corinthian (LPC) scale aryballos. (Charterhouse 151.1960)

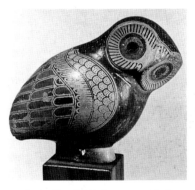

185 Corinthian (LPC) figure-vase. Owl. (Louvre CA1737; H. 5)

186 Corinthian (LPC) figure-vase. Partridge. (Leiden RO.III.85; L. 16.5)

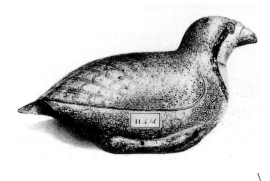

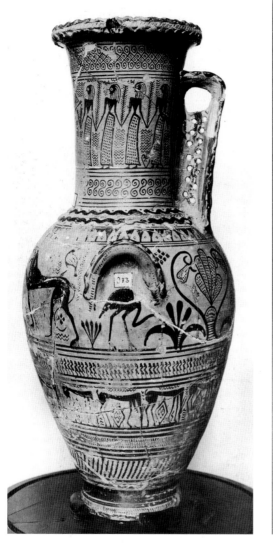

188.1

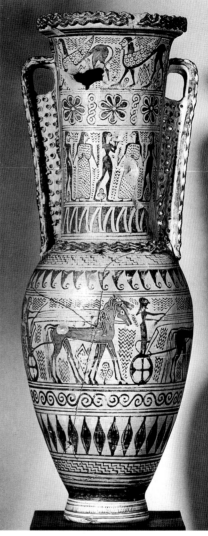

189

188.1,2,3 Attic (EPA) hydria from Analatos, by the Analatos P. (Athens 313; H. 55)

189 Attic (EPA) amphora by the Analatos P. (Louvre CA2985; H. 80)

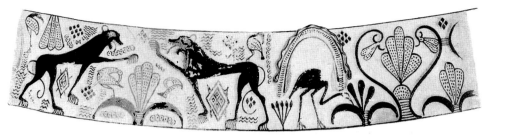

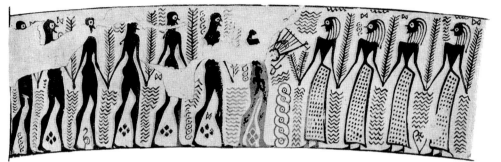

188.2,3 Details

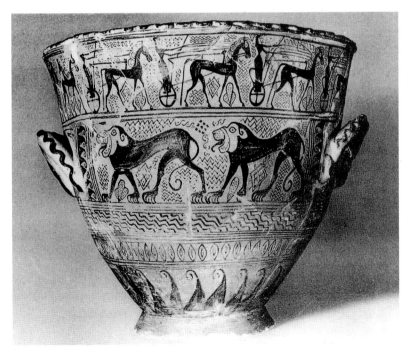

190 Attic (EPA) crater from Aegina by the Analatos P. (Munich 6077; H. 44)

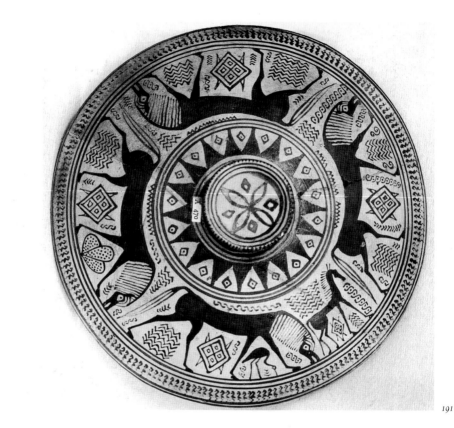

191

191 Attic (EPA) lid by the Analatos P.
(London 1977.12-11.9; W. 25.8)

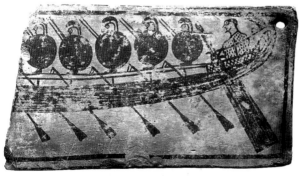

192 Attic (EPA) votive plaque fr. from Sunium by the
Analatos P. Warship. (Athens 14935; W. 16)

193 Attic (EPA) votive plaque fr. from Aegina town
by the Analatos P. Inscribed ...'*sonos epist*'... (Athens
18772; W. 5)

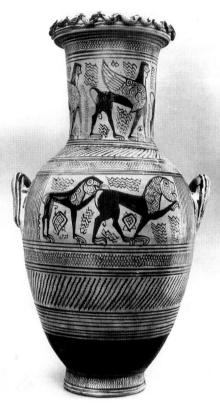

94

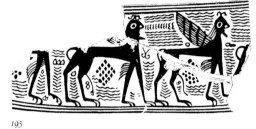

195

194 Attic (EPA) hydria from Spata (Attica) by the Mesogeia P. (Athens, once Vlasto; H. 44))

195 Attic (EPA) fr. by the Mesogeia P. (Once Athens)

196 Attic (EPA) amphora detail. (New York 10.210.8)

196

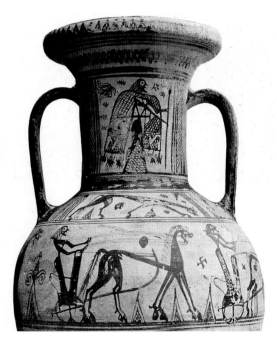

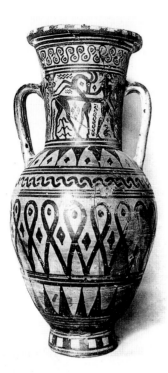

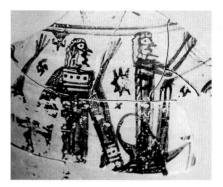

198 Attic (EPA) amphora fr. from Phaleron. (Athens 15958)

197 Attic (EPA) amphora. (Berlin 31006; H. 44.5)

200 Attic (EPA) tankard. Mourners. (Reading 54.8.1; H. 12)

199.1,2 Attic (EPA) amphora from Pikrodaphni, details. (Athens 222)

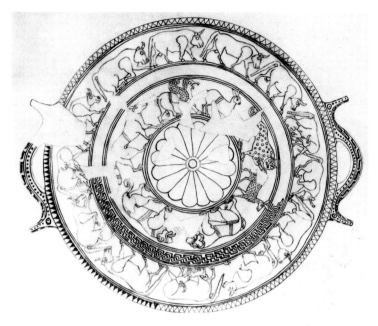

201 Attic (MPA) plate. (Ker. 74; Diam. 30)

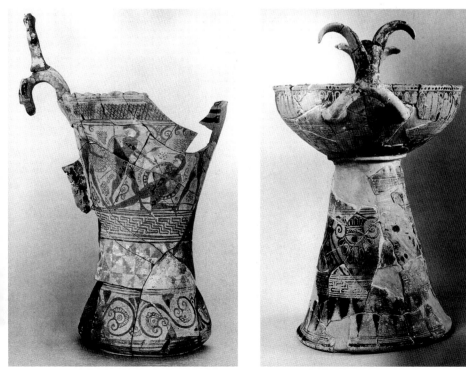

202 Attic (MPA) tankard. (Ker. 73; H. 19) 203 Attic (MPA) standed bowl. (Ker. 138; H. 30)

204

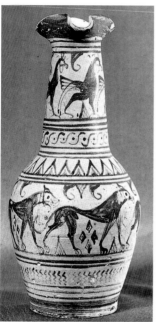

205

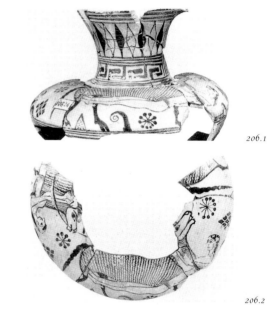

206.1

206.2

205

207.1

207.2

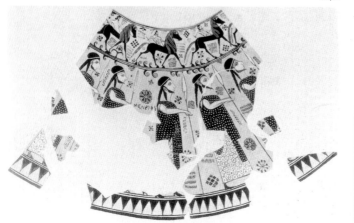

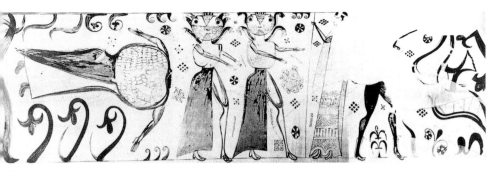

208.1

208.2

204 Attic (MPA) tankard frs. *Prothesis*. (Ker. 80)

205 Attic (MPA) 'Phaleron' oinochoe. (London 1865.7-20.1)

206.1,2 Attic (MPA) oinochoe frs. from Aegina by the Ram Jug P. Odysseus' companions flee Polyphemus. (Aegina 566; W. 25.5)

207.1,2 Attic (MPA) stand from Aegina by the Polyphemus P. Menelaos and heroes. (Berlin A42; H. 68)

208.1,2, Attic (MPA) amphora from Eleusis by the Polyphemus P. Odysseus blinds Polyphemus; Gorgons pursue Perseus, guarded by Athena, their decapitated sister behind them. (Eleusis; H. 1.42m)

209 Attic (MPA) crater from Aegina by the Oresteia P. Death of Agamemnon? (Berlin A32)

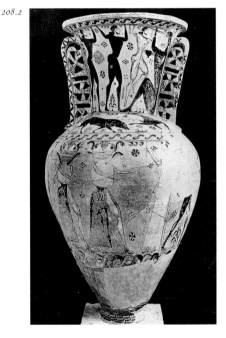

209

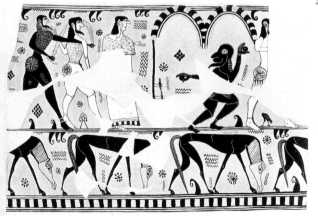

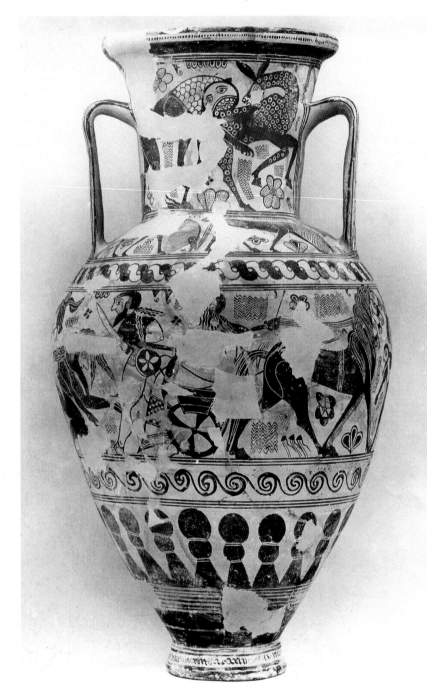

210 Attic (MPA) amphora by the New York Nessos P. Heracles and Nessos. (New York 11.210.1; H. 1.08m)

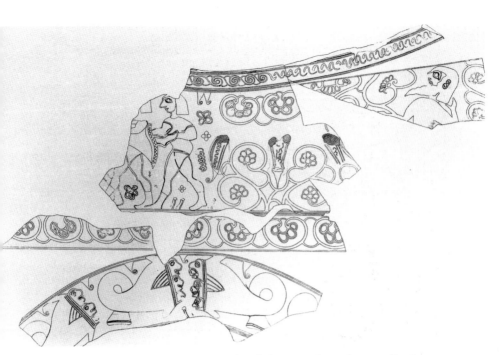

11 Attic (MPA) crater fr. by the New York Nessos P. Sacrifice of Iphigeneia ? (Boston loan 6.67; H. 52)

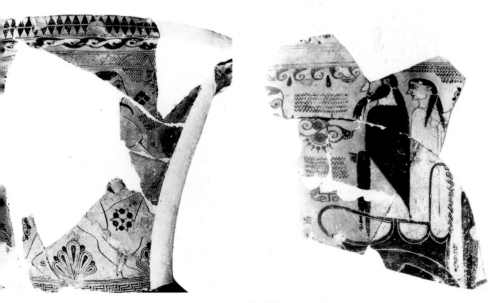

12.1,2 Attic (MPA) amphora from Kynosarges (Athens), details. (Athens 1002)

After the Black and White Style greater interest is shown in the use of the black figure technique, but still on large vases and so maintaining Athens' lead over Corinth in the matter of monumental vase painting. The Kynosarges amphora is residually Black and White, with developed black figure and still much Orientalizing filling ornament [212]. There is an easy transition to fuller use of black figure though the linear fill persists (*ABFH* figs.3–5).

Argive

The Argolid has much to teach us still about its 7th-century pottery, but there is promise in what there is. Painted votive shields from Tiryns lead us out of Geometric into what appears to be a myth scene, possibly with an Amazon warrior [213], and there is other work to match Early Protoattic [214]. There was outline drawing, even beside straight black figure [215], and an account of the blinding of Polyphemus of some novelty, with the reclining giant [216] beneath a rim with the old watery pattern of Geometric. There are several craters with mainly Subgeometric decoration but some curvilinear and Orientalizing detail, which had their followers in the west.

Laconian

pottery remains Subgeometric until the mid-7th century, with some modest outline-drawn figures [217], probably as dependent on Argive as the LG had been. Then a sequence of styles began that can be related to the stratigraphy of the site of the temple of Artemis Orthia at Sparta. Laconian I introduces the characteristic row of black squares and dots which long remains popular as a lip pattern, notably on an equally distinctive shape, which has become known as a *lakaina* and is rather like a footless chalice [218]. Another new shape is like a kotyle with high lip [219] and a new pattern which will have a long life is the row of pomegranates. Broad black areas and red bands are fancied, over a whitish slip. Figure work is timid; mainly rows of little lions with outline faces, red necks and silhouette bodies [220]. Laconian II sets in around 620 and is more ambitious, admitting black figure but clinging to many Orientalizing patterns. Small goblets with flaring walls [221], cylindrical mugs and other more exotic drinking vessels [222] are added to the shapes, and heavy step patterns to the motifs. Some fine cups are Corinthian in shape [223] but decorated in the Laconian manner outside (the rows of squares are more spaced now) and with full interiors – whirls of fish [224] or concentric friezes around a gorgoneion. These must bring us to the 580s and hold promise of better to come, but Spartan potters, in a state with a reputation for austerity, had already struck out with individual if unassuming new styles of decoration and shapes. They found a ready market in their colony Taras [219, 222, 224].

Euboean

Eretria is the principal source on the island and the products are uninspiring. There is a long sequence of grave amphorae (Groups A-D), running on into black figure, and some tall tankards with similar decoration. Amphorae of Groups A and B are still Subgeometric in decoration but favouring additional red bands [225] and occasionally a silhouette figure. Group C is grander with plenty of red and white on outline-drawn women on the necks (one was called a goddess, *thea*), animals on the body, sometimes with a little incision [226]. In Group D there are pairs of animals on neck and body, all black figure except for some outline lion heads, and a lot of messy floral filling [227]. These no doubt bring us into the 6th century. All backs are covered with crude loops. The early groups (A, B) are well represented in the Eretrian colony at Mende in north Greece. Another distinctive shape is the tall tankard with bulbous body. [228] has the women of Group C again, now with a woolly snake, while [229] has slightly finer black figure than Group D on a different shape. Whatever notice was taken of other wares over the 7th century seems not to have had much effect. SKYROS in the Sporades islands east of Euboea had enjoyed a comparable PG and Geometric record, but has also yielded a group of vases representing a short-lived Orientalizing style with touches of black figure [230], like a cross between Cycladic and Protocorinthian.

Boeotian

The big vases of a basically Geometric type continue with the familiar upright wavy lines and white additives, but with an animal life that takes on some Orientalizing reality [231]. A group of small slipped amphorae continue the better LG tradition adding discreet florals to the Geometric patterns [232]. Some of these may take us even later than the mid-7th century. In the 6th century some Boeotian towns adopt black figure or have it thrust upon them, as we shall see, but there is a lingering Orientalizing also, perhaps to the very end of the century, in the bird bowls. These are open bowls rather than cups, sometimes with stems, with two or four handles, presumably for some special and Boeotian domestic purpose since they are not closely matched in other Greek wares [233]. They are decorated with outline-drawn birds with various floral and geometric filling, the birds being drawn upside down. Other shapes decorated in this manner include kantharoi, skyphoi and alabastra. Their paint tends to be reddish, on pale slip, and they look very old-fashioned, but cemeteries full of them beside other wares, at Rhitsona and Akraiphia, have clinched their date. Related are some rather primitive painted figurines of a seated goddess [234], and cylindrical copies of a ritual headdress (*polos*), sometimes decorated in black, red and yellow over a chalky white, and with more ambitious figures [235] which hark back even more obviously to 7th-century fashions. Antiquity attributed a certain

backwardness of response to the Boeotians, and there is certainly much of their pottery which either looks outdated or is wholly imitative of others; and we look in vain for anything to compensate in their other arts (apart from the poet Hesiod, a relatively dull fellow).

Cycladic

Dedications on Delos and redeposited grave goods from Delos on Rheneia remain a major source without telling us on which island the pots had been made. Nevertheless some degree of assent has been reached to identifications of the rich and varied island Orientalizing production, although it is none too easy to date, and some may linger well into the 6th century when the succession seems slight. Subgeometric styles are persistent, followed by outline-drawn figure decoration of considerable originality and colour; closer, that is, to the Attic/Argive styles than the Corinthian.

The most determinedly Subgeometric, with minimal concession to the sort of outline-drawn detail that we see in Protoattic, is the Delos Group Ad (as with the Geometric we use the excavators' letter classification) with mainly silhouette animals in a field of ladders of zigzags and lozenges [236]. It occasionally admits fuller-bodied creatures with patterned bodies [237]. The vases, mainly amphorae, are very homogeneous in style, surely the product of a one-family workshop and expressing the vision, however derived, of a single potter. It will only be properly located through clay analysis, but Paros is favoured. Delos Group D is another group of early Orientalizing, meagre though distinctive, with no known home [238].

THERA's Subgeometric amphorae run into the 7th century and admit a little Orientalizing ornament, as we have seen. More in the tradition of the Wheel Group [92] is a series of 'Linear Island' amphorae which are best represented on Thera although their predecessors are judged Parian [239–40]. They have broad low necks with vertical stripes or zigzags, and big metopal patterns on the bodies with animals rather like Protoattic, birds, lions and grazing horses. There are also a few finer vases (the Leiden Group) with more carefully drawn Orientalizing animals perhaps of around the mid-century [241–2]. With them goes a griffin-headed jug found in Aegina [243]. Thera is a good source for examples of the whole series, and since they are rare elsewhere they do seem to have something to do with the island, however unlike they are to its certain LG and other Subgeometric. Only in recent years have excavations shown that there was a rich and probably local production of other Orientalizing vases, even some incipient black figure, but not enough has yet been published for it to be possible to define a local style, and perhaps the islanders were not overgenerous with their wares to temples and tombs on Delos. Thera was an island of Dorians, not perhaps much engaged with the Ionian cult centre on Delos. Simple Subgeometric decoration seems to linger on Thera into the 6th century on some globular

pyxides. The most remarkable product, also of the early 6th century, is a clay house model from a tomb, inscribed with its owner's and maker's names (Archidika, Andrias), and equipped with miniature pots like a doll's house [244]. It is painted like pottery and we may not deduce that house walls were decorated in the same way. Other clay house or temple models were made in early Greece – Corinthian found at Perachora, Argive [130], Laconian, Cretan [150].

An Heraldic Group (Delos Ba) of slim amphorae shares the Subgeometric-cum-Orientalizing interest, another close-knit group that defies easy attribution although NAXOS is a probable source. The neck decoration is of panels and vertical strips with animals, with some cable dividers, and striped bodies [245–7]. More plausibly from the island is the Protome Group (Delos C), another very individual production, succeeding the Heraldic but on broader shapes of amphora and hydria and with finer detail of outline for the foreparts of animals which decorate the shoulder panels [248]. These surely bring us to the mid-century. Thereafter we find in Naxos examples of larger amphorae with sophisticated scenes, including what is to be a popular island motif – the epiphany of deities in a chariot, often with winged horses; here Ares and Aphrodite [249]. The figures are drawn in outline filled with brown washes of paint, rather like more advanced versions of Attic Black and White Style, though probably slightly later in date. One piece bears part of the painter's signature, name missing. The distinctive red clay of Naxos should help attribution of all these vases, but again we need more analysis of clays and clay sources.

The big Naxian vases lead us to the most ambitious of the island groups, long called 'MELIAN' because so many were found on Melos. Ionian PAROS seems a more likely source, however. Melos itself was Dorian, like Thera (see above), but 'Melian' vases are well represented on Delos, unlike Theran, so perhaps 'ethnic' affiliations counted for something where religion was involved, but the Melians were ready enough to use the vases at home. They are the only island vases that got around the Greek world, to the Parian colony of Thasos and even to north Africa. This may be because they were conspicuous and unusual, favoured by folk not enamoured of black figure (for they run well into the 6th century, but many are big and heavy), or because we have underestimated a special current of island trade. The principal shape is a very big amphora with tall neck, conical foot and lid [250], plus a number of smaller amphorae and hydriae, and dishes [251]. The most striking element of decoration is the use of bold spiral complexes with angular cross hatched links. The artists were not the only Greeks to be inspired by double-arched handles to add eyes [252]. The figure drawing is a mixture of outline and silhouette, worthy but seldom lively. A wash and added colour is freely applied and even a little incision on later pieces. The subjects include a variety of animals, many women's heads, and a number of mythological or divine scenes. The epiphany of gods in a chariot, as on the Naxian [249], is a favourite on the large amphorae [250], but the best are a Heracles with his chariot [252] and the Artemis fragment [253]. The style may

not have been born much before the mid-7th century, with the finer big amphorae mainly in the second half of the century, but on grounds of iconography and drawing, which in some ways resembles Middle Corinthian (which we have yet to see), the latest vases must run into the 580s. The last phase, from the late 7th century on, includes a few of the standard smaller shapes and decoration, but also some with figures done in real black figure, or with thin white lines imitating incision [254], plus a few imitating the late Wild Goat style. Parian THASOS has been considered as the source of comparable imitations of these later vases, and the island also seems to have made its own versions of Naxian and Chian, as well as some fine colourful plates [255–6].

The probability is that there were several other local schools of Cycladic Orientalizing in a period in which the islands seem busy in other decorative crafts; recall the vases from Skyros, to the north [230]. Apart from the distribution of 'Melian', which has been noted, and the interest shown by the Parian colony of Thasos, most of these Orientalizing Cycladic wares stayed at home or were taken to Delos.

Cretan

The Orientalizing styles of Crete are, at KNOSSOS, roughly divided into early and late (EO, LO) running to near the end of the 7th century with the transition presumed somewhere around the middle. After a fairly subdued LG, eastern patterns are taken up, though not quite the ones that had produced the odd proto-orientalizing of PGB a century before [146–51]. Cyprus seems to have been a major source of inspiration and there are plenty of copies of Cypriot flasks with multiple circles at the sides. Figure decoration is not much in evidence other than birds [257–9], many of the Cypriot clothes-peg-shaped type, some with more than one head, which is a motif that began in Geometric [155] if not the Bronze Age. 7th-century Cyprus was in these years producing its richly colourful series of pictorial vases with highly imaginative avian fantasies, but it was unfortunately not these that were copied. Most decoration of the Knossian vases is essentially floral: lotus friezes, rosettes, some of the flowers come to suggest bees to the painter [260]. Multiple circles appear still and the white-on-black of LG was retained for some bands carrying the circles. The burial pithoi are still made, their bodies heavily striped; some are decorated with circles only, and some have the loop feet already remarked. A special class of polychrome pithoi is painted in red, blue and black over a thick creamy white slip [258–9]. The paints are matt and not durable, so this may be a ware for graves only and the technique does not appear on other shapes. One can only imagine that these are colours freely used for painting wooden objects, furniture or the like.

In LO Knossos some craftsmen show themselves capable of considerable delicacy of potting and painting. The Fortetsa Painter (named from one of the prolific Knossos cemeteries) decorated small flasks with floral and geometric

patterns in an impeccable miniaturist style and with intricate compositions [261]. This is also the manner of decorating the strange flask [262]; a fantasy of bird vase, woman's head and arms, and bull's head spout, which in Crete makes one think of Europa as much as any siren. Of other small shapes the Corinthian kotyle was copied, and there are small bottles of near eastern type, without neck or handle [263]. One alabastron is closer to Protocorinthian in shape and decoration, bearing black figure sphinxes [264] with straight, cross-barred wings of Syrian type, one wearing a helmet of Greek make, answering the eastern helmet/headdress worn by some sphinxes. The figure style, though, is clearly derived from Protocorinthian. Of the larger shapes the polychrome pithoi dominate while other shapes are less imaginatively treated with lines, circles and minor Orientalizing florals.

Other parts of Crete have yielded 7th-century vases which are quite distinct, yet are more like the Knossian than any other Greek wares; but none adopt the polychrome. At AFRATI (ancient Arkades) the mid-century potters are perhaps taking more note of mainland work. There is some quite big black figure on dinoi (imitating bronze cauldrons), while one example [265] also copies the griffin protomes in high relief, painting them bird-bodied, and adding a sphinx with spiky crown and cross-barred wings. [266] renders the goddess' head too in relief (the face gone). There is also an odd technique which seems to anticipate red figure and has reserved figures in the black ground, but with the outlines also reserved [267]. Other pots would not look out of place at Knossos or even elsewhere in Greece, as [268], or [269], inevitably (in Crete) identified as a Theseus and Ariadne.

Crete also offers figure-vases, especially of owls [270], and some lions holding unguent bowls between their forelegs, an eastern conceit [271]. Flasks may also carry figure attachments and animal-head spouts. PRAISOS has yielded a puzzling plate combining outline drawing and black figure and a figure scene that still defies plausible reconstruction [272]. GORTYN [273], ELEUTHERNA and PRINIAS are other important sources. At KOMMOS there are some vases odd in both technique, black-incised, and subject [274]. One of the most eloquent has no closer provenance than 'Crete', a big spherical flask of eastern inspiration with a very Phoenician/Egyptian head at the neck, wearing a crescent pendant, and the usual Cretan Orientalizing ornament [275].

Cretan Orientalizing pottery stayed idiosyncratic to the last, aware of but not much led by mainland styles. Contact with eastern sources, in Cyprus and Syria, clearly remained influential. Puzzlingly, decorated pot production seems to dry up around the end of the 7th century, along with most of the other distinctive Cretan arts, after centuries of distinguished and imaginative work. Just a few Cretan vases of the 6th century are recognized in exports to the north African colony at Taucheira (Tocra), from clay analysis, their shapes, and the surprising use of old Minoan patterns [276].

Western Greek

The Geometric and Subgeometric pottery styles of the western colonies were mainly dictated by the styles of mother cities, especially Euboea and Corinth, the Corinthian having a wide distribution even in non-Corinthian areas thanks to Corinth's early infiltration of western markets by the direct route across from the Corinthian Gulf. In the 7th century Orientalizing styles in the west look less to Corinth, and there are what appear to be local styles adopting outline drawing, no little colour, and Orientalizing decoration of types that recall and even outdo the Cretan. These are Sicilian and include myth scenes to match any of the homeland in originality. On [277] the lion has been hoisted from the horizontal to be made to look attacking. Crete is in fact named as a colonizer in Sicily, at Gela. Other pots are more restrained [278]. At Megara Hyblaea there are some notable polychrome pieces [279]. One class of decoration, generally associated with an open crater shape, was first observed at Syracuse (the Fusco craters, named from the cemetery where they were first found [280]). A similar shape and subsidiary decoration is found in south Italy also, at Incoronata near Metapontum [281]. The source for this style presents some problems since it is not obviously dependent on Corinth, and seems best matched in the few craters found in the 7th-century Argolid [214]. Argos had no great reputation as a colonizer, nor did her pottery travel much, so we must assume that one or more potter/painters did travel, and established, perhaps first in Syracuse, a style that attracted general western attention. This is a little odd and suggests an inter-colonial awareness that we might not otherwise have suspected. The most famous of the western products of this shape was found in Etruria, at Caere, and is moreover signed by the artist, Aristonothos [282]. It bears yet another Blinding of Polyphemus scene, close in date to the others noted already [208, 216], and with no less circumstantial detail. The other side is more topical: a sea fight between a Greek warship and an armed merchantman. Its inscriptions could be colonial Euboean, and so from Sicily, or, if from Cumae in central Italy, showing that the style and shape had travelled north. The finds near Metapontum (Incoronata) and Siris contain more varied shapes (standed dinoi, etc.) and decoration, including incipient black figure. The styles differ, with close approximation to Cycladic, Protocorinthian and even Protoattic work and are iconographically rich. The time is ripe for a comprehensive study of these western wares, to determine origins, dates and affiliations.

It will have become clear that the Oriental in Greek Orientalizing vase decoration is treated in vastly different ways in different places. There is nothing seriously Oriental in shapes beyond a copying of bronze standed cauldrons, spherical flasks, and some exotica, especially in Crete, and the Greeks stuck to their preference for vessels, especially cups, with handles and feet, as loyally as did the east-

erners to their handleless round-bottomed bowls (although we shall find some East Greeks picking up the habit in a period of over-exposure to the east). In Corinth the copying of animal and floral forms is direct but very quickly naturalized, or rather denaturalized, since what little botanical or biological plausibility was displayed by the originals is soon translated into quite different decorative forms. The medium was important, and this may account for the difference between Protocorinthian, inspired by incised ivory and metalwork, and the Wild Goat style, which we shall meet in the next chapter in East Greece, from woven scenes. Corinth seems to have learned all it needed by about 700 but still kept an eye on the east, as the updating of the lion heads from Hittite to Assyrian demonstrates [172–73 to 178]. Elsewhere it seems that Greeks were soon copying each other rather than the east, and there are no more significant borrowings to be noted until the 6th century, with quite different effect.

Iconographic borrowings also seem mainly restricted to the early period. We have seen how the appearance of eastern monsters could, through copying or adaptation, be adjusted to serve Greek myth; recall remarks on the chimaera [173], while, after some experiment [208], a convention for the petrifying gorgon head was devised, probably in Corinth before about 650, out of the facing lion head with gaping jaws and lolling tongue of eastern demons (as Pazuzu), added to human eyes and mane/hair. For the basic Greek archaic type which emerges from these trials see [392, 395]. The borrowing of group scenes depended very much on how they might be reinterpreted. Thus, the man attacked by two lions which is eastern and recurs in various parts of Greece down to 700 [23, 65] had no future, presumably since he could not be accommodated in Greek story. On the other hand the man or warrior attacking a rearing lion, which in the east demonstrated divine/heroic/regal power, was readily taken over for the Greek Heracles and therefore survived, including many details such as the beast's hindleg scratching the hero's leg [66]. His use of a sword, however, had eventually to give way to attack with bare hands, probably for Greek mythographical reasons, although it seems that some variants on basic Greek stories could have been suggested by eastern iconography of comparable scenes. This is best shown on vases but is a subject too vast to be more than mentioned here.

The 'life' scenes, as those of burial in the preceding period, probably owe as much to contemporary experience as to any eastern or Egyptian models. The florals are indebted to eastern Trees of Life and the common Assyrian lotus and bud or palmette friezes, which are to have a very long career in Greek art.

The range of shapes decorated does not vary much from the Geometric, but we get a distorted view of this since certain larger shapes, or delicate small ones, and not always the same ones, were singled out for the more elaborate decoration which is inevitably given some prominence in the text and pictures here. The other shapes are of importance for the understanding of life and trade, and are appropriate to a full archaeological handbook dealing with more than pots.

The new narrative and scene-setting which the Orientalizing style eventually, but not originally, facilitated, was not confined to pottery. Pottery is the most prolific source but the scenes do not have the comprehensive range that we find on later Attic vases. The East Greek world may have had a fuller record in this area than mainland Greece in our period, but in other media (metalwork). Elsewhere, scenes in these other media seem not to go beyond what we have on vases. The death scenes on the big Attic Geometric vases survive modestly on smaller Attic vases made for the grave [200, 204]. Big-bodied amphorae are found in graves all over Greece (except East Greece) and it is easy to take them as grave vases although their decoration seldom does much to support this view, except perhaps for the death goddesses of Eretria. We may be seriously misled by the accidents of excavation. Some, like the big Eleusis amphora [208], look like grave markers, but in fact this was used as a coffin for a child, as were the Eretrian [225–7]. In houses or sanctuaries, their role may have been more as elaborate containers.

The new range of myth scenes has naturally, and wrongly, been taken to reflect on contemporary literary interests, especially Homer. But what Homer, be he of the 8th or 7th century, added to the corpus of Greek story-telling, which makes him the paramount artist he is, was not primarily the subject matter of Greek art at that time, but a shrewd complex of plot, allusion and mood, of striking similes taken from everyday experience, of exploration of the problems of loyalty, duty, retribution and the inevitability of the will of the gods. So when we find a spate of Polyphemus scenes in the mid-7th century, on vases [206, 208, 216, 282] and bronzes (in East Greece), this has nothing directly to do with the episode repeated by Homer in the *Odyssey*, but with the basic story, long known and recounted in various ways, not all of them necessarily poetic, and for some reason becoming prominent or popular at the time. Nothing else in the *Odyssey* attracted attention then, and not for a hundred years or more do the Homeric poems as such seem to attract artists, graphic or theatrical, perhaps only after regular recitals of them became a feature of Athenian life. The vases and the *Iliad* or *Odyssey* are separate symptoms of the same phenomenon. This might, however, have been the popularity of a travelling bard singing the Polyphemus story in the mid-7th century. It would be agreeable to think that his name might even have been Homer, and the poet is now dated by some to the period of the vases or later. This is the only plausible link that I can envisage. Other epic subjects were codified by lesser, and therefore non-surviving, poets – the rest of the narrative of the Trojan War, Heracles' life and labours, the Theban cycle, Perseus, Bellerophon, etc. Scenes from these stories which appeared before and after such codification could not and did not depend on them. The ubiquitous Heracles, who demonstrated how a mortal hero might defy even the gods and win through by fortitude and piety rather than magic, was ever popular and much of the imagery involved was not complicated but derived from scenes of hunting or fighting. We have seen already how the Greeks

drew on the east for inspiration for the creation of images of the monsters of their myth. From earliest times they strip them of the more extreme abnormalities: a centaur looks more plausible with horse forelegs than human ones!

Since the repertory of images was not confined to vases, it cannot be discussed in greater detail here beyond the question of whether choice for depiction on vases attests some specific intention. The possible energizing effect of florals and animals has been remarked, but these are becoming subordinated to figure scenes, except where the latter are determined by the vase's function, funerary or other cult. Much can be made of the apotropaic role of some motifs – the gorgon head, eyes, etc. – but these are exceptional, and the treatment of a vase shape as a body should also probably be taken more as a matter of aesthetics than magic. Seldom can a scene be identified as peculiarly appropriate to a location or to other specific occasions. Even the epiphanies of gods on chariots, apparently favoured in the islands, are not conspicuously of the major local deities. Stories of rape or abduction may reflect on Greek attitudes to marriage but are not exclusively or even partly the subjects for what we might take to be marriage vases, any more than death-of-a-hero scenes are for funeral vases. The use of the myth-historical past to comment on the present is a prime characteristic of Greek narrative and apparent already in Homer, but not to any notable or perceptible degree in popular Greek art (our pots) before the 6th century.

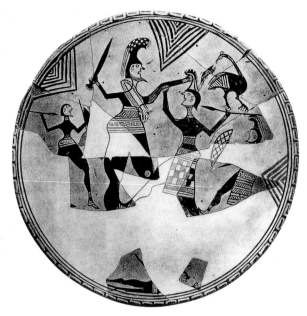

213 Argive model shield from Tiryns.
Achilles or Heracles and Amazon? (Nauplion; W. 40)

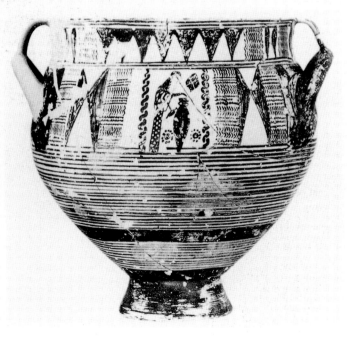

214 Argive crater. Early 7th century. (Argos C26611; H. 54.6)

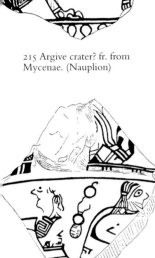

215 Argive crater? fr. from
Mycenae. (Nauplion)

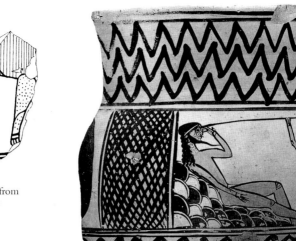

216 Argive crater fr. Polyphemus blinded. (Argos C149; H. 24.5)

217 Laconian fr. from Sparta,
Artemis Orthia. (Sparta; H. 14)

218 Laconian lakaina. (Sparta; H. 7.5)

219 Laconian tall kotyle from Taras.
(Taranto 105541; H. 10.6)

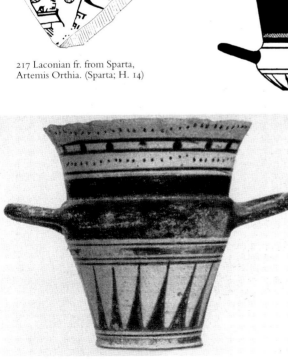

119

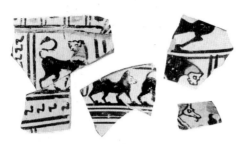

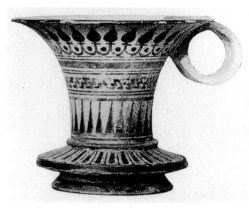

220 Laconian frs. from Sparta, Artemis Orthia. (Sparta)

221 Laconian cup from Sparta, Artemis Orthia. (Sparta; H. 7)

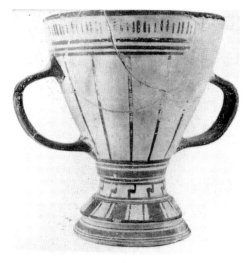

222 Laconian kantharoid cup from Taras. (Taranto T.5bis; H. 15)

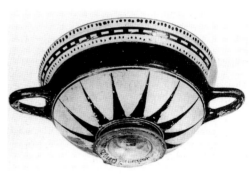

223 Laconian cup from Camirus. (Berlin F1647; H. 8.1)

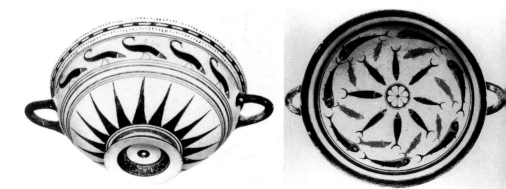

224.1,2 Laconian cup from Taras. (Taranto T.285; Diam. 20)

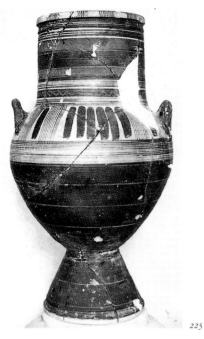

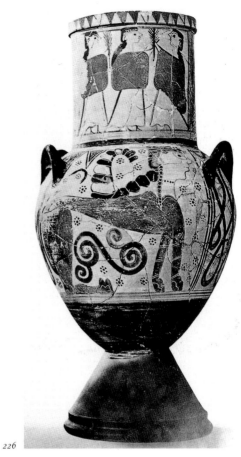

225 Eretrian amphora. (Athens 12078; H. 64)

226 Eretrian amphora. (Athens 12129; H. 72)

227 Eretrian amphora. (Athens 12436a; H. 65)

227

225

226

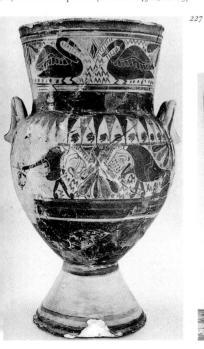

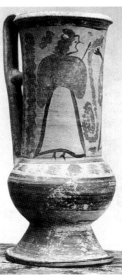

228 Eretrian tankard. (Louvre CA2365; H. 24)

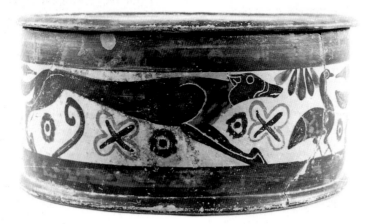

229 Eretrian pyxis. (Athens 276; H. 11)

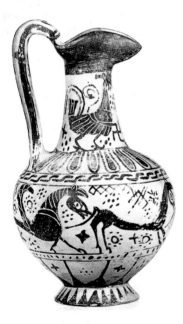

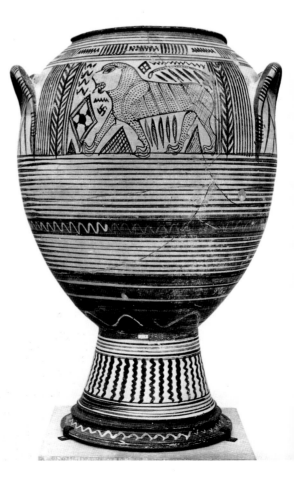

230 Oinochoe from Skyros.
(Bernoulli Coll.; H. 26.5)

231 Boeotian crater.
(Athens 228; H. 64.4)

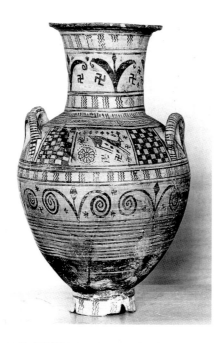

232

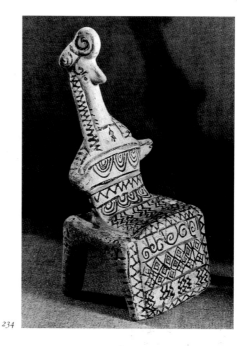

234

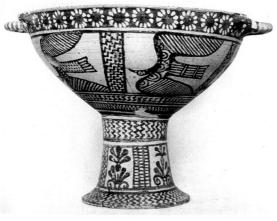

233

232 Boeotian amphora. (Copenhagen NM 3873; H. 55)

233 Boeotian bird bowl. (Munich 418; H. 20.6)

234 Boeotian idol. (London 1879.6-24.3; H. 18)

235 Boeotian *polos*. (Stockholm NM; H. c.20)

235

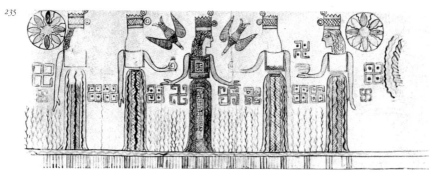

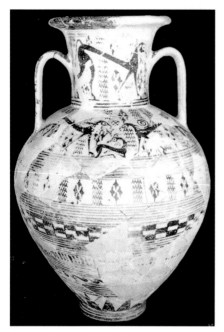

236 Cycladic Ad Group amphora from Delos. (Mykonos Ad1; H. 48.5)

237 Cycladic Ad Group amphora detail from Delos. (Mykonos Ad4)

238 Cycladic D Group skyphos from Delos. (Mykonos D10; H. 16.6)

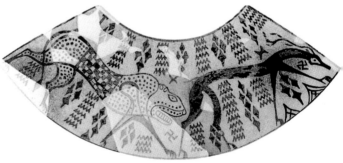

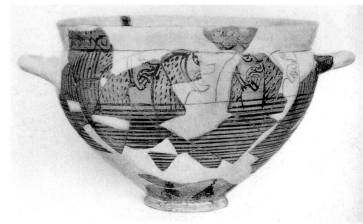

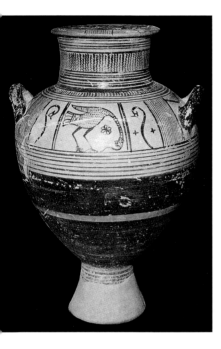

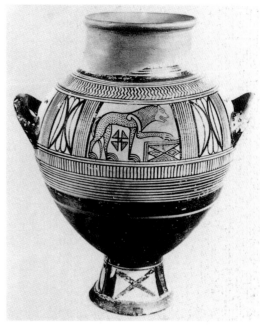

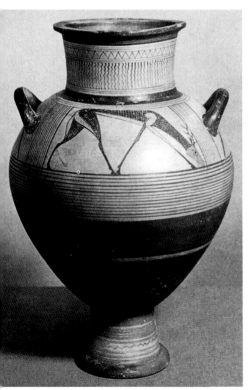

239 Cycladic 'Linear Island' amphora from Thera. (Thera 1303; H. 53)

240 Cycladic 'Linear Island' amphora. (Athens 11709; H. 48)

241 Cycladic Leiden Group amphora. (Stockholm NM; H. 59)

242 Cycladic Leiden Group amphora detail. (Paris, Cab. Med.4710)

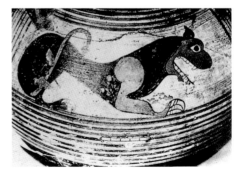

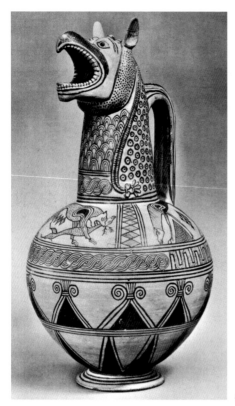

243 Cycladic (Parian?) oinochoe from Aegina. (London A547; H. 41.5)

244 Theran house model. (Thera; H. 38)

245 Naxian amphora detail from Delos. (Mykonos Bc19; H. 38.2)

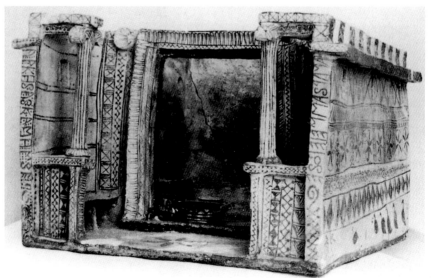

244

245

243

246

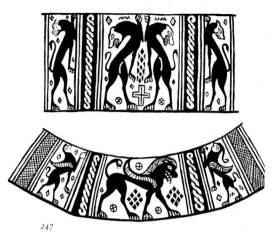

247

246 Naxian amphora from Delos. (Mykonos Ba1; H. 47.6)

247 Naxian amphora detail. (Athens 11708)

248 Naxian amphora from Delos. (Mykonos C1; H. 30)

249 Naxian amphora fr. from Naxos. Ares and Aphrodite. (Lost; H. 13)

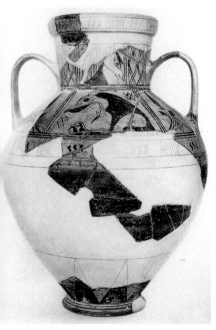

248

249

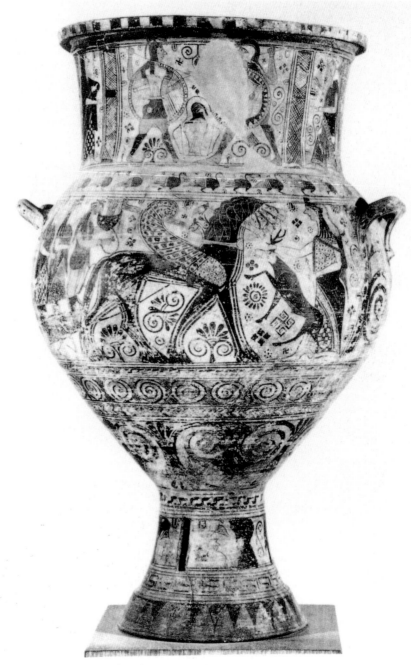

250.1,2 'Melian' (Parian) amphora from Melos. Fight; Apollo with Muses? (Athens 3961; H. 97)

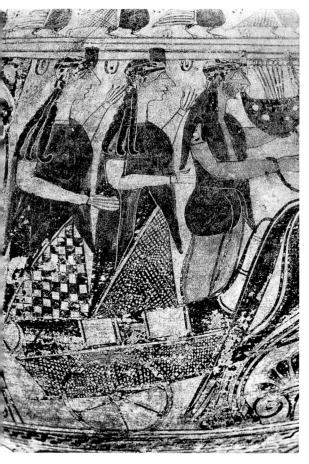

250.2 Detail

251 'Melian' (Parian) dish from Delos. Phallos bird. (Delos)

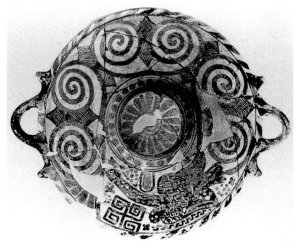

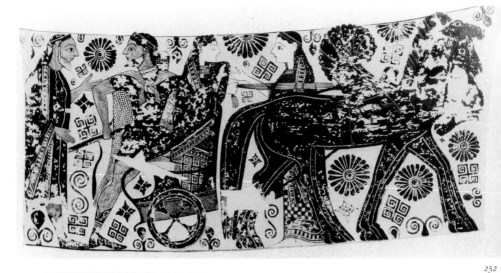

252

252.2

252.1,2 'Melian' (Parian) amphora from Melos. Heracles with his bride; handle detail. (Athens 354; H. 1m)

253 'Melian' (Parian) amphora fr. Artemis. (Berlin F301; H. 30)

254 'Melian' (Parian) hydria from Delos. (Mykonos; H. 35.5)

254

253

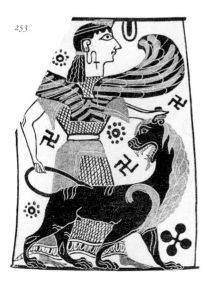

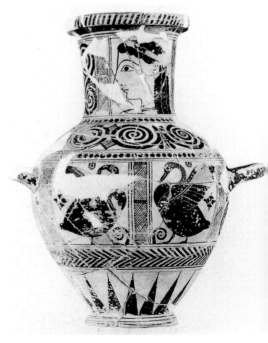

55 Cycladic (Thasian?) plate from Thasos. (Thasos 2057)

56 Cycladic (Naxian?) plate from Thasos. Bellerophon and Chimaera.
Thasos 2085; W. 28)

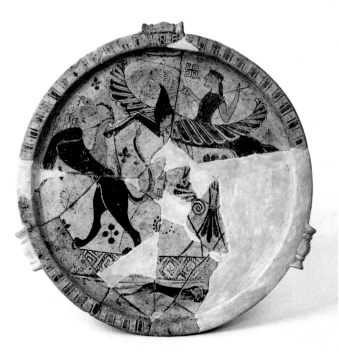

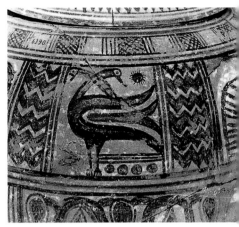

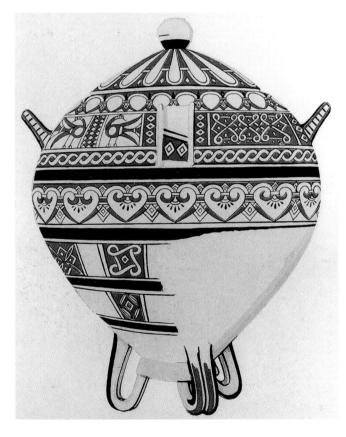

257 Knossian (EO) pithos, detail.
(Heraklion, Fortetsa 1402)

258 Knossian polychrome (EO) pith
detail. (Heraklion)

259 Knossian polychrome (EO) pith
(Heraklion, Fortetsa 1383; H. 53)

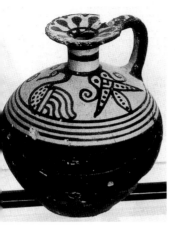

260 Knossian (LO) aryballos. (Heraklion, Fortetsa 1280; H. 8)

261 Knossian (LO) flask by the Fortetsa P., pattern. (Heraklion)

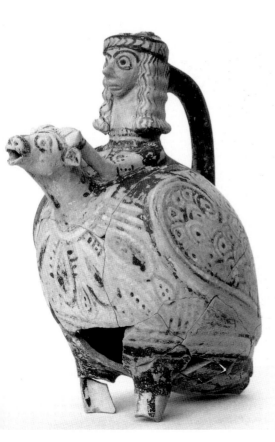

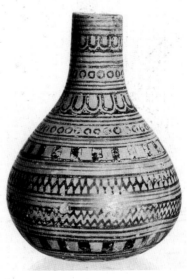

263

262 Knossian (LO) figure-vase. (Heraklion, KMF)

263 Knossian (EO) bottle. (Heraklion, Fortetsa 1373; H. 10.7)

262

133

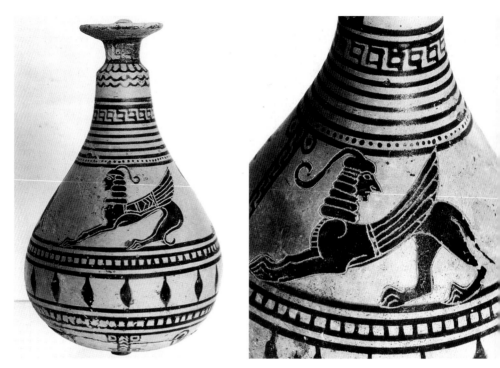

264.1,2 Knossian (LO) alabastron, and detail. (Heraklion, Fortetsa 1299; H. 12)

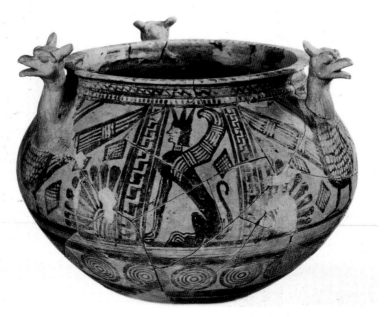

265 Cretan griffin-bird dinos from Afrati. (Heraklion, Afrati L18a; H. 21)

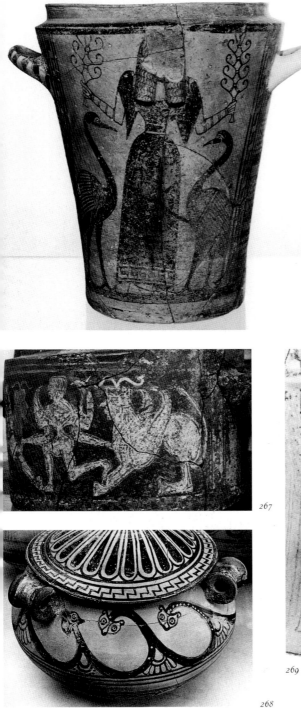

266 Cretan pyxis from Afrati.
(Heraklion, Afrati L43; H. 38)

267 Cretan pyxis from Afrati.
(Heraklion, Afrati pithos 20;
H. 21.5)

268 Cretan lidded bowl from
Afrati. (Heraklion, Afrati pithos
69; H. 23.2)

269 Cretan oinochoe detail from
Afrati. (Heraklion, Afrati L60)

266

267

269

268

270 Cretan figure-vase from Milatos. (Oxford AE191; H. 13)

272 Cretan plate fr. from Praisos. Hero an〈 sea monster. (Heraklion; Diam. 35.5)

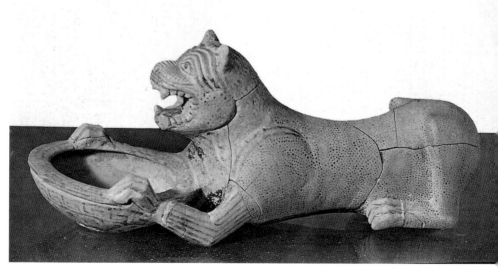

271 Cretan figure-vase from Afrati. (Heraklion, Afrati R77; L. 32.6)

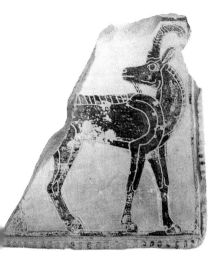

273 Cretan plaque from Gortyn. (Heraklion)

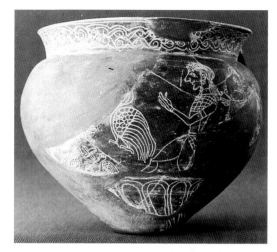

274 Cretan cup detail from Kommos. (Heraklion 25787; H. 11.4)

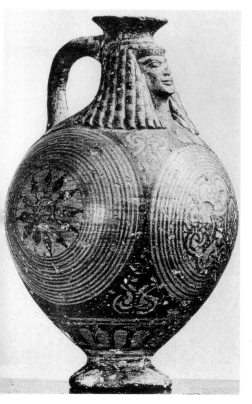

276 Cretan hydria from Tocra. (Tocra 921; H. 41.2)

275 Cretan flask. (Berlin F307; H. 10.3)

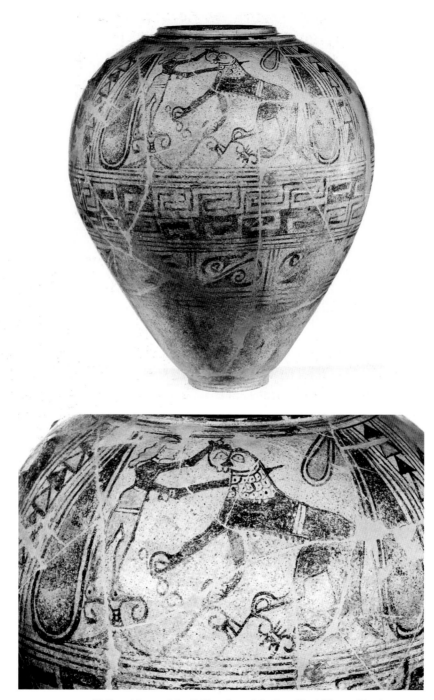

277.1,2 Sicilian pithos, and detail. Heracles and the lion. (Basel BS1432; H. 53)

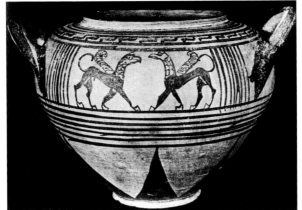

278

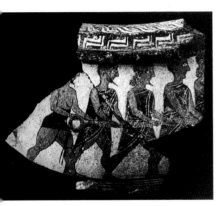

279

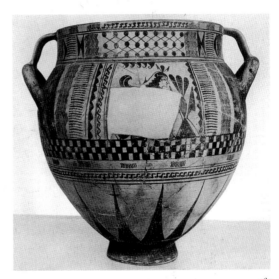

280

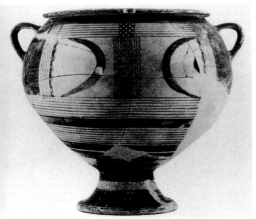

281

278 Sicilian dinos from Gela. (Gela; H. 13.5)

279 Megarian polychrome fr. from Megara Hyblaea. (Syracuse)

280 Syracusan crater from Syracuse (Fusco). (Syracuse; H. 50)

281 West Greek crater from Incoronata. (Metaponto 145345; H. 35.5)

139

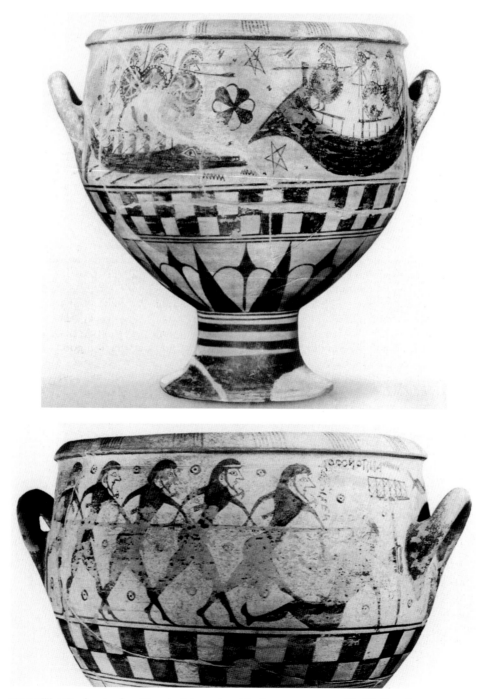

282.1,2 West Greek crater from Caere by Aristonothos. Merchantman meets warship; blinding of Polyphemus (Rome, Conservatori; H. 36)

Chapter Five

EAST GREECE: ORIENTALIZING AND BLACK FIGURE

There are two reasons for giving the Greeks who lived on the coast and islands of the east Aegean a separate chapter for their pottery of the 7th and 6th centuries. Their Orientalizing styles were different in appearance and inspiration from those of the rest of Greece, and in the 6th century the various classes of black figure emerge from the Orientalizing in such a way as to make meaningless any attempt to separate them.

The 7th century was an exciting time in Anatolia. The Phrygian empire gave place to the Lydian whose centre of power at Sardis was closer to the Greek cities and islands. Smyrna prepared for the worst by building massive walls in the oriental manner, but succumbed to Lydia in the early 6th century, and thereafter the East Greeks were alternately harried and dominated by Lydians, then Persians, at the same time enjoying the rule of 'tyrants' (some in Persian pay) like those of the Greek mainland, and like them patrons of crafts, especially architecture. The pottery record is unexciting, as we shall see, but this is a good reminder that Greeks should not always be judged by their pots. We may regret that the East Greeks did not decorate their pottery with the wealth of figure scenes that we find elsewhere in Greece, but it is becoming clear that they were leading Greece in figure decoration on metalwork and ivory and perhaps in painting on other media. This not only puts decorated pottery in its place in this area; it also reflects on the unusual status of the medium elsewhere in Greece. The East Greeks and their neighbours became culturally interdependent, the easterners having the wealth and power, the Greeks patronized by them and borrowing from them ideas in art and architecture from which they were to forge some of the most notable achievements of Archaic Greek art – but not in pottery decoration.

The Wild Goat style

Geometry died hard. The type fossil, the N. Ionian bird bowl [137–8], continued through the 7th and 6th centuries getting shallower and broader, its decoration more summary, admitting base rays, eventually outlined, and with the handle zone replacing the diamonds and bird with rosettes or flowers or eyes on through the 6th century. [283] is a freak, multiple version, probably made for dedication. Bird bowls seem to remain a speciality of North Ionia. Other minor

shapes, in which local preferences can be distinguished, especially in the various islands, are hardly more ambitious, carrying varieties of Subgeometric patterns and few figures, even after the mid-century. Mainland Greek and Cycladic styles were being observed from a distance, but only at about the middle of the 7th century do some vase painters copy and exploit a new eastern source for the East Greeks' peculiar brand of Orientalizing vase painting – the Wild Goat style. This is an animal frieze style, such as was adopted long before in Corinth, but preferring outline drawing with added white and red to the small incising black figure, and generally with repetitive animal friezes in which the goat is prominent without monopolizing. The background filling is dense and often floral – rosettes and half-rosettes. With the animals and patterns go various subsidiary friezes of which the cable (single or multiple guilloche) and spiky lotus and bud friezes of Assyrian type are the most conspicuous. Linear maeanders are Subgeometric in appearance but perhaps not in derivation. Floral displays as centrepieces are composed of large spirals, lotus and palmettes. The tapestry-like effect is probably a fair indication that a prime source of inspiration may have been eastern textiles. The animal friezes are familiar enough in Syria and beyond; also some of the rosette patterns, mainly on metalwork or minor stone reliefs. There is nothing Egyptian/Phoenician about them but we may underestimate Anatolian production in other media, and there are many tapestry-like decorative panels which appear in Greek art from this time on which are well represented in Anatolia and earlier Phrygia. The Anatolian empires stretched far to the east, and we are reminded that East Greeks seem to have taken over from the Euboeans the current of trade with Syria through Al Mina in the 7th century. By the end of the century they had also established a port of trade in Egypt, at Naucratis in the Nile delta, as far up as big ships could go, with minor but interesting repercussions in the medium we are studying. So they were well placed to learn from whatever the east promised.

Rhodian potters were for long credited with the invention and much of the production of the Wild Goat style because so many vases were found on their island. (It should be noted that the Classical (and modern) city of Rhodes is not a source, being a later foundation, and that for our period finds are mainly from Camirus, Lindus, Ialysus and Vroulia; so 'Rhodes' here means the island only.) Finds in the Ionian sites to the north and clay analysis have considerably modified this view. MILETUS emerges as a major producer of the vases in their heyday, while other states contributed their own versions. Indeed it is the Rhodian production that is now less easy to define, except for some idiosyncracies, though the island was in the best position to observe the presumed eastern inspiration, unless this arrived via Anatolia. Rhodes has also, we have seen, surrendered any primacy in the production of bird bowls.

Development of Milesian Wild Goat broadly runs from experimental (Early

Wild Goat = EWG), beginning around the mid-century, through more uniformly composed Middle Wild Goat (MWG I and II), which is capable of revealing considerable drawing skill and decorative flair. The most popular shape for the style is the broad bodied oinochoe with round (early) or trefoil lip and with the painting over a pale creamy slip. The shoulder frieze commonly has a central floral with the grander animals flanking it [284, 287–8]. This brings us to around 600 BC, by which time other parts of the East Greek world are experimenting with black figure (LWG). The finest Milesian MWG speaks for itself, and was sufficiently distinctive to prove acceptable on distant shores of the Mediterranean, and in the Black Sea where Miletus was a vigorous colonizer [285], though not in mainland Greece, and even to promote imitation in Etruria (Swallow Painter: GO fig. 241) and the Cyclades. The addition of geese and dogs enlivens the friezes, and antlered creatures are as common as the goats. Only clay analysis will prove where some of the more wayward or colourful [289] examples of MWG belong. [290] presents us with a rare figure subject on an exceptional and colourful plate, with a Trojan scene. It was found on Rhodes but inscribed by an Argive, it seems. It displays an ambitious figure style similar to those of the Cyclades; Hector's shield device, notice, is incised black figure.

The Milesian style degenerates in the early 6th century (MWG III); animals had begun to elongate, the neat round half-rosettes clinging to borders becoming broad hammocks, and the trim rows of petals, tramlines [291–2]. Dishes with or without stands and plates are an East Greek speciality, also decorated with floral hoops [293–4], and the Wild Goat decoration is seen less commonly on the other standard Greek shapes of crater and amphora. Plates are popular in LWG Rhodes and neighbouring islands (Nisyros, a debased type as [295]), generally with single large creatures, although a few are more elaborate [296–7] and colourful [298].

The advent of black figure in East Greece has been mentioned. It seems mainly a phenomenon of North Ionia though not, in its WG form, of the islands. The technique infects the filling ornament which becomes more target- or bun-like than the still floral contemporary Corinthian rosette fill [369–71]. Corinth may well be the source of inspiration for the introduction of this LWG black figure, though of nothing else of note. The decoration is still the animal frieze, and with the same animals, but it is possible for a single pot to have both outline and black figure friezes, the two techniques hardly ever being mixed. It appears most commonly on oinochoai, large dinoi with vertical lips [299], large hemispherical cups [300] and some column craters. The cups may have black interiors decorated with incised florals picked out in red and white, a style of decoration to which we shall revert in a moment.

A few pots are decorated all over [301] or with broad black friezes with incised floral decoration, recalling the scale-patterned bands on some MC at Corinth [381]. These do seem to have been made in Rhodes, perhaps an answer to the black figure animal friezes just described. The incised floral bands are also admitted as the sole decoration of a small group of fine-walled conical cups (Vroulian

cups) made in Rhodes before and after about 600 [302]. An unusual shape, the situla, bears a relationship to these incised-black wares [303–4]. The shape must be inspired by the Egyptian bronze situla, which is made with a swing handle for suspension and has a round base. The Greeks naturally added side handles and a flat base for their versions. The decoration is in panels high on the body. Some good examples of before the mid-6th century bear still rather old-fashioned ornament. The main series have incised-black florals below or are plain, with single or pairs of figures or animals in the panels [303]. These end by around 525 but there is an impoverished succession for the shape and decoration later in Rhodes [304]. Oddly, the main series is represented almost wholly at Tell Defenneh (Daphnae) in the eastern part of the Nile delta, but not at all at Naucratis. (Daphnae's record ends with the Persian invasion of 525.) The possibility of production by Rhodians in Egypt, but not at Naucratis, has to be admitted. The shape derives from Egypt and in the decoration there are some Egyptian motifs to identify (a falcon on a *nb* basket).

There are other intimations of Greek pottery made in Egypt: a Wild Goat vase of odd style from Saqqara on which the bulls' horns are drawn fore-and-aft in the Egyptian manner [305]; a black figure vase with painted cartouches [306]; and by Chians.

Chian

is the most distinctive of the Ionian wares (some prefer 'Chiot'). Chios was a large and rich island with a strong trading reputation and a producer of expensive wine. Its clay is grey and unlovely but fine, so it proved possible to make very thin-walled vessels, but they had to be coated with a white slip to carry any delicate painting, and it is thick and tends to come off in flakes. There are important sources for the early period in the island, but for the latest 7th and 6th centuries we have to turn to the many places to which its cups (chalices) and some other shapes were exported. Foremost among these is Naucratis in the Nile delta where much Chian pottery has been found. It included some plain kantharoi with pre-fired inscriptions on them, bespoke for dedication at Naucratis' sanctuaries [307]. The suspicion lingers that these were made there with imported clay (Nile clay is horrid) rather than ordered and then carried (they are very fragile) from Chios; this would also explain the few ordered by Aeginetan traders (who also operated in Naucratis) to take to their home island for dedication. And if made in Chios why were the plain pots bespoke there with inscriptions and not the many finely decorated ones? There are other Chian finds in north Africa, on the coast opposite Chios (especially Pitane, Erythrae), in several of the western colonies and Etruria, Cyprus, and some on the Greek mainland and on Aegina (see above). Chian wine was carried in distinctively shaped wine amphorae and are among the first to carry decoration, lines and loops which hark back to Mycenaean patterns. I show two other shapes with similar decora-

tion, 6th century [308–9]. Notice the multiple brush on the shoulder of [308].

Most of the smaller 7th-century vessels are basically Subgeometric with a little animal life. The development of the Chian chalice from the LG skyphos with high walls has been described [140]. By the end of the 7th century the walls can carry various panel patterns or Wild Goat friezes [310]. One of about 600 is plain but for the signature of its maker, Nikesermos. The Chian Wild Goat style may appear earlier on a very white-slipped oinochoe from Smyrna but is only certain on some chalices, the Aphrodite Bowl from Naucratis [311], and some finds on the island which suggest a local fondness for making big oinochoai with animal heads as the necks [312]. The painted animals tend to have elaborate curvy body patterns reserved on them (notably the bulls) and in the fill the half-rosettes are often horseshoe-shaped. The bi-sexual fragment [313] is unexpected.

By about 600 a series of prolific and individual groups of decorated vases began, including some in black figure, the earliest of these being in the Sphinx and Lion style. This presents rows of little animals: sphinxes, lions with ruff manes, birds, sirens, few others, in incised fill which recalls Early Corinthian (620–590) and may be suggested by it. The real interest in the group lies in the shapes – not the chalice, but various bowls with vertical rims (*lekanai*), some lidded, big conical bowls which may also have conical lids and stands [314–5], and some odd bell-shaped vases; many have applied relief women's heads on them. It is easier to explain the figure drawing in terms of other work in Greece than the choice of shapes.

Another very distinctive group of black figure from a single studio appears in about the 560s. It imitates the finer styles of Laconian black figure, imitating also the Laconian cup shapes and their secondary decoration ([316] the pomegranate borders, see [417–8]) but allows the style also on to some chalices. No Laconian has been found on Chios but the style and shapes could have been met at Naucratis where all the examples (but for one on the Black Sea) have been found, leaving the possibility (no more) of production in Egypt.

Animal Chalices have distinctively Chian LWG animals in the usual fill, often with much added colour [317–8]. These perhaps run to the 570s, followed by Simple Animal Chalices which have lost the fill [319], and sometimes even the animals, in favour of florals or nothing. These may run to the 530s, but the chalice shape lingers on in Chios into the Hellenistic period, sometimes with minor florals. A truer successor to the Animal Chalices is the Grand Style, well represented at Naucratis. This is perhaps of the 580s to 550s. The chalices are sometimes very large, crater-size. They carry outline-drawn figures often with considerable polychrome touches, an extreme version of anything to be seen in the islands or Corinth. There is little or no fill. This is the one major East Greek group whose painters seem to have been ready to indulge in major mythological scenes, but there are sadly few and fragmentary or badly flaked examples [320].

Beside these there is production of black figure chalices, generally less fine:

one series concentrates on figures of turbaned komast dancers [321], another on animals [322]. These probably run to the 540s. Oddities are some chalices with figures in white on black, and, towards the end, one or two unslipped but figure-decorated kantharoi and chalices which look more like ordinary black figure; the latter are either low and flat-footed, or tall with chalice-shaped bodies and feet. These are decorated in panels or narrow friezes. An oddity shared by the majority of the open vases throughout the 6th century is the way in which their interiors are decorated too: at least with red and white lines, often with outline-drawn lotuses and palmettes, and on the finest and biggest with red and white animals and figures as well as quite complicated floral friezes [323]. Some phialai mesomphaloi, copying an eastern metal shape, also display this polychromy very well [324].

Not the least merit of the Chian production is the way in which it can be so closely studied, thanks to the volume of finds, their distinctive appearance, and the apparently highly compartmentalized deployment of the island's potteries. It gives a better insight than most into the diversity and organization of pottery production in a well-defined area.

Samian

styles are somewhat more difficult to describe. One might have expected a similar record to that of the island's neighbour and rival, Chios. Much seems still Subgeometric in the 7th century, followed by some Wild Goat style vases of high quality [325]. In the 6th century there is one strange polychrome vase which may be a deliberate attempt to imitate the Chian Grand Style chalices; otherwise both the shape and style of decoration were studiously ignored in favour of something more challenging. This appears in the small group of so-called Ionian Little Master cups of before and around the mid-6th century [326–9] which are probably of Samian origin. Their decoration looks rather like black figure, but the details are mainly in thin reserved lines, a technique we shall meet shortly being adopted in Miletus at about the same time. The Little Masters are so named for their resemblance to the contemporary phenomenon in Athens of miniaturist painting on high-stemmed, thin-walled cups with upright lips (*ABFH* 58ff.). The shapes may have been developed in East Greece, however. The Ionian variety regularly carries myrtle or ivy leaves on the outside of the lip, and often a frieze of animals within the lip. Between the handles there may be small figures or items in relief (knucklebones, animal heads). The interiors are generally filled, even if only with close-set concentric circles, which may also frame a tondo bearing a figure or small group like the Attic, even sometimes with the tongue border. The pattern resembles the interiors of turned wooden cups; the lines were of course applied on the potter's wheel. More impressive are the scenes filling the interior which include an imaginative vineyard [327] in which the painter has allowed the shape to dictate the composition, with a lot of fine detail

(all in reserved lines) including the bird flying to its nest, threatened by a snake, a locust and another long-legged bird. There is extremely delicate drawing on some pieces, where the graver has been used as lightly as a brush [328]. Other interiors have a whirligig of dolphins encircling a warrior, or a floral complex [329]. No less accomplished are some kantharoi whose bodies are modelled human heads, the lip interiors carrying birds or a school of dolphins [330]. This practice of appropriate decoration of interiors with fish (or ships) is taken up by Attic painters.

Milesian

potters have been seen to be the champions of the best WG styles of the 7th century. The idiom declines but clay analysis has shown that in the 6th century a series of vases in what is called the FIKELLURA style (after a place in Rhodes where it was found) is of Milesian origin. It seems to have travelled well in East Greece, especially to Rhodes and Samos, once thought to be places of origin, and to Milesian colonies in the Black Sea where it was also imitated (at Istria, near the Danube mouth). It is clearly a development of Wild Goat, and its style and technique of figure decoration was surely the inspiration of a single potter/painter. It introduces new decorative patterns and schemes which render it one of the most instantly recognizable of Greek pottery styles [331–9]. The commonest shape is a broad amphora [331–2] with some stamnoi [333], slimmer amphorae [334] and cups. On amphorae, lips are slashed, necks decorated with guilloche or a strip of maeander and squares. On vase bodies, the most distinctive new pattern is the row of crescents and an odd scheme of oblique black and white stripes, like feathering, which, when combined with a scale pattern, makes the whole vase a bit like a bird [335]. Florals are the old lotus and bud friezes, in black, but also a good range of spiral and palmette patterns which call for far more finesse and were barely glimpsed in earlier Wild Goat for centrepieces. These are disposed in friezes or as under-handle clusters. Figure decoration is mainly in silhouette, with little outline drawing but a lot of thin reserved lines for detail (as on the Samian cups [326–7]). These give the impression of incision, which would certainly have been an easier way of achieving the same effect but was eschewed for either aesthetic or technical reasons (it needs a very fine clay and slip not to become chipped and messy). The animals are inherited from Wild Goat, plus some beady-eyed panthers and partridges, with minimal fill. Human figures include dancing komasts [336], symposia [337], a Dionysos [338], pygmies fighting cranes and various demons with animal heads and wings [339] such as are seen elsewhere in Ionian art (on gems not vases). Drinkers' cups are of the handleless eastern variety [336–7]. Isolated figures may be set in the centre of the field without a ground line [332, 338], breaking away from the usual domination of frieze and panel in vase painting. The style was invented before the mid-6th century and runs on towards its end, the decoration lending itself to easy defini-

tion of individual painters. While its borrowings from Corinth or Athens seem minimal, there is much about the amphorae, and their use of florals especially, which suggests that Attic potters may themselves have profited from knowledge of Milesian Fikellura.

Clazomenian

potters present us with our first black figure on large vases in a style comparable with that of the mainland schools. Pure black figure decoration, as well as black-figurized Wild Goat, seems a speciality of North Ionia. One class is plentiful enough for detailed study and seems to have been made in CLAZOMENAE mainly through the third quarter of the 6th century. There are three major groups: the Tübingen Group (named for the home of a major example), followed by the Petrie Group (named for the excavator of Naucratis) and the terminal Urla Group (named for the site near Clazomenae). Most have been found in Egypt, at Naucratis and Tell Defenneh (Daphnae; which gives a terminus of 525 BC). The main shapes are neck amphorae and hydriae, and a deep lidded bowl rather like a casserole [340]; as in Chian, applied relief women's heads are common. Of the ornament scale/feathers with white dots and rows of crescents (as on Fikellura) are characteristic. Friezes of animals are generally dull. Rows of rather wooden women [340–2], sometimes holding hands, are popular, but there is very little mythology. The rather odd fragment [346] shows a herald before a king and queen, perhaps Priam and Hecabe. Decorative peculiarities are the massive spade-beards of males [343–4], and the use of rows of white dots on figures. White is often set straight on the clay (not on black, as in Attic) and was not deemed essential for female flesh (as in Attic). The rider on [344] could be taken for a boy, his shoulder thrown forward, not a Godiva, who could not be easily explained.

Related are the Enmann Class, with big-animal or figure scenes in the amphora panels ([347] is unusually plump), and the Knipowitch Class of amphorae with sagging bodies and concave lips, favouring the forepart of a winged horse in the panels [348]. There is other black figure work in a variety of sometimes eccentric styles from Naucratis and various other sites, origins yet to be located. They include good drawing on a bowl from Aeolis, north of Ionia [349], an engaging man or demon leading a camel (drawn from memory, I imagine) found at Smyrna [350], and other studies which play further on the oddities of Clazomenian anatomy, some of which travelled to Egypt [351]. Some of these vases may be later than the main Clazomenian series. North Ionian black figure coincides with a period of major export of Attic black figure, yet can hardly be said to imitate it except in very general terms, even if it has little itself of real distinction to offer (but see below, on [485]).

The last gasp of the Wild Goat style is seen on clay sarcophagi, which are not treated in detail here (they are, after all, not pots) but have some interest for their

decoration and its relationship to vase painting. The series begins around 530 and lasts to the 470s, so there seems to be a gap since the last of the purely Wild Goat vases, though we may underestimate how long these went on being made. The Wild Goat animals, the fill and florals, are generally execrable [352] but the figure decoration can be more careful and includes versions of black figure with the lines executed in thin white paint [353], not incision, and even a stab at red figure [354]. They are generally called Clazomenian since many were found in the town cemetery, though the decoration is not all that close to the black figure pottery just described and the type may have been devised elsewhere. One imagines travelling potter/painters making them where required – there is a number of late examples from the north Greek town of Abdera, which had colonial links with Clazomenae.

Aeolian

Sites to the north, Pitane and Myrina, have proved important sources, and Larisa (on the Hermos River), but there is little from Lesbos as yet. Phocaea, between Aeolis and Ionia, is often hailed as an important centre mainly because it was a prominent state in the west (its folk emigrated in the face of the Persians) and so thought responsible for Ionian styles in Italy and beyond.

On Aeolian craters the Wild Goat style is practised with some odd proportioning of florals and a fondness for a paint which fires red, even beside the usual brown/black. A distinctive shape is a splay-necked stamnos [355–6]. Anatolian taste may intrude here, as it does in the continued production of pale grey (silvery) bucchero pottery, a ware which Aeolis shares with the non-Greek mainland opposite and which goes back to Bronze Age pottery traditions there.

Striped and figure-vases

This is the place to mention the long and prolific tradition of plain striped cups in the East Greek world ('Ionian cups') which represent a *koine* with various centres of production, even outside Ionia and Rhodes (in mainland Greece and the west). They may start in Samos, before 700 BC, with stripes and a wavy line on the lip. They usually have a reserved lip, handle zone, and a stripe lower down, and East Greek examples favour groups of close set lines, like the interiors of Samian cups. The striping recurs on various other shapes with the same background. The example I show [357] is a *lydion*, copying a Lydian perfume vase, which was also copied by various Greek black figure schools, including Attic (*ABFH* fig. 159).

East Greece was generous with small figure-vases from the late 7th century on. Most are simply current types of clay figurine, hollow, with a disc mouth added (unlike Corinthian where the orifice is disguised) and most seem likely to be Rhodian. Some have more pretentious decoration from the vase painter's

repertory. These include helmeted heads and sandalled feet, with black figure palmettes or gorgoneia painted on the handle plate, various women's busts, gorgon busts [358] and heads of Acheloos, the horned river god [359]. Another class, decorated with dash-stippling seems Milesian, and is more modest in supplying vase mouths [360].

Other Anatolian

Inland PHRYGIA and LYDIA (its capital at Sardis) enjoyed a special relationship with the Ionian cities culturally, as well as dominating most of them politically and militarily. Local production combines Greek and Anatolian in shapes and decoration, and the provincial Wild Goat vases made there depend on the Greek. But it is likely that the Greeks derived thence many of the tapestry patterns used on their pottery, even the soon-to-be ubiquitous maeander and square friezes. There is very fine pottery with such patterns at Ephesus, which had a strong Lydian connection. The non-Greek island of LEMNOS has some engaging Orientalizing pottery, as much Anatolian as Greek in inspiration. To the south CARIA, as in LG, used a provincial version of Greek Wild Goat on rather angular versions of oinochoai [361].

The East Greek pottery I have described remained essentially Orientalizing throughout, and only superficially affected by Corinthian and Attic black figure. Keeping it together in this chapter has helped to accentuate the strong traditional elements in East Greek vase painting, and the unusual way in which this tradition was able to create quite distinctive new styles at a time when the rest of the Greek world was developing the craft in ways which are on the whole far more interesting in content and style, at least to us, though less varied in appearance. We are in an area of the Greek world where the potters could be intermittently innovative but remained basically uninterested in developments elsewhere. The cities and islands, except for Rhodes, also remained relatively indifferent to reception of Corinthian or Attic decorated pottery; there may be, indeed, some influence east to west in pottery shapes and decoration (mainly in Attic; *ABFH* index, s.v. East Greek). For reasons best known to themselves the East Greeks did not much use their pottery as a field for any notable range of narrative scenes such as we find in the rest of Greece, and this remains true to the end of black figure, a period in which other Greek wares are especially generous with such subjects. Only Homer's island, Chios, seems an exception, but the evidence is meagre, perhaps dependent on painting in other media for which there is more evidence now in a mainly Greek style but from non-Greek neighbours (at Gordion in Phrygia and in Lycia at Elmali: *GO* figs. 105, 122). Instead, it seems that incised and beaten metalwork was a more popular medium for such decoration; the little that has survived is either from East Greek sites (notably Samos)

or finds at Olympia recognized for their style. This is a serious lack since the indications are that East Greece may have been the inspiration for much that we find farther west, in Athens if not Corinth, and we are denied the opportunity to prove the debt.

East Greece had a brilliant record in this period in sculpture, architecture and metalwork, its merchants were ubiquitous, its philosophers both imaginative and practical, yet at some levels it suffered a degree of cultural isolation from the Greek mainland, and this is most apparent in the more modest crafts. With the arrival of the Persians in the mid-6th century some artists and others moved west across the Aegean and played an influential role in the development of the arts in the west, both in Greece and Etruria. But we should remember that some of the later production in East Greece described here was done under the shadow of Persian rule, however indirect. Even before then, many East Greeks may seem Anatolians first, Greeks second.

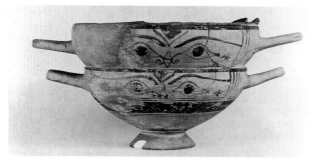

283 N. Ionian multiple eye bowl from Naucratis. Dedicated by Rhoikos (the Samian architect/sculptor?) About 575-550. (London 1888.6-1.392; H. 10.8)

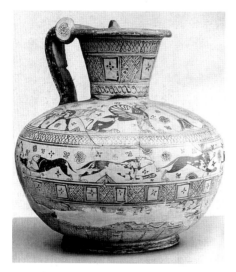

284 Milesian (MWG) oinochoe from Camirus. (Berlin 295; H. 30)

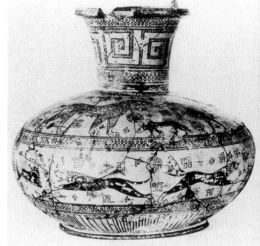

285 Milesian (MWG) oinochoe from Black Sea. (St Petersburg; H. 30)

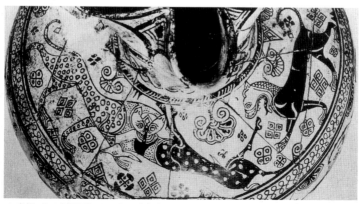

286 Milesian (MWG) oinochoe detail. (Athens, once Vlasto)

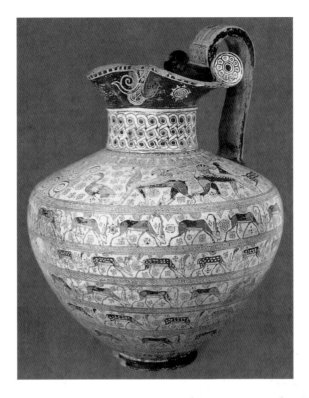

287 Milesian (MWG) oinochoe (the
Levy or Marseilles oinochoe). (Louvre
CA350; H. 39.5)

288 Milesian (MWG) oinochoe.
Boston 03.90; H. 29.2)

289 Milesian (MWG) oinochoe from
Rhodes. (Vienna IV.1622; H. 38)

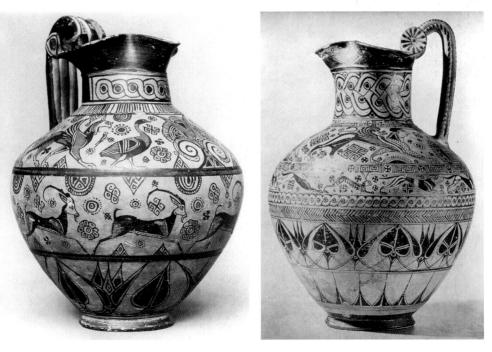

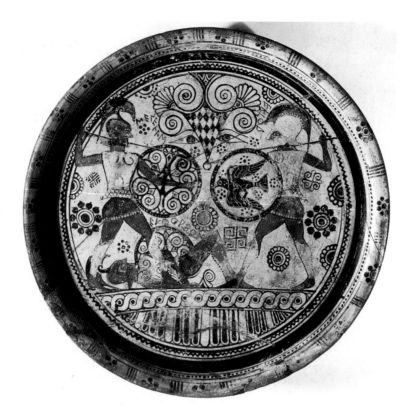

290 Rhodian? (MWG) plate from Camirus.
Menelaos fights Hector over the body of Euphorbos.
(London 1860.4-4.1; W. 38.5)

291 LWG oinochoe detail from Rhodes. (Rhodes)

292 LWG oinochoe. (London 1865.12-14.2; H. 33.5)

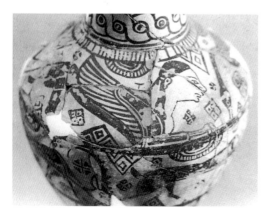

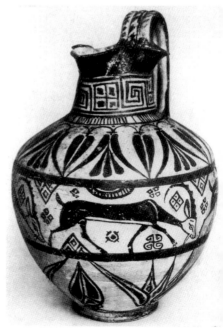

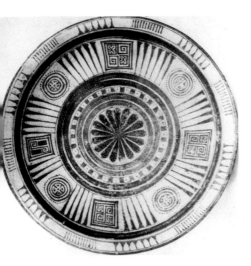

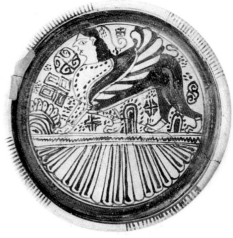

293 LWG dish. (London 1867.5-8.904; W. 30)

295 Rhodian? (LWG, Nisyros type) plate from Tocra. (Tocra 613; W. 29.8)

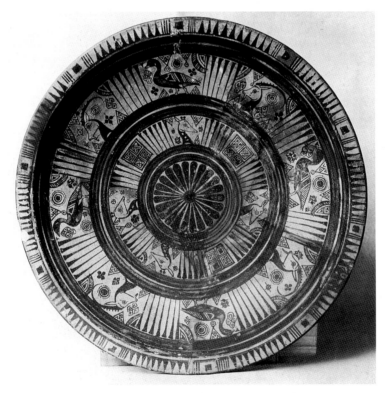

294 LWG dish from Camirus. (Paris, Cab. Med. 70; W. 37.5)

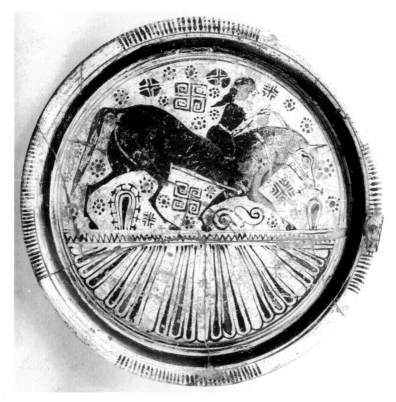

296 Rhodian (LWG) plate from Rhodes. Rider. (Berlin 3724; Diam, 29.3)

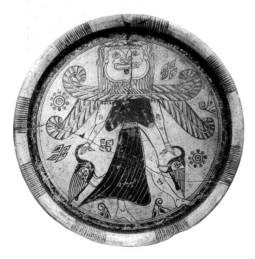

297 Rhodian (LWG) plate from Camirus. Gorgon-headed goddess. (London 1860.4–4.2; W. 32)

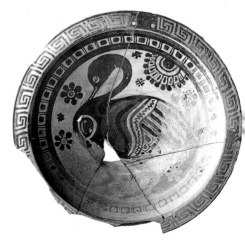

298 Rhodian? (LWG) plate from Tocra. (Tocra 631; W. 32.8)

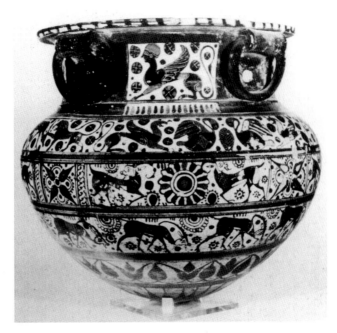

299 N.Ionian (LWG) dinos from Italy. (Louvre E659; H. 35)

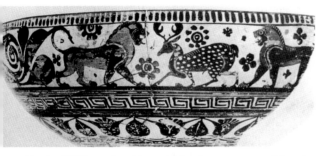

300 N.Ionian (LWG) cup from Naucratis. (London 1888.6-1.535; W. 22.8)

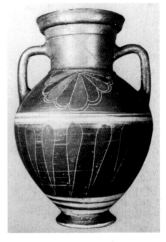

301 Rhodian (LWG) amphora from Siana (Rhodes). (Bonn 459; H. 28.5)

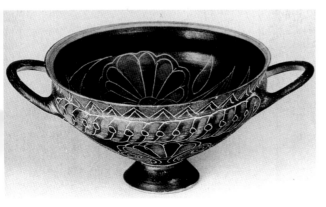

302 Rhodian 'Vroulian cup' from Camirus. (London 1861.4-25.41; W. 12)

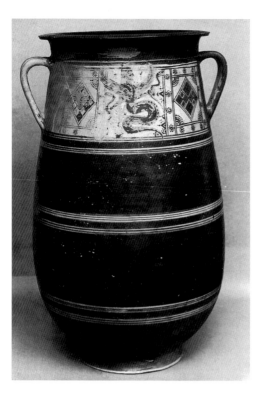

303 Rhodian situla from Tell Defenneh. (London 1888.2-8.1; H. 53.6)

304 Rhodian situla from Ialysus. (Rhodes 10.64; H. 40.5)

305 East Greek oinochoe from Saqqara (Egypt). (Cairo 26135; H. 34)

306 East Greek amphora from Egypt, with cartouches of Apries. (Basel, Cahn; H. 26.4)

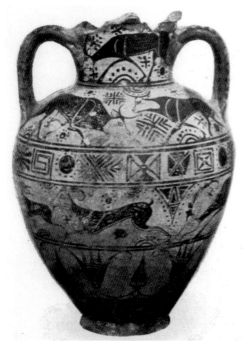

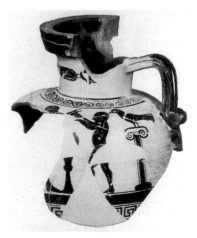

307 Chian votive kantharos, restored, from Naucratis. (London)

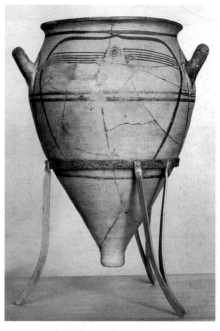

308 Chian pithos from Chios town. 6th cent. (Chios)

309 Chian hydria from Chios town. 6th cent. (Chios)

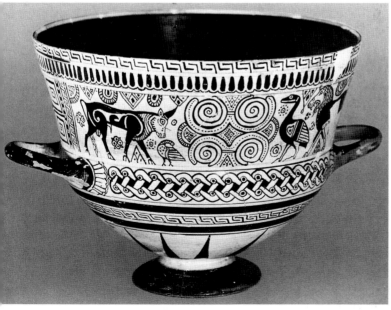

310 Chian chalice from Vulci. About 600. (Würzburg L128; H. 15.8)

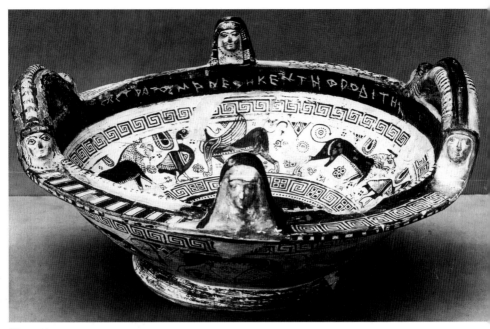

311

312

313

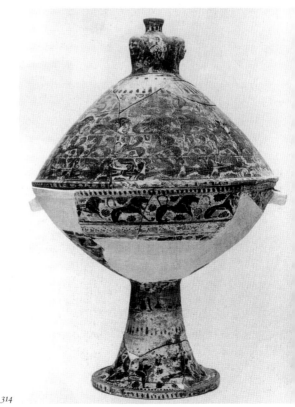

314

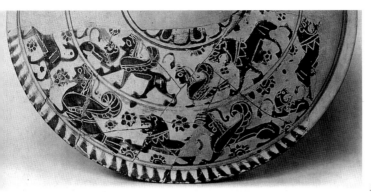

315

311 Chian bowl with dedication to Aphrodite from Naucratis. (London 1888.6-1.456; W. 38)

312 Chian oinochoe neck from Emporio. (Chios, Emporio 634; H. 19.5)

313 Chian phallos/vulva vase from Naucratis. (London 1888.6-1.496; L. 14.6)

314 Chian (Sphinx and Lion style) standed bowl from Pitane. (Istanbul; H. c.50)

315 Chian (Sphinx and Lion style) fr. of lid from Naucratis. (London 1888.6-1.547; H. 10)

316 Chian cup fr. imitating Laconian from Naucratis. (Oxford G133.2+6; W. c.18)

317 Chian chalice fr. from Naucratis. (London 1888.6-1.463; W. c.22)

318 Chian chalice fr. from Naucratis. (London 1888.6-1.465; H. 12)

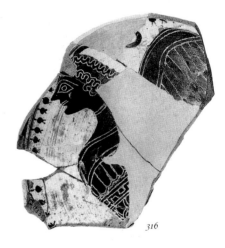

316

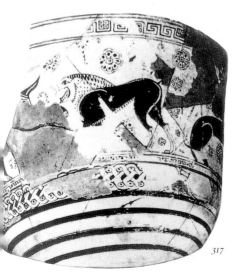

317

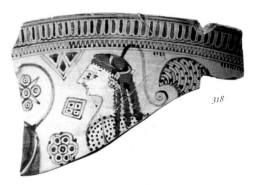

318

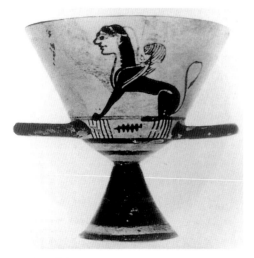

319 Chian chalice from Camirus. (Louvre A330.1; H. 14)

320 Chian polychrome chalice frs. from Naucratis (London)

321 Chian chalice fr. from Emporio. (Chios, Emporio 748; H. 6)

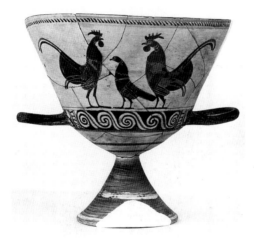

322 Chian chalice from Tocra. (Tocra 785; H. 17.7)

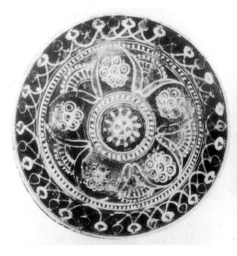

324 Chian phiale mesomphalos from Marion (Cyprus). (Nicosia 1952.VI-17.1; W. 18.5)

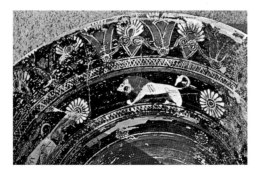

323 Chian chalice interior from Pitane. (Istanbul)

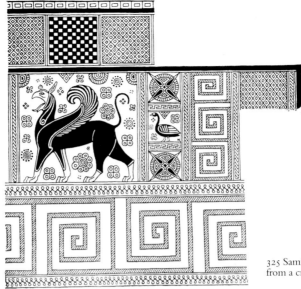

325 Samian WG panel from a crater. (Samos)

326 Samian cup. (Riehen, private)

327.1,2 Samian cup from Italy.
(Louvre F68; W. 23)

328 Samian cup frs. from Naucratis.
(Alexandria 17047, 17145)

329 Samian cup interior from Heraion, Samos. (Athens, Heraion K1383, 1419)

330.1,2 Samian face-kantharos from Vulci. (Munich 2014; H. 21.4)

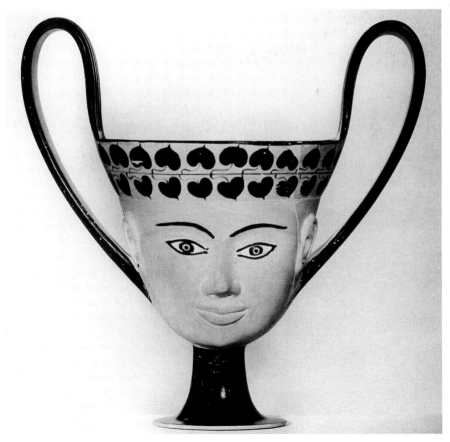

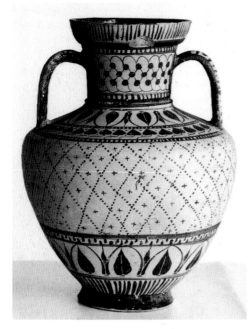

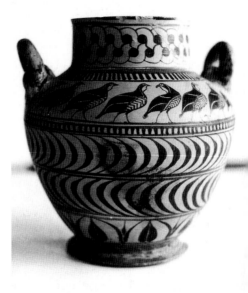

331 Milesian (Fikellura) amphora. (Rhodes 13078; H. 34)

333 Milesian (Fikellura) stamnos from Ialysus. (Rhodes 15429: H. 18.6)

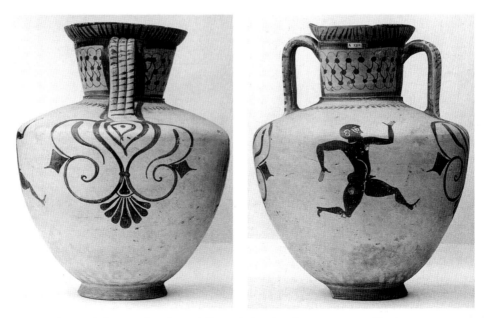

332.1,2 Milesian (Fikellura) amphora from Fikellura (Rhodes). (London 1864.10-7.156; H. 34)

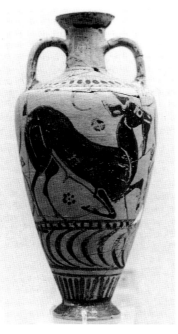

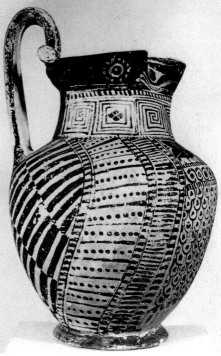

334 Milesian (Fikellura) slim amphora from Makri Langoni (Rhodes). (Rhodes 13165; H. 20.5)

335 Milesian (Fikellura) oinochoe from Camirus. (Louvre A321; H. 29)

336 Milesian (Fikellura) amphora. (Altenburg 197; H. 31)

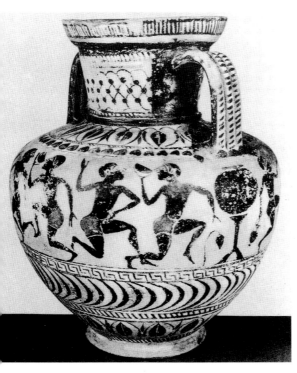

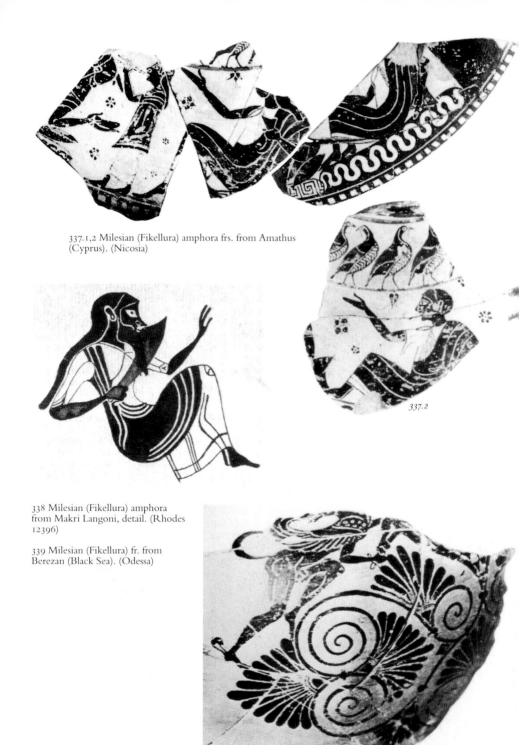

337.1,2 Milesian (Fikellura) amphora frs. from Amathus
(Cyprus). (Nicosia)

337.2

338 Milesian (Fikellura) amphora
from Makri Langoni, detail. (Rhodes
12396)

339 Milesian (Fikellura) fr. from
Berezan (Black Sea). (Odessa)

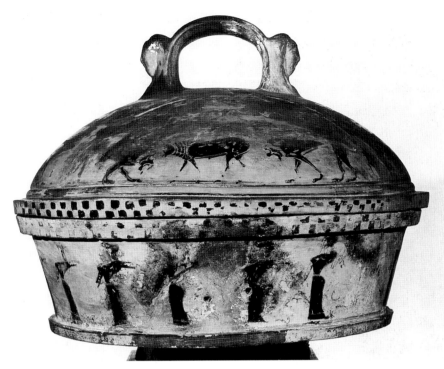

340 Clazomenian (Tübingen Group) lidded pyxis. (Munich 570; H. 38)

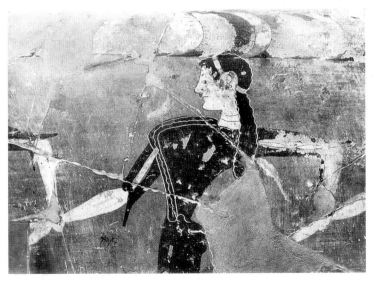

341 Clazomenian fr. (Tübingen Group) (Tübingen 2656)

169

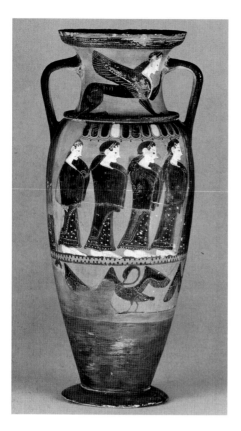

342 Clazomenian (Petrie Group) slim amphora from T. Defenneh (Egypt). (London 1888.2-8.71a; H. 53.6)

343 Clazomenian (Petrie Group) slim amphora from T. Defenneh. (London 1888.2-8.78a; H. 25)

344 Clazomenian (Petrie Group) slim amphora from T. Defenneh. (London 1888.2-8.69a,b; H. 31)

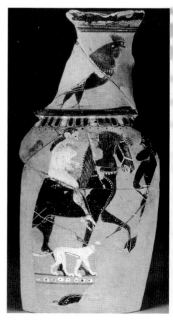

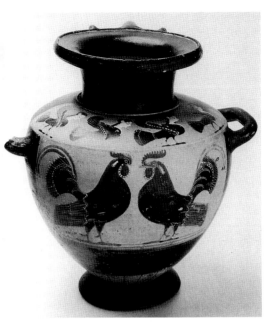

345

346

347

348

345 Clazomenian (Urla Group) hydria. (Moscow, Pushkin 1b 1364; H. 27)

346 Clazomenian fr. from Clazomenae. (Athens 610; W. 10)

347 Clazomenian (Enmann Class) amphora from Rhodes. (Berlin 2932; H. 25)

348 Clazomenian (Knipovitch Class) amphora from Rhodes. (Athens 12713; H. 26.5)

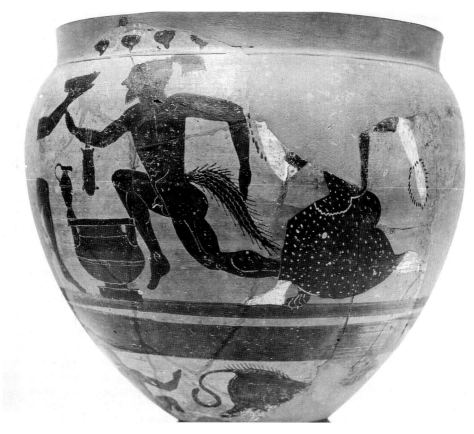

349 N. Ionian deep bowl from Kyme (Aeolis). c.500 BC. (London 1904.6-1.1; H. 29.9)

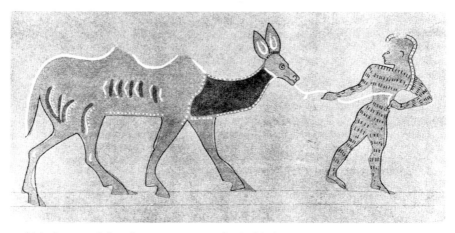

350 N. Ionian crater fr. from Smyrna. 540-530 BC. (Izmir, OS45)

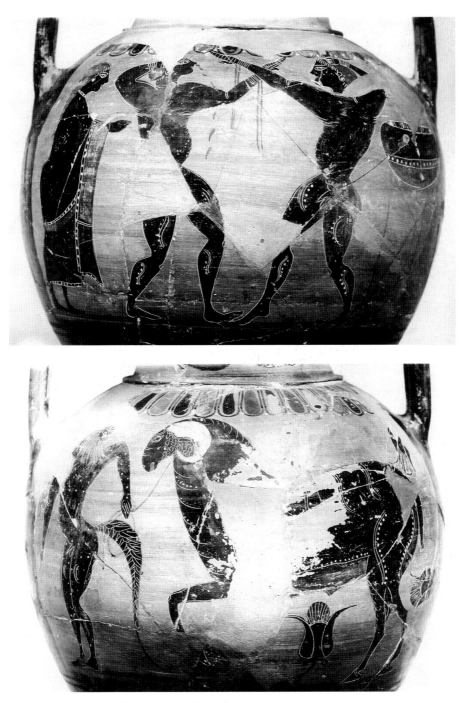

351.1,2 N. Ionian amphora details from Karnak. (Berlin 5844; H. 35)

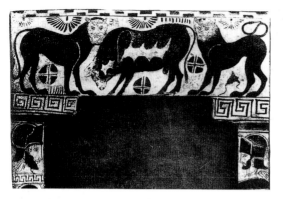

352 Clazomenian sarcophagus detail from Camirus by the Hopkinson P. (London 1863.3-30.2; W. 63)

353 Clazomenian sarcophagus fr. from Clazomenae by the Borelli P. (London 1886.13-26.1; H. 44)

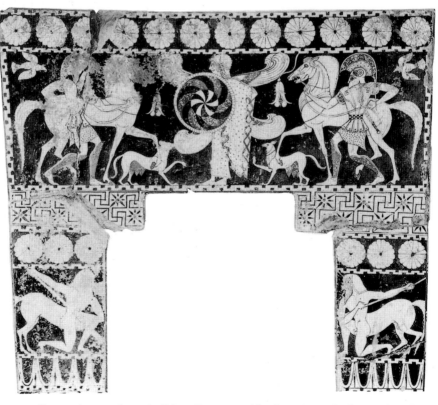

354 Clazomenian sarcophagus detail from Clazomenae. Albertinum Group. (Berlin 4824; W. 92)

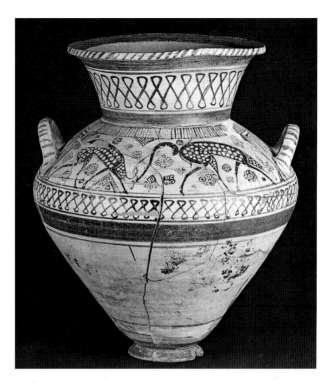

355 Aeolian stamnos from Pitane. c.600 BC. (Izmir)

356 Aeolian stamnos from Myrina. c.600 BC. (Louvre B561; H. 35)

357 Ionian lydion. (Munich 532; H. 11.3)

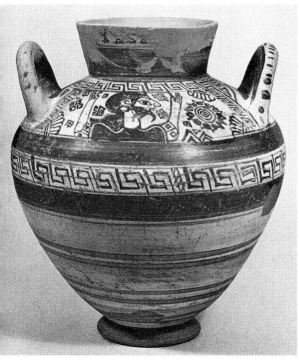

358

359

361

358 Ionian figure-vase from Rhodes. 600–575 BC.
Gorgoneion. 600–575 BC. (Berlin 1961.4; H. 7.5)

359 Ionian figure-vase from Tocra. Acheloos head.
(Tocra TC73; H. 6.25)

360 Ionian figure-vase. Heron. (Cleveland 88.65;
H. 13)

361 Carian oinochoe. (Zürich, Mildenberg Coll.;
H. 23.3)

360

Chapter Six

THE BLACK FIGURE STYLES

We have seen how the Orientalizing vase painters of Corinth developed the black figure technique through the 7th century. Before the end of it they evolved an even more thoroughgoing black figure which abandoned most of the Orientalizing ornament except the animal friezes and the filling rosettes, now incised, and even gave up most of the subsidiary floral patterns which other Greek artists were long to favour. Athens accepts full black figure before 600, and through the 6th century various other towns take up the technique for styles which seem to depend to varying degrees on the example of first Corinth, then Athens. The story is patchy, and not through lack of finds. The last chapter surveyed the decidedly idiosyncratic black figure record of different parts of East Greece, where other styles were still practised. Some Greeks decided to ignore the technique and their potters stayed with plainer vases while their customers relied on imports if they wanted anything grander by way of figure decoration. Potters, even in those towns which had a distinguished black figure record, did not necessarily maintain production all the time. Most start to become really busy in the last generation of figure-decorated Corinthian vases, and by the beginning of the 5th century virtually none was still in business. This is explained partly by the prolific and relatively cheap provision of competition from Athens, partly through lack of interest. In other words, there is something far more personal about the various 6th-century schools, and their relative quality or fecundity is for the most part no direct reflection of the wealth or taste of their citizens or of other local arts that may have flourished.

The Athenians' black figure has been explored elsewhere (*ABFH*) but needs to be referred to here from time to time. It became a very different phenomenon from the vase painting products of the rest of Greece. This was due partly to the fact that the Athenian potters had learned from Corinth that the market was worth observing and developing. There were other more parochial reasons too. In the Geometric period the figure decoration of Attic vases was exceptional in Greece for the way it was designed to convey special messages about status and cult. The only comparison is with Argos, where the messages were different and less sophisticated though no less apparent. While the 7th-century pottery of Attica does little to suggest that such a tradition was maintained, we find in the 6th century a deliberate development and use of figure scenes which reflect civic and religious attitudes in a way that Corinth's vases seem never to

have done, and that other states seem not to have sought to any obvious degree. Athenians were different, and the volume of their figure-decorated pottery allows us to glimpse some important aspects of this difference. In a remote way it prepares us for the fact that Classical Athens, rather than any other Greek state, was to be the home of democracy, of the theatre as social comment, and of humanist philosophy. Our subject here is essentially non-Athenian, but the contrast is telling and worth keeping in mind.

The black figure technique is as typical of Greek art of the later 7th century to the early 5th as is the development of the senior arts of major architecture and of archaic marble statuary. In a way they represent Greek art coming of age. Although there are still instances of influence from the east or Egypt on pottery, and especially in figure scenes, they are trivial. Both the sculpture and architecture owe part of their inspiration to the non-Greek, but all three arts – painting as seen on pottery, sculpture and architecture – represent a thoroughly Greek statement of an artistic mode which had been locally created out of previous influences from various sources, and which served peculiar local needs. In a way this sees the de-Orientalizing of Greek art, and a necessary preliminary to the Classical Revolution which sets in seriously after the Persian invasions of 480/479 BC, but is presaged in various ways in the century before.

Corinthian

We may detect an element of weariness in the animal frieze decoration of Transitional Protocorinthian vases, but the animals were to prove remarkably persistent. Other traits in Protocorinthian had been a developing interest in narrative and colour, both of which had a future and are the inspiration for interesting and influential work; yet the overall impression of the full Corinthian black figure style (Ripe Corinthian it is sometimes called) is of prolific production of rather boring vases, with a little more interesting figure work, mainly for the export market, eventually expiring in the face of more innovative Attic competition. This is not the whole story, however; the effect of Attic production may have been misjudged, and the Corinthian record in these years can be seen to have set a new pattern for successful pottery production in the Greek world which Athens was to exploit to remarkable effect.

The three conventional main phases, Early, Middle and Late (EC, MC, LCI), used to be distributed to the quarter centuries between 625 and 550 BC (followed by LCII, a terminology which I ignore here where LCI = LC). The rather uncertain evidence for absolute dates from colonies and events datable from non-Greek sources has suggested a slightly later start, but the end must be about right, transitions coming in the late 90s and late 70s of the 6th century. It becomes increasingly more useful to use correlations with the more easily determined sequence of Attic vases, in terms of style, mutual influence and finds in the same context (usually graves), and although absolute dates remain somewhat elusive

the application of conventional dates to new finds invariably tallies well with other, historical expectations. The volume of production is matched by a considerable range in competence, and it is well to be wary of an instinctive feeling that poor = late. In some ways LC goes out in a blaze of glory.

Stylistic distinctions between the main periods are less easily defined, except with the help of painter-attribution, than changes in shapes and choice of decoration. Painter-attributions in Corinthian have not carried the same overall confidence that Beazley's authority bestowed on Attic black and red figure pottery. The shapes are telling, not much dependent on fashions elsewhere but rather setting standards for others, so the discussion here goes by shape rather than date. The shapes of oil vases are more apparently important than those for the symposion, though these are certainly plentiful, notably the crater. This is one major difference from the Attic experience.

Spherical aryballoi [362–8] were made by the thousand, and exported freely, presumably with perfumed oil. Corinth's dominance in the market for small, pretty oil flasks seems absolute, with a little competition from East Greece, but the new styles of drawing do not produce as many miniaturist masterpieces as did Protocorinthian. They do, however, often carry friezes devoted to scenes of life [363] or myth [364–5] and are by no means wholly dominated by animal friezes although these, or single creatures [362], are the commonest decoration. [363] demonstrates the importance of familiarity with the Corinthian alphabet in these studies.

The elongated oil vase, the alabastron, was no less popular, more given to standing figures [369–71] than animal subjects. Many of these were quite large, and introduce the elaborate MC painting style with much added colour and rows of white dots. Larger versions of the spherical aryballoi were given flat bases and began to appear in MC, some very elaborately painted [365] though most have just animals. A great many of the smaller aryballoi (and some lingering pointed aryballoi as well as alabastra) are simply decorated with rows of double dots, stripes (including red), some with vertical red, white and black stripes (like an orange or a football [367]), or little animals or warriors in a hailstorm of fill (LC); two rows on [366]. Quatrefoil aryballoi [368] have the old eastern cross of lotuses

and buds wrapped around them, increasingly debased from MC to LC. There are also little ring aryballoi [372], amphoriskoi [373], and bottles [374] generally with simple decoration, appearing in M-LC. [375] is exceptional for its elaborate scene and the revelation of the name of the painter, Timonidas, whom we shall find again [409.5]. There is even one strange throw-back to the old Mycenaean oil vases, a version of a stirrup vase [376 compare 1]. All these types are unexciting but wonderfully indicative of vigorous trade.

Pyxides are commoner in Corinthian than in most Archaic wares. Examples with concave sides [377] continue from PC, or with straight sides (powder-pyxides), or plump and rounded. The last sometimes have little handles in the shape of female heads (head-pyxides)[378], and some stand on stems in MC. Oinochoai continue, with broad or narrow feet, even a few of the old conical shape until MC [379], and in M-LC some with globular bodies. The olpai come to attract a revival of the scale-pattern bands. [380–1] give a clear indication of the degeneration of the animal frieze, which in [381] looks the worse for the crude fill rather than poorer drawing. The shape is given up in MC, replaced by an Attic form with pouring lip and recurved body. [382] represents a revival of the added-colour-on-black decoration that was sometimes practised in Protocorinthian. There are plates with concentric rows of animals, relatively crude on [383] (M-LC), or with one finer, large figure or figures on both sides in the MC Chimaera Group [384–5]. An odd round bowl, with lug handles or tripod feet, and with the rim inturned against spilling, was presumably for cosmetic oil or water [386]. These have long been miscalled kothons and their probable real name – exaleiptra – has not quite caught on. Such conservatism is harmless enough until it causes mistakes.

Of cups the kotylai are the most characteristic, retaining often the rim patterns, base rays and the usual animals [387]. The near-vertical sides make a good field for detailed myth and action scenes [388–9]. Many have plain silhouette animals, or rows of stripes like the simplest aryballoi, and many are miniatures, mainly for dedication. There are some deeper, larger varieties with lids (so not cups) in EC. While the PC cups, deriving from LG skyphoi, continue, deeper cups appear, mainly in M-LC and perhaps inspired by East Greek cups [390–4]. These become as important as the kotylai. Many simply carry animals but there are elaborate examples with myth scenes [391] and several have a gorgoneion within [392] or heads [393–4]. Both the shape and scheme of decoration are influential in Attic. Some are very large [390, 392], not at all handy as real cups nor robust enough for mixing vases; it is difficult to see them, and comparable enlarged forms such as the biggest Chian chalices, as other than display pieces.

The column crater is an important local creation, recognized as 'Corinthian' in antiquity [396–402]. It is a variant on the old craters which had supports running from the shoulder handles to the rims. In the new type the rim is a heavy flat hoop to which the handles rise; later with projecting square plates under which the handles are set, the loop itself sometimes disappearing into the plate

so that it seems supported by two columns. This development shows that the shape was devised in clay, not metal, but in LC some have a vertical strap rising from the handles to the rim, like an abbreviated 'volute-crater' handle (Attic, *ABFH* fig.46). This type is called 'Chalcidian' (see [*476*]) but was probably invented in Corinth, and is perhaps best designated a stirrup crater. In the standard type the handle plates may be decorated with human heads or single animals, and the top of the rim with rays (E-MC), florals (MC) or step-zigzags (M-LC). By LC the column crater had acquired a relatively high neck. Its concession to Corinthian convention is the animal frieze that normally appears below the main figure scene, and the vase back sometimes sports big animals. Of other larger vases the neck amphorae [*404*] and hydriae are relatively uncommon, and 'one-piece' belly amphorae are mainly LC, decorated in panels [*405–6*].

Moulded (rarely modelled) elements on or added to Corinthian vases were apparent in PC mainly in the shaped tops to some of the finer aryballoi [*176*]. In later black figure there are the heads attached to pyxides [*378*] and sometimes more elaborate additions which suggest the influence of metal vases. Figure-vases go on being made in some numbers, little dotted creatures with concealed mouths [*407*], and some occasional better pieces with human or monster subjects [*408*], but seldom as fine as the PC had been, though much exported.

We turn now to the subject matter of the decoration. The animal kingdom of Corinthian vases is fairly stereotyped. Lions are popular, and facing-head 'panthers', sometimes shown as a different species by bearing spots; otherwise there are bulls, boars, goats and birds, especially cocks, few horses unless ridden. Crosshatching is used for manes, red for manes, bellies, and to highlight ribs and haunches. Rows of white dots emphasize some anatomy. Feline shoulders are drawn as outline boxes (where Attic used double lines); wing feathers are alternately red, notably on the many sphinxes, sirens and other hybrids (griffin-birds are favoured [*393*]) that escort their mortal kin. There is hardly ever any interaction and only the roughest symmetry to composition of friezes. This is the basic black figure animal frieze style that we see in so many other versions elsewhere in Greece. The background is filled with incised rosettes and blobs, often crowded and trimmed to fit the empty spaces; only on the later craters and some cups are the creatures free of them. The florals remain the old lotuses, buds and palmettes, in chains, crosses and interlaces. Decoration is in friezes rather than panels (except on the LC amphorae) and no fancy borders are developed; horizontal dividers are often just dot zigzags or nets, in black, or black and white, or red and white on black stripes; rows of tongues appear at shoulders or round tondos, often multicoloured, and rows of white dot-rosettes with red hearts, as on the necks of craters and neck amphorae; at best there are floral chains. In MC there is some revival of interest in bands of scale patterning, as in LPC, but the scales are larger and cruder [*381*]. Base rays persist.

There is little or nothing by way of true progress in the design of these friezes. The slacker, later artists elongate their animals, thus economizing on the difficult

bits – the heads. From details of drawing and shape preferences the works of individual painters can be distinguished and assigned to the various periods on grounds of context or development of shape. Many of the animals are quite finely drawn and some single studies, as on the Chimaera Group plates (MC [384–5]), are noble if stiff.

The human figure drawing and narrative scenes are a different matter. They increase in range and importance with time, offered on most shapes, even on some of the small oil flasks and bottles [375], which otherwise sport single figures or animals, and the grandest appear on amphorae, hydriae, oinochoai and, especially, column craters. The Eurytios crater [396] is among the earliest, around 600 BC, and instructive for many reasons. On the rim are animals, including dogs and eagles after hares, with a stag hunt and horsemen on the handle plates. The shoulder frieze is a fine floral; the animal frieze at the belly is of horsemen, fill-free. The main scene is a symposion with reclining guests, a scheme shown first here in Greek art, as we have it, and was a practice learned from the east, perhaps via East Greece. There is no fill. Inscriptions (I repeat – it pays to learn the less conventional letters of Greek dialects outside Athens to understand the iconography of the vases if nothing else) tell us that this is Heracles at the feast of Eurytios, with his daughter Iole: an innocent-looking occasion but a prelude to mayhem for those who know the story. Not for the last time the artist chooses a tense but quiet moment to recall an event of total drama, but also one that lends itself to a dignified, symmetrical pattern of shapes and figures, which only reveals itself as a specific occasion from the inscriptions. On the back of the vase is a battle; beneath the handles, at one side servants of the feast, at the other Ajax falling on his sword. We notice conventional black figure but with broad areas of red for dress, bedding, and on mens' faces; also how much is outline drawn – the woman's face, a dog, couch legs. This makes for a more polychrome effect than is achieved in most black figure where the added white and red are not integral to the overall colour effect. So advanced does all this appear that many used to think the vase relatively late, but the floral and figure drawing reveal the date.

A comparable degree of polychromy was observed in LPC vase painting. That was miniaturist, but also seems to have been practised on larger clay works for an architectural setting. It may be that larger work, on wood or wall, was well enough familiar in Corinth for the vase painters to be inclined to imitate it, when not committed to the specialized pottery techniques of black figure. But we have also observed that where black figure had not been accepted in the 7th century, Greeks were well disposed to draw in outline and with colour masses, and there are Protocorinthian vases with outline figures and heads, though few. Athens remained more committed to line, and the only literary records we have of 'major' late archaic painters refer to Corinth and nearby Sicyon before Athens. By early LC the vase painter had begun to adopt for a proportion of his finer figured vases a new technique that enhanced the polychromy. This put a pale red slip on to the pale clay, giving as it were a fourth colour to the red, white and

black, and especially necessary where the clay itself was whitish. Attic potters were by this time firing their pots more red than pink, and in time came to enhance the red further, but never with the same effect or intention, and we should judge that the Corinthians' choice was primarily aesthetic, although knowledge of the appearance of Attic vases might have helped. At the time the red-ground style was adopted in Corinth, Athens was only beginning to compete seriously for markets, and Attic vase painting was being heavily influenced by Corinth in other ways, not least through the possible immigration of Corinthian potters.

There follows a fine range of figure scenes, many of mythological content, either demonstrated by inscriptions or assumed. White is more freely used now, for women's flesh, some manes, whole horses and parts of the bodies of other animals [399]. On occasion even a male body may be shown in white [404], probably simply to exploit the polychromy or highlight a prominent figure. As a result whole scenes seem to be more easily read than their Attic equivalents, even (and especially) where masses of overlapping, fighting figures are involved, and with more outline and detail done by brush than graver there is a more flowing feel to the figure groups, so that the purely black figure parts can seem harsh and rigid. Here again the work of individual painters can be distinguished, not perhaps quite as readily as in Attic where the sharply linear style is more revealing of personal 'hand-writing', but allowing identification of influential artists. We know most of these vases from the export market to Italy. It has been thought that production was designed for Etruria, but if we knew as much about local use in Corinth of the finest pottery, as we do in Athens (from the Acropolis finds), we might think differently. Certainly, it is only on vases from Corinth and Athens that we find merchant marks put on at source for the export market: from Corinth, usually red-painted letters, from Athens incised graffiti, letters or monograms.

Another crater, later than the Eurytios crater [396], and known as the Amphiaraos crater [401], is no less revealing of what could be achieved in single-scene narrative. The scheme for the subject may have been invented in East Greece (seen on a fragmentary bronze at Olympia) but the vase is the fullest expression we have, for all that details may be derivative and not the vase painter's own. A similar version on another Corinthian monument of about the same date, the Chest of Cypselus at Olympia, is described in some detail by Pausanias centuries later and there are versions on Attic vases. The vase is red-ground. The rim has a floral, the handle plates gorgons; below the main scenes the uncommon horsemen, again. The back shows the chariot race at the funeral games for Pelias. At the front a conventional scene of a warrior departing by chariot is made specific by detail, personnel and inscriptions. Amphiaraos is off to war, to Thebes, an expedition from which he knows he will not return. His fate is known also to the seer who sits right, clutching his head in despair. The king's wife, Eriphyle, had been bribed to send him, with the fine necklace which she

holds conspicuously at the left. His young son (who will avenge him by killing his mother) implores him to stay, but he glares round at her, sword drawn more in threat to her than to an enemy. The setting is palatial and swarms with animal omens. Again an artist had chosen a tense moment that manages to encapsulate the drama that preceded it and the tragedies to follow, and a vase painter has preserved it for us, and perhaps added to it in ways we cannot judge. At the same time was created an archetypal heroic departure scene which can serve as model for others.

The range of mythological scenes on Corinth's vases is notable mainly for its differences from Attic and from the other main corpus of such scenes of the period, on Peloponnesian bronze shield bands. There are several Heracles scenes [396–7, 402], though by no means all the Labours. Those with the Hydra are especially popular in E-MC [365, 388]; it was the nearest Labour to Corinth, at Lerna. Notice the attendant Athena who often holds a little jug, possibly to hold the poisonous Hydra's blood, which Heracles will use for his arrows and which will eventually bring about his own death. The hero is not characterized with club and lionskin as he is regularly in Attic, but as any other hero, often naked. The Theban cycle of stories is relatively more popular than in Attic, Amphiaraos included; the expedition set out from south Greece. Troy is quite well represented, with a special interest in the suicide of Ajax ([391] and out of sight on [396]), and a unique scene of the Greek conciliatory mission to Troy before hostilities [400]. We miss Dionysos (one or two exceptions) and satyrs, gigantomachies and much else familiar from Athens, but it must be remembered that the Attic narrative series only really begins in the years when LC vases were being painted and close comparisons could be misleading. Many of the red-ground scenes are of anonymous chariot groups, often attended by groups of three women [399], and there are many other apparently generic subjects owning no known identity in myth.

Of secular subjects the most striking are the komast dancers [385, 388, 390, 398], who appear first in EC. They are copied in Attic (the Komast Group; ABFH 18) and appear on many other Greek vases [321, 336, 429, 441–2, 444] as well as serving as models for scenes of satyrs dancing. It is not certain that the other komasts copy Corinthian vases rather than illustrate a common Greek practice, which is first attested in Corinth but could derive from East Greece. The jolly figures wear tight shirts, apparently padded, slapping their bottoms and generally cavorting in an unseemly manner. Wine helps – they are often at a crater – and at Corinth naked women may join in. Sometimes one dancer is crippled [?385, 390], and there are scenes which hint at the procession which returns the lame god Hephaistos to Olympus. In Attica he would be accompanied by Dionysos and satyrs (ABFH fig.46.7). Possibly the dancers could enact bibulous myth and we are witnessing an early stage in the creation of a Greek theatre of dance and song celebrating divine or mythical occasions. Another common secular subject is the chain dance of women [374], perhaps for a local festival.

One special class of figured pottery deserves separate mention: clay plaques. Near Corinth's Potters Quarter, on the slopes of Acrocorinth, there was a shrine of Poseidon to which the potters and painters took votive plaques. Some are quite crudely painted but the scenes include valuable representations of potters at work in the clay beds [409.1], tending the kiln and perilously attempting to close its top during a flare-up [409.2–3], and there is a horizontal section through the kiln itself [409.4]. Some are from the best painters, very few of whom we know by name, but Timonidas painted and signed a fine example with a hunter and dog [409.5] (see his [375]). Many others show Poseidon and his consort Amphitrite [409.6].

Around the mid-6th century the figure-decorated vases cease being made in Corinth, though the plaques seem to continue. It is not easy to explain this as the result of Attic competition; indeed plainer Corinthian vases go on being made and exported in quantity, though a declining export market might have helped the decision by some painters to abandon the more elaborate decoration. Other clay objects were still painted, such as little clay altars [410], and we even have evidence for the style as practised on wood on large plaques dedicated in a cave shrine near Sicyon [411], inscribed in Corinthian letters. Maybe mere pottery no longer seemed adequately rewarding for their skills. At any rate, it would be wrong to think that Corinth itself declined in step with the halt in production of figure-decorated vases; except, that is, for profits from specialist pottery export.

Corinth's later production, well into the 5th century and sometimes called LC II, keeps to the old shapes but with minimalist decoration, often with broad plain bands (the White Style). Minor later developments will be mentioned in Chapter 7.

After Corinthian and Attic, other black figure production in the Greek world is by no means an anticlimax, though less prolific.

Laconian

The story of Laconian black figure is largely told in stemmed cups – *kylikes* in common parlance though the name is mainly a convenience reserved for the fine stemmed cups of Attica. Laconian styles of figure drawing are not pretentious but some of the painters are skillful, and despite a rather wooden manner of drawing they display some originality in composition and narrative in the large cup tondos. The vases travelled to the old Laconian colony of Taras (Taranto) in south Italy, but were also well received elsewhere in Italy, especially Etruria, and in north Africa, both in Cyrenaica (east Libya) where there were strong Dorian Spartan connections, and at Naucratis in the Nile delta, where their presence is a compliment to their quality as well as reflecting links with Cyrenaica, whose Greeks were much involved in Egyptian affairs in the 6th century. There is also much on Samos, with which Sparta seems to have had an old alliance (but none

on neighbouring Chios although the island's vase painters copied Laconian [316]). Styles closely comparable with Laconian seem to have been practised elsewhere in the west Peloponnese, in Elis and at Olympia. The series of black figure vases runs on into the last quarter of the 6th century; these are Laconian III and IV in the terms of the apparent stratigraphy and styles found at the Artemis Orthia sanctuary at Sparta, but the sequence of decorated vases is better understood now in terms of the painters and their interrelationships.

From about the 570s the cups grow tall stems, like the Attic Little Master cups (*ABFH* 58ff.), but the general form still owes much to the example of Corinth and East Greece. By this time it is probably pointless to try to assign major sources of influence for the shapes; this is simply a period in which the Greek drinking cup acquires a new elegance of form, with a tall stem and a broader, relatively shallower bowl. While the earlier development can be traced readily back to Geometric skyphoi, the new cups are more like shallow, straight rimmed eastern bowls and phialai, supplied with feet and handles in the usual Greek manner. The transition is less a matter of natural evolution of forms and probably more one of choice by individual potters who popularize local variants which may then, in some details, be taken up elsewhere. Thus, later Laconian cups with a concave rim and grooved top to the stem are related to the Attic Droop cup (540s on; *ABFH* 61–2) without it being at all clear in which direction the form passed. Laconian cup lips are usually plain but for rim stripes, though some have florals or pomegranate nets. Stiff tennis-racket palmettes or lotuses, often plain black, project from handle bases, and between them may be the characteristic Laconian pomegranate friezes or spiky lotuses and buds. The lower bowl may also have pattern bands and even animal friezes, and the stem may carry grooves or reserved lines. Attic and Ionian cups were more austere in these areas. Inside, the lip is usually black and the whole bowl devoted to a figure scene, occasionally in concentric friezes, or a whirligig, or in registers with an exergue [414], or even divided with two scenes back-to-back [419]. As time passed less of the interior may be decorated, following the Attic fashion of relatively small tondos, and then the lip within may have pomegranates or spiky lotuses. The black florals are as characteristic of the ware as the incised and coloured.

Of other figure-decorated shapes the hydria is the most important – a heavy, imposing form, mainly early and favouring animal friezes and many pattern bands [424–5]; few amphorae of Corinthian type with bulbous lips [412]; distinctive column craters with straps rising from handles to rim (the stirrup craters) which we have noted briefly in Corinth and are related to volute craters [436]. There are also some flat-bottomed aryballoi, oinochoai, plates and lakainai, the local shape we encountered in Chapter 4 [218]. A number of these retain the old Laconian patterns such as the rows of squares and dots. The vases continue to carry at first a white slip which is in time abandoned. Added colour on figures is exclusively red (purple) not white, which is surprising.

The process of identification of the major painters has gone through some vicissitudes but the differences are relatively unimportant. Other painters worked beside the big names and stylistic identities are slightly more difficult to grasp than in Attic.

The Naucratis Painter worked within the second quarter of the century, to judge by style and contexts with Corinthian. He has Corinthianizing animals, also on shapes other than cups [412], and big-figure tondi [415] beside which the symposion circle of [413] and the tiered composition of [414] look exceptional. The armless Zeus with his eagle is odd [415] and might reflect the form of a primitive statue. There are several other cups by various painters which show a deity seated and approached, as [434], many of them from sanctuaries and probably made deliberately as votives.

The Boreads Painter (*alias* Hephaistos Painter) is a major contemporary, freer with colour on his ornament, which can take some original turns [416]. On his name vase we meet the pomegranates bordering the tondo [417] (a feature the Chians copied [316]). On [*Frontispiece*] he turns an heraldic scheme effectively to the service of myth by dismounting Bellerophon to spear the Chimaera. The Naucratis Painter had used the same scheme for an anonymous hero between two rearing horses. The odd composition of [419] presents a conventional Return of Hephaistos and an anonymous man with a lion (Admetos is suspected). Note, from the former scene, that Laconian satyrs have no tails (the naked figure is unlikely to be Dionysos).

The Arkesilas Painter is more interesting, working little before the mid-century; interesting for his style, subjects and historically. His name vase [420] shows the King of Cyrene, wearing his African sunhat, supervising the weighing and stacking of wool (probably) under an awning infested by monkeys. The temptation to identify here the important Cyrenaic crop, *silphion*, is probably to be resisted. The way the bales are being stacked in the exergue recalls Egyptian scenes. This vase, and another Laconian painter's picture of a woman, probably the nymph Cyrene, wrestling a lion, gave rise to the idea that all these vases were made in Cyrenaica, a mistake corrected by excavations in Sparta. But Sparta had a connection with north Africa, as the exports show, and this was reflected by this travelled artist on a vase which went to Italy. The fragment [421] is from Samos; it reverts to the symposion with demons theme of [413–4] and allows outline flesh for women. This is a Corinthian practice and necessary where white paint was not used in figure scenes, as it was in Athens. There are problems on [423] too. The pair of warriors being pursued have outlined legs and blank faces. Are they Amazons? – is this Heracles seizing an Amazon belt? (The answers are probably yes, no.) On [422] the two juxtaposed scenes are set at opposite ends of the world, as then known: Atlas in the far west, Prometheus in the Caucasus, both figures being Titans.

The Hunt Painter took a very original view of the world. He worked mainly in the third quarter of the century. His mythological scenes may carry names of

protagonists, as on one of his fine hydriae [424]; other Laconian painters do not advertise their literacy. His tondos are mainly myth, but also everyday life (and death [428]). The best take a porthole view of a frieze, chopping off figures like a pastry-cutter [426–8]. That he was well aware that his picture was but an excerpt might lead one to think that the fuller composition must have existed somewhere, but it may only have been in his head. The effect is impressive; on [427] Hermes and Heracles are allowed less than a leg and an arm each, while the focus is on a splendid Kerberos. Other scenes are more traditionally composed within the circle, and distinctive fat fish and birds attend in exergues or elsewhere. Many of his lesser works are occupied with komasts who probably derive from Corinth but are generally better dressed [429].

The Rider Painter is a contemporary but lesser artist though the focus of a large and prolific group and iconographically interesting [430–3]. The Polyphemus scene is familiar to us by now [430]; here the proffered cup explains how the giant was immobilized, the legs he holds show him a cannibal, yet the blinding proceeds without regard to exact unities of time and action: a normal practice in archaic Greek narrative and very well demonstrated here. The cavaliers [432] are attended by winged figures, like the symposiasts [413–4, 421], and it might be that in both settings they carry some reference to heroized dead, though this seems an odd subject for this type of vase, which was not retained for home use but freely exported. The dinos [433] is an unusual shape for Laconian; it has also an animal frieze, Heracles fighting centaurs, besides the komasts dancing at a version of a volute crater. There are other Laconian painters, with shorter lists of attributions. I show another deity cup [434] and the name vase of the Typhon Painter with a bristling monster [435].

Overall the drawing style of the Laconian black figure artists must be judged little more than competent. They lacked the colour sense of the Corinthians and the narrative flair of many Athenians. When they try hard they achieve little more than fussiness, but some were capable of compositional innovation and had an original way with subsidiary decoration. Moulded attachments to many vases suggest that they were no little influenced by an important local metal-vase industry, which is strongly suspected. The volute crater, metallic in origin, was known as a 'Laconian crater' and there are good clay relief vases which betray their inspiration in metal.

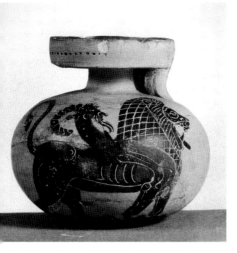

362 Corinthian (EC) aryballos from Camirus by the
Heraldic Lions P. Chimaera. (London, V&A
910.2498)

363.1,2 Corinthian (MC) aryballos. Related to
Liebieghaus Group. Dancers; inscribed *Polyterpos.
'Pyrvias leading the dance; to him an olpa'.* (Corinth
C-54-1; H. 5.3)

363.2

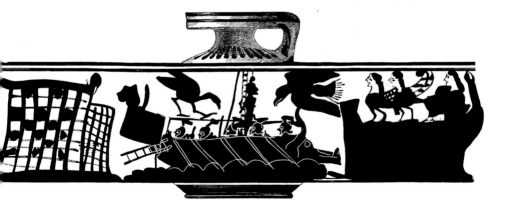

364 Corinthian (LC) aryballos from Boeotia. Odysseus defies the Sirens. (Boston 01.8100; H. 10.2)

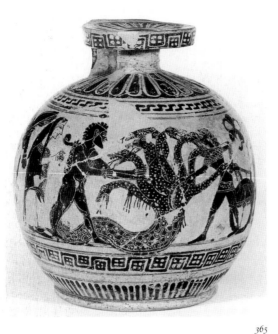

365

369 Corinthian (EC) alabastron from Tocra by the Taucheira P. Mistress of animals. (Tocra 31; H. 33.5)

369

365 Corinthian (MC) aryballos. Athena, Heracles, Iolaos and the Hydra. (Basel BS425; H. 14.7)

366 Corinthian (LC) warrior aryballos. (London market)

367 Corinthian (EC) 'football' aryballos. (Leipzig T318; H. 7)

368 Corinthian (LC) quatrefoil aryballos. (Charterhouse)

366

367

368

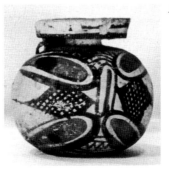

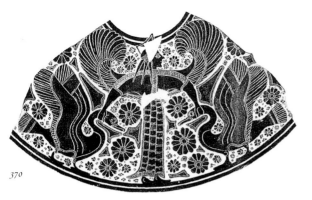

370

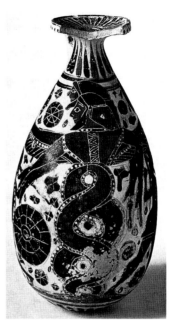

370 Corinthian (EC) alabastron by the Taucheira P. (Delos 451; H. 32.3)

371 Corinthian (EC) alabastron. Luxus Group. (Hamburg 1966.12; H. 20.9)

372.1,2 Corinthian (MC) ring aryballos. (Würzburg H5389; H. 6.8)

373 Corinthian (MC) amphoriskos by the P. of Palermo amphoriskoi. (Basel market; H. 12.8)

374 Corinthian (MC) bottle. (Brussels A3430)

371

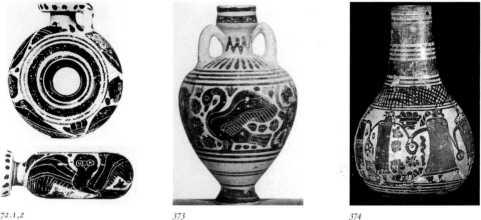

372.1,2 *373* *374*

375 Corinthian (LC) decoration of bottle signed by Timonidas. Priam observes Achilles' ambush of Troilos. Athens 277; H. 14)

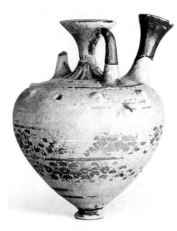

376 Corinthian (MC) stirrup vase.
(London 1970.9-10.2; H. 8.4)

377 Corinthian pyxis (MC). (Athens 908;
H. 17)

378 Corinthian head–pyxis (MC)
by the Stobart P. (San Simeon 5620;
H. 20.1)

379 Corinthian (MC) conical
oinochoe.

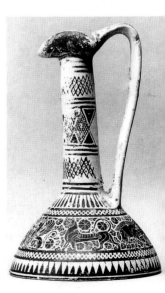

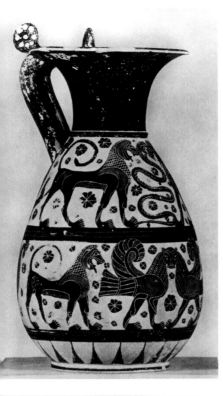

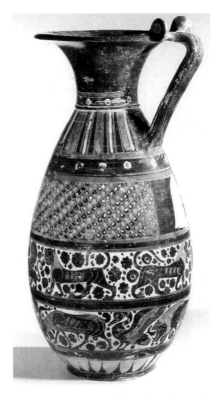

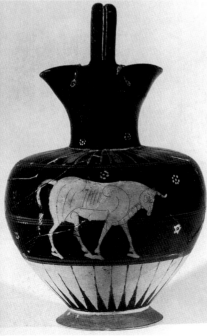

380 Corinthian (EC) olpe from Rhodes by the P. of London A1352. (London 1860.2-1.18; H. 30)

381 Corinthian (MC) olpe. (Swiss market)

382 Corinthian (MC) oinochoe by the White Bull P. (Berlin F1117; H. 25.5)

383 Corinthian (MC) plate from Tocra. (Tocra 306; W. 29.1)

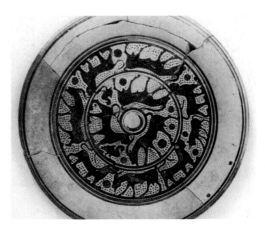

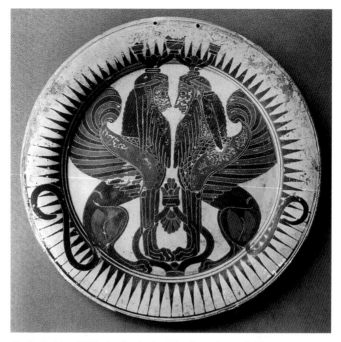

384 Corinthian (MC) plate by the P. of the Copenhagen Sphinxes
(Chimaera Group). (Copenhagen NM 1630; W. 28.3)

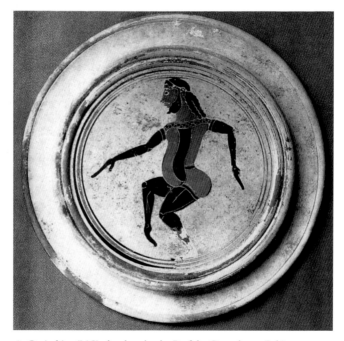

385 Corinthian (MC) plate base by the P. of the Copenhagen Sphinxes
(Chimaera Group). A komast. (Copenhagen NM 1631; W. 28.6)

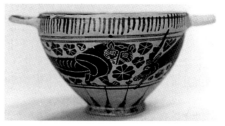

386 Corinthian (EC) exaleiptron (kothon). (Würzburg L118; H. 9.8)

387 Corinthian (EC) kotyle. (London market)

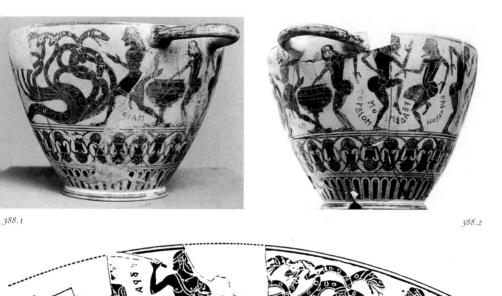

388.1

388.2

388.3

388.1,2,3 Corinthian (MC) kotyle by the Samos P. Heracles and the Hydra; komasts. (Louvre CA3004; H. 12)

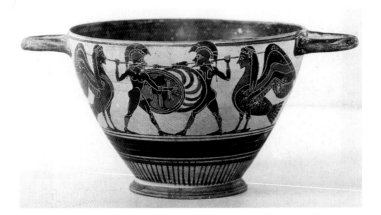

389 Corinthian (MC) kotyle by the
Samos P. (Boston 95.14; H. 9.5)

390 Corinthian (MC) cup. Komasts.
(Oxford 1968.1835; W. 33)

391 Corinthian (MC) cup by the
Cavalcade P. Suicide of Ajax. (Basel
BS1404; W. 20.3)

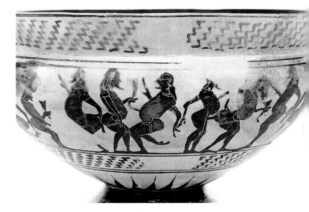

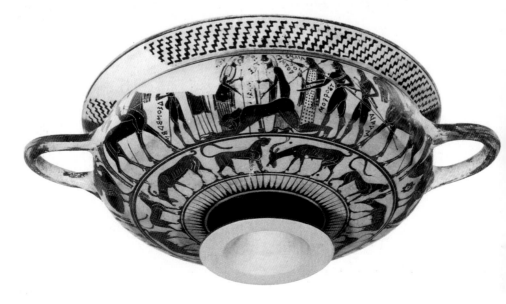

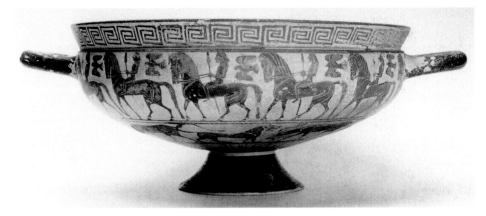

392.1,2 Corinthian (MC) cup by the P. of the Moscow Gorgoneion kylix. (Moscow, Pushkin 1b7; W. 29.7)

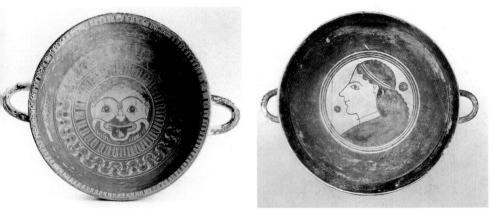

392.2

393.2

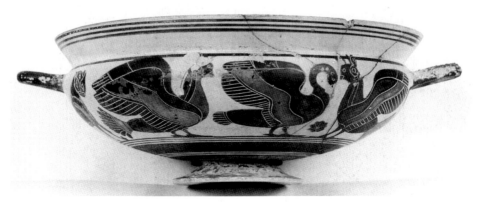

393.1,2 Corinthian (MC) cup by the Medallion P. (Boston 12.422; W. 19)

394 Corinthian (MC) cup interior by the
Klyka P. (Athens 992)

395 Corinthian (MC) lekane from Camirus by the Medallion P.
(London 1861.4–25.46; W. 36.2)

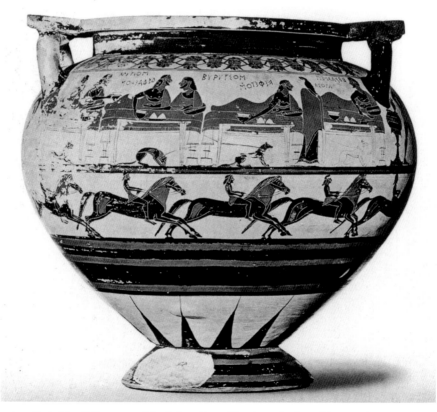

396.1,2 Corinthian (EC) crater, and detail, from Caere. Heracles at the feast of Eurytios. (Louvre E635;
H. 46)

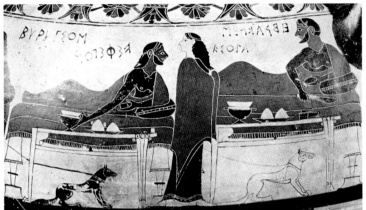

396.2

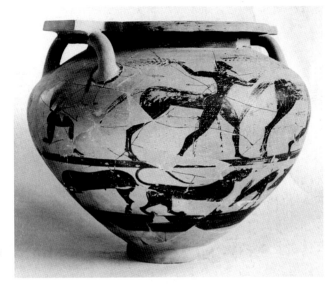

397 Corinthian (MC) crater. Heracles and centaurs. (Corinth C-30-103; H. 37)

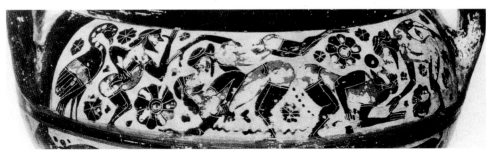

398 Corinthian (MC) crater detail. Komasts. (New York 41.162.79)

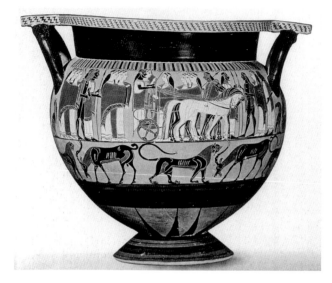

399 Corinthian (LC) red-ground crater from Caere by the Cavalcade P. (Vatican 16448; H. 42.5)

400 Corinthian (LC) red-ground crater detail. Mission of Greek heroes to Troy; Menelaos, Odysseus and Talthybios (herald) greet the priestess Theano. (Vatican, Astarita)

401 Corinthian (LC) red-ground crater by the Amphiaraos P. Departure of Amphiaraos. (Berlin F1655)

402 Corinthian (LC) red-ground crater detail. Heracles rescues Hesione from the *ketos*. (Boston 63.420)

403 Corinthian (LC) red-ground amphora fr. Andromeda Group. Perseus rescues Andromeda from the *ketos*. (Berlin F1652)

404 Corinthian (LC) red-ground amphora detail from Caere by the Tydeus P. Tydeus murders Ismene. (Louvre E640)

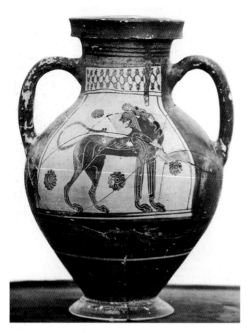

406 Corinthian (LC) red-ground amphora. (London market)

405 Corinthian (MC) red-ground amphora by the Geladakis P. (Corinth C-50-101; H. 31)

407 Corinthian (EC) figure-vase. (Syracuse)

408 Corinthian (EC) figure-vase. Gorgon squatting on a tortoise. (Basel Lu80; H. 21.5)

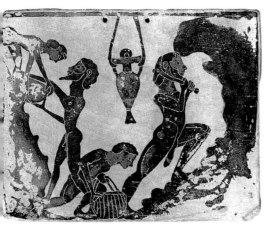

409.1

409.2

409.3

409.4

409.5

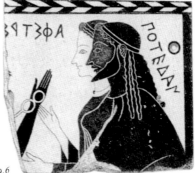

409.6

409.1-6 Corinthian plaque frs. from Penteskoupha.
5 – signed by Timonidas (see [375]) (Berlin F871,
802, 909, 892, 846, 486; H. 10.4, 10.5, 4.5, 9.8, 22,
8.8)

410.1,2 Corinthian altar fr. Later 6th cent. Pygmy and crane; lion. (Corinth MF8953; H. 13.2)

411 Wooden plaque from Pitsa (near Sicyon). Copy. (Athens 16465; H. 32.3)

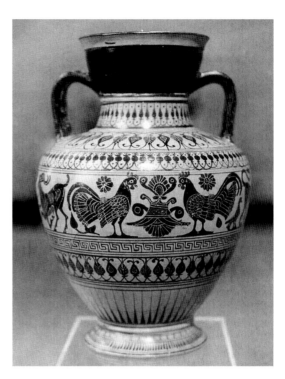

412 Laconian amphora by the Naucratis P.
(Toledo 64.53)

413 Laconian cup by the Naucratis P. (Louvre
E667; W. 22.5)

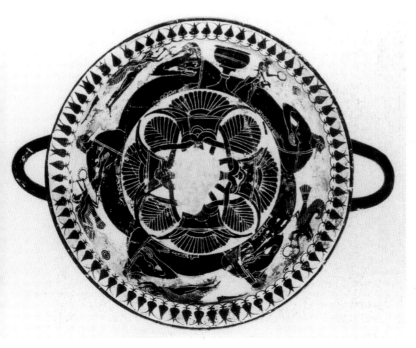

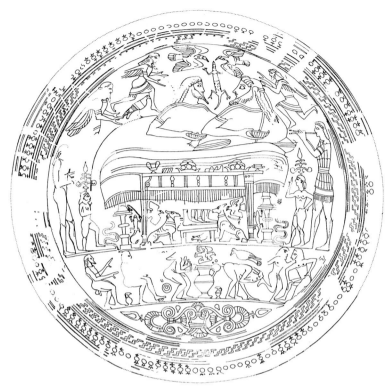

414 Laconian cup by the Naucratis P. (Pratica di Mare E1986 (Lavinium); W. 22.3)

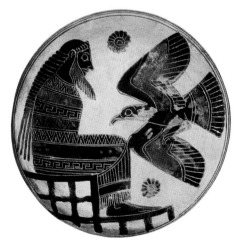

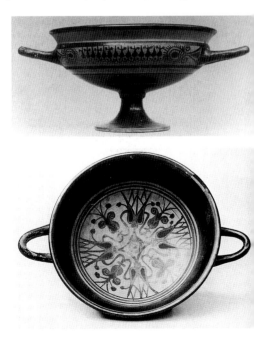

415 Laconian cup by the Naucratis P. Zeus and eagle. (Louvre E668; W. 18)

416.1,2 Laconian cup by the Boreads P. (New York 22.139.77)

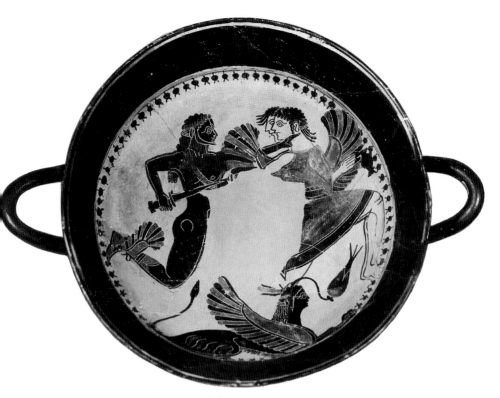

417 Laconian cup by the Boreads P. Boreads and Harpies. (Rome, VG; W. 18.5)

18 Laconian cup by the Boreads P. (Malibu 85.AE.121; 7. 14). See Frontispiece

419 Laconian cup from Ialysus by the Boreads P. Return of Hephaistos; man and lion. (Rhodes 10711; W. 13.5)

420.1,2 Laconian cup from Vulci by the Arkesilas P. Arkesilas. (Paris, Cab. Med. 189; W. 29)

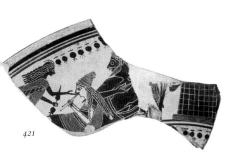

421

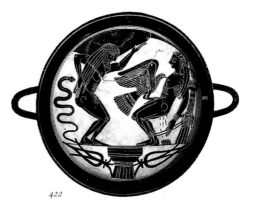

422

421 Laconian cup fr. from Samos by the Arkesilas P.
(Berlin 478x)

422 Laconian cup from Caere by the Arkesilas P.
Atlas supports the heavens; Prometheus attacked by
Zeus' eagle. (Vatican 16592)

423 Laconian cup by the Arkesilas P. Heracles and
Amazons (?) (Rome, private; H. 19)

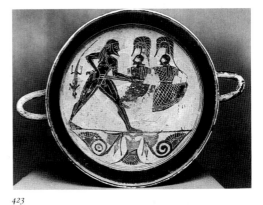

423

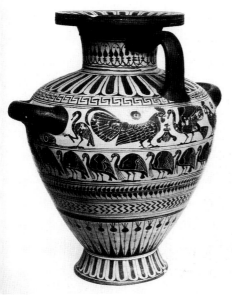

424 Laconian hydria detail by the Hunt P. (Rhodes
15373)

425 Laconian hydria from Vulci. Manner of the Hunt
P. (London B58; H. 39.5)

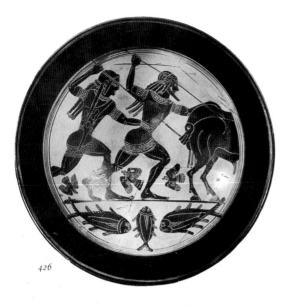

426

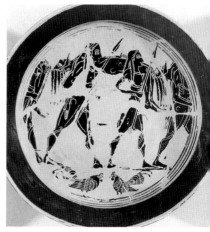

426 Laconian cup by the Hunt P. (Louvre E670; W. 19.5)

427 Laconian cup by the Hunt P. Kerberos (with Hermes and Heracles). (London, Erskine; W. 19)

428 Laconian cup by the Hunt P. (Berlin 3404; W. 15)

428

427

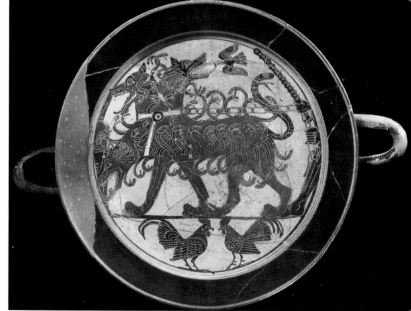

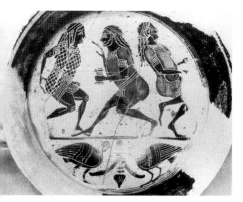

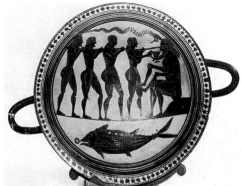

429 Laconian cup by the Hunt P. Komasts. (Florence 3879)

430 Laconian cup by the Rider P. Blinding of Polyphemus. (Paris, Cab. Med. 190; W. 21.4)

431 Laconian cup by the Rider P. Kadmos. (Louvre E669; W. 18)

432 Laconian cup by the Rider P. (London B1; W. 23.2)

433 Laconian dinos detail by the Rider P. (Louvre E662)

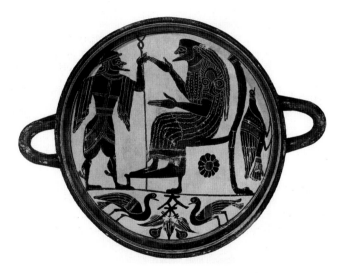

434 Laconian cup by the Chimaera P. Hermes before Zeus. (Kassel T354)

435 Laconian cup by the Typhon P. Typhon. (Cerveteri 67658)

436 Laconian stirrup crater. (Louvre E691; H. 40)

Sparta itself was an austere place, by all accounts, at least in the way of life of its citizens, the Spartiates. They were dependent wholly on a servile class of defeated neighbours (Helots), sustained by a rigid military regime and a support group of immigrant metics and *perioikoi* (dwellers-around). The figure-decorated pottery of Sparta can be seen to provide only a very limited range of desirable crockery, and its decoration seems very much at variance with what we read about Spartan life in antiquity – 'Spartan' in life style, 'laconic' in speech. Many vases were exported, no doubt taking advantage of commercial and other links with old colonies (Taras), Samos and north Africa, and indicating the enterprise of potters and merchants, but there were good pieces also placed for dedication in Sparta's local temples. There is some evidence, in other arts too (sculpture, architecture, bronzes), for immigrant craftsmen capable of work of high quality, matching anything from other Greek cities, and the assumption is that the true Spartiate was too proud or inhibited to express any feeling for crafts or be moved to practise them. This is not easy to believe, and it is more likely that we are here at the mercy of a reputation exaggerated in the telling (in antiquity), that obscures the otherwise fairly normal life of most or much of archaic Sparta. It is not that our two sources, texts and archaeology, tell radically different stories, but that each tells only part of a story which is coherent and plausible and must be reconstructed to accommodate the positive rather than the negative evidence from all sources.

It might be noted here that there was a considerable Laconian production of plain black vases, at best decorated with red or white lines and trivial friezes, and that these include big pots, such as the stirrup craters [436] as well as the usual Laconian shapes and aryballoi, spherical and flat-bottomed. There seems to be a higher proportion of such vases from archaic Sparta than of comparable plain wares from Athens or Corinth, and they are of high quality so far as the potting goes; perhaps these served the more austere tastes of some at home, but they were exported in numbers too. There is also from the main studios a number of small cups (12–13 cm across) decorated in the usual black figure manner. These have been thought appropriate for non-citizens, who, it seems to me, might deserve less decorative cups rather than smaller ones.

Boeotian

The 6th-century cemeteries of Boeotia have been prolific and stocked the shelves of many museums, but few have been professionally excavated. Exceptions are Rhitsona (ancient Mykalessos) and Akraiphia. Masterpieces are in short supply from these sites: 'Rhitsona, like *retsina*, is mainly a matter of taste', commented Payne, cruelly, since the publications were excellent, which is what matters. But the identification of Boeotian black figure depends much on alleged provenances. In the sixth century there was nothing like a Boeotian League of towns, and any common features that we may think to discern in their crafts are

probably to be judged in the same terms as we might their common dialect and spelling habits. For the pottery, more might be done with clay analysis and there are visual clues in both clay colour and style, but there has been a tendency to label any rather shaky black figure as Boeotian, which cannot always be right, and there is much which is not quite pure Attic or Corinthian that might be Boeotian but might as easily be from elsewhere in central Greece or Euboea. Continuity of practice does not help much (as it will in Euboea) since we have seen that some potters were prepared to maintain an Orientalizing mode through the 6th-century [233], and the earliest black figure is so wholly dependent on Attic, and to a lesser degree (shape) Corinth, that we can never be sure whether we are dealing with some sort of provincial Attic or the work of immigrants. Several early 6th-century vases said to be from Boeotia look like provincial Attic of the sort also represented among Acropolis dedications. They resemble the styles practised by the Athenian Gorgon Painter and his followers [437] and we cannot be quite sure that they were made in Boeotia. At least one artist, however, who was prolific, can be proved to have worked in Athens, where we call him the Painter of the Dresden Lekanis. In Boeotia he becomes the Horse-Bird Painter [438], painting alabastra, round aryballoi and tripod-kothons, mainly Corinthian shapes, while in Athens his shape preferences were different (*ABFH* 19, fig.32), but we do not know whether he was his own potter. This may have been a time of social unrest in Athens, which could have encouraged craftsmen to leave home, but it overlaps a period of apparent immigration to Athens of potter/painters *from* Corinth. Another probable immigrant from Athens is the Tocra Painter whose work is so far only known from a batch exported to Tocra in north Africa, but which seems of Boeotian origin to judge from appearance and analysis of clay. His cups are the Attic 'Siana' shape, his tondo animals Corinthianizing, drawn with care and distinctively precise coloration [439]. At the end of the century Teisias made some fine plain kantharoi and skyphoi, signing himself 'Athenian' since he was working away from home [440].

Many other Boeotian vases, mainly kantharoi and tripod kothons, carry engaging scenes in what looks a slightly comic but lively style. There are many komasts [441–2, 444], giving rise to a so-called Dancers Group, an occasional satyr [445], some odd juxtapositions of stock figures [443] and unusual myth scenes. On [446] Theseus dispatches the Minotaur while Ariadne attends, and rows of Athenian boys and girls await their rescue in two tiers. The flier on the back has been thought to be Icarus but the horseman is more prominent, perhaps with a demon escort. One of the poorer artists leaves us his name, Gamedes, on an odd oinochoe [447]. Polon created some unusual figure-vases [448]. These vessels, a very rustic menagerie, seem a speciality of the area [449]. Other inscriptions on Boeotian vases are few, but include some *kalos* names praising youths, as in Attic. Most of them are of the second and third quarters of the century. A distinct class of mainly miniature vases of the mid-century are decorated with silhouette

figures; better called 'Early Silhouette' than 'Geometricizing'. They are thought to have been made at Koronea. [450] is one of the larger and more elaborate.

The most important shapes favoured for black figure in Boeotia are the kantharos, associated in myth with Dionysos and with Heracles (who was born in Boeotian Thebes and 'died' not far away), and what we call a lekane, a heavy, vertical-rimmed dish, sometimes lidded, which was also popular in Athens, though without such a long black figure career. Its popularity must depend on its function. If a table dish this would have been for something like beans or stew, but it would be a mistake to explain ancient eating behaviour in terms of our own. Its predecessors include Geometric dishes [63] and much later successors seem to have been women's toilet ware.

The main series of black figure lekanai belongs to the third quarter of the 6th century and the foremost painters are the Protome and Triton Painters [451–2]. The vases carry animal friezes, rather like the Attic ones by Lydos and his followers, but the fill is most often a variety of linear devices rather than incised rosettes. There are small tondos within, with figures (animal protomes sometimes for the Protome Painter).

In the second half of the century there is more atticizing work, notably on skyphoi. There are some technical tricks, as on the black polychrome [453]. Fairly early (third quarter) is the Camel Painter (a Bactrian! [454]), once thought Attic, and later there are large skyphoi with gorgoneia [455]. The many late Attic skyphoi imported may have encouraged imitation, and well into the 5th century there are cups with black figure, some hardly more than silhouette, of the same inspiration [456]. The skyphos [457] reverts to the old shape but in the late silhouette style and offers a naive picture of work in the pottery, a man squatting at the wheel, another strung up and being chastised.

The Boeotian townsfolk seem to have liked figure-decorated vases but their potters somehow failed to create any local idiom of any quality, their shape range was limited (few big mixing vases), and there was throughout an enormous import of second- or third-rate Corinthian and Attic. But the interest was maintained well into the 4th century, as we shall see.

Euboean

Black figure in the island of Euboea places us on surer ground, at least for ERETRIA where there are copious finds, readily identifiable local preferences, and continuity of practice with the 7th century which guarantees local production. After the latest Corinthianizing grave amphorae [227], Attic black figure is the main source of inspiration but no immigrants are suspected, at least in the early stages, although the Athenian tyrant Pisistratus moved his court there for a while in the mid-century, and the city's fortunes were to be closely linked with Athens.

Of central importance are three big grave amphorae, decorated on neck, body and foot. They derive from the 7th-century shapes [225–7] but are given conical lids and upright handles which bring them close to the Attic type of *lebes gamikos*. Since two of the three have wedding scenes on them it looks as though the wedding-death association may already be expressed here in art, though the vases may not have been intended for the grave from the start. They were used, as were the earlier Eretrian amphorae, for the burial of infants, whose only marriage was to be with Hades. The earliest [458] has a Judgement of Paris on the neck, a divine wedding on the body. It also introduces other Eretrian specialities: as little incision as possible on figures, in the florals the regular use of white placed directly on the clay (not over black) for the lotus sepals, and the rows of bulls in the animal friezes. The second vase has another divine wedding, names inscribed (Peleus and Thetis); the third Heracles and the Hydra [459].

The big amphorae lead us to other shapes of the usual Attic repertoire, but exhibiting the whitened florals, innocence of incision, rows of bulls and the like. There are hydriae [460], amphorae [461] and plates [462–4]. All look like adjusted Attic black figure but there are also some in a somewhat wilder style: a belly amphora with a satyr molesting a deer, and a heavy amphora with vertical handles at the shoulder (like a stamnos) with demons and a Heracles with centaurs [465]. These deviate from conventional black figure, rather as much Boeotian did but on more ambitious shapes and must be Euboean, if not Eretrian.

Analysis and some of the stylistic hallmarks indicate that a number of the lekythoi of the Dolphin Class, formerly regarded as Attic, are Euboean. Since clays cannot yet be distinguished it is always possible that these, or others mentioned here, were made in the other major Euboean city, CHALCIS. Her colonists in the west, we shall find, have more to offer which seems not to reflect on possible mother-city styles of the 6th century. Eretria at least emerges as a town with a continuing interest in making its own figure-decorated pottery, in the hands of craftsmen who can display some originality.

Other Greek

In the Cyclades ANDROS has yielded a group of alabastra with rather cylindrical bodies which may be local products [466] and we have seen how elsewhere in the islands some Orientalizing series end in the 6th century with real black figure without creating wholly new styles, as did East Greece (last chapter). THASOS, always quick to imitate others, is the source of a number of lekanai which are not unlike Boeotian but sometimes offer two rows of animals, not the usual one, and of late black figure plates with more ambitious figure scenes, resembling Attic [467]. There are also imitations of Chian black figure. Athenian occupation of ELAEUS, at the Dardanelles opposite Troy, resulted in local production of simple, silhouette lekanai (*GO* fig. 310).

The Western Greeks

We have seen how in the 7th century the Western Greek colonies adopted Orientalizing decoration for pottery in a fairly homogeneous outlining style in which the principal influences seem to have been Argos and East Greece rather than Corinth. The record of locally produced figure-decorated pottery in the 6th century is far simpler and largely a question of one major school flourishing through the second half of the century. This is the CHALCIDIAN, which is not a misnomer although it was first applied under the misconception that the pottery was made in homeland Chalcis (Euboea) because the inscriptions on some of the vases were in Chalcidian script. But the finds were all in the west, and it has become clear that the vases were also made in the west, presumably by Chalcidians, from around the mid-6th century to about its end. For a while a Greek studio working in Etruria was postulated as the origin, but that would not explain the amount found in South Italy, where the only Etruscan vases which arrived in any number were of black bucchero, perhaps as curiosities or in the hands of Etruscans who were used to them. The finer, painted Etruscan wares did not travel south into areas well used to the Greek pottery types that had inspired them, while the bucchero was novel. The Chalcidian colony at Rhegion (Reggio) at the toe of Italy seems a likely source, and although clay analysis has yet to prove this, it at least shows that the clay is not Euboean. It is sometimes thought that the potters who started the production in the west came from Chalcis itself, but there is nothing in Euboea to suggest that what we now call Chalcidian black figure was born there, and the various influences in terms of shapes and decoration are better explained by exposure to the wares most commonly imported in the west – Corinthian, Attic and East Greek. The incentive to start local production must be credited to a gifted western Chalcidian potter and/or painter who was inspired to emulate the imported wares and corner some of the local and Etruscan market. This he did success- fully, although he had relatively few companions and followers and production was not great. The quality was high and the prices probably much cheaper than the marked-up imports. The painter was the Inscription Painter, who was highly literate, as his sobriquet suggests, and capable of what seems to be original inven- tion in the interpretation of Greek myth ignored by vase painters elsewhere. This seems a case where the inspiration and imagination of an individual artist explains the genesis of a major class of pottery, rather than any special needs of a community well used to imported vases of varying quality, including the best.

The commonest shapes in Chalcidian are neck amphora and hydria, with few belly amphorae usually decorated in panels, and sometimes with an angle in the profile at the shoulder and a separate figure frieze above it [481]. The stirrup crater shape is borrowed from Corinth [476], and sometimes called 'Chalcidian', but also the ordinary column crater. There are lipless cups, like the Attic eye cup, some of which have low splaying feet like the base of a column [480]. This was

a shape also met in Athens but probably devised in the west; Athenian potters were awake to shapes familiar in their western markets (*ABFH* fig.176) and in this case also picked up some Chalcidian decorative traits along with the new cup shape. In the same spirit the Chalcidian copied an Etruscan deep cup shape [478]. Skyphoi have vertical walls and the handles are sometimes knobbed [482]. Psykters (wine-coolers) take the Corinthian form of double-walled amphorae with shoulder spouts for the wine in the outer cavity [477].

The potters had access to good clay, the refined slip of which fired a rich brown/black, enhanced by being applied on the better vases in more than one coat often leaving a paler border strip on black masses. With time, the thicker 'relief line' used by Attic painters is employed. Red and white is disposed generously, rather in the Corinthian manner, but not fussily. The white on black for women's flesh often leaves the outline black, unlike Attic, but the Inscription Painter can also apply white on the clay within an outline [473, 477]. Figure profiles are supple and recall Ionian art (whence Etruscan, which may have helped their popularity) in outlines of body and head, while incision is restrained. There is a small range of supplementary decoration – step patterns from Corinth, conventional lotus and palmette chains in which the lotus is regularly stretched, but the common lotus and bud friezes have bulbous bases to the flowers/buds making them look like roses; this is a hallmark of Chalcidian. The black necks of amphorae, hydriae and craters often carry wavy red lines, sometimes red and white dot rosettes, like Corinthian. Oinochoe shoulders have rows of big ivy or incised rosettes.

The Inscription Painter, founder of the school, introduces virtually all the shapes to be accepted including the Chalcidian cup and the copy of Etruscan deep cups. He is likely to be the potter too. He is prolific with inscriptions, and this seems to go with a considerable iconographic originality. We owe to him a unique scene of Heracles attacking a winged Geryon [468], the wings being a western additive, observed also by a western poet (Stesichorus) and probably of Ionian inspiration; a unique death of Achilles [469], his body fought over by the two sides, while Diomedes is being patched up in the wings, all supervised by a splendid Athena wearing a really wicked snaky aegis; a unique Perseus receiving his kit (cap of darkness, winged shoes and bag for the Gorgon's head – *kibisis*) from the nymphs [470]; a most unusual wrestling match between Peleus and the lady huntress Atalanta [473], with the Calydonian boar spoils behind them, probably a variant on the usual story of how they were awarded; a unique Zeus fighting Typhon on the same vase; Helen with Paris, Andromache with Hector [474], in a pre-battle farewell scene at Troy that owes nothing to Homer; a unique and more Homeric slaughter of the sleeping Rhesos and his men, and theft of their horses by Odysseus and Diomedes [475]; and other myth scenes presented in a manner that owes little or nothing to the example of the homeland schools. His animals are taut and decorative and even his satyrs and maenads dance with a realistic, not copybook verve [472, 477]; the satyrs have horse hoofs, like Ionians.

This, I feel, is an Artist with a capital A, one of the very few of such merit in this book, and for quality and invention to match the best Athenians.

The succession is not altogether an anticlimax. The Phineus Painter offers a blind Phineus, his dinner spoilt and the thieving Harpies being chased by the sons of Boreas; beside this mythical bustle satyrs ambush bathing nymphs behind Dionysos' chariot, drawn by lions and stags [479]. This cup was valued enough in antiquity to be mended, and re-mended. The painter specializes in cups, skyphoi, oinochoai and neck amphorae, logically adding ears, human or animal (a satyr's) to the eyes on cups, making them look even more like masks [480]. But most of his vases have animals and monsters only, sometimes composed around a floral interlace of palmettes and buds. This is true of most of the rest of the work of the Chalcidian painters although there is a goodly range of myth, but they are the last worthy exponents of the animal frieze style which had heralded Orientalizing decoration on vases a hundred and fifty years earlier.

There are two late subsidiary groups, 'pseudo-Chalcidian', the Memnon Group and the Polyphemus Group, producing neck amphorae clearly related to the main series but poorer and derivative [483–4]. They are better represented in Etruria than in the south and their clay differs from true Chalcidian but has something in common with Etruscan clays, so it is just possible that a Chalcidian or two from Rhegion did move north to serve the market.

In Greek areas of Italy there is nothing else of note except the Hyblaea Class of late small neck amphorae, once thought Attic, but probably made in Sicily, where there was massive import of late Attic black figure, but the possibility of some small-scale local production in other colonies cannot be discounted. Greek black figure was influential not only in Etruria but to the south, in Campania, and at Taras, while elements of the style and technique penetrated other native areas. There are many good black figure vases, generally not excavated but of probable Italian provenance (since they are complete, often an indication of finding in a built tomb, whether underground or not, which is not a characteristic of Greece itself) which are not readily assigned to any of the recognised schools.

Etruria

The activity of Greek potter/painters in Etruria and for the Etruscan market has been documented in earlier chapters from the Geometric period on. It seems mainly to have been a matter of Greek enterprise from the various western colonies, and if 'pseudo-Chalcidian' was indeed made in Etruria, we can see that the practice continued into the 6th century. The figure decoration on the walls of Etruscan tombs from the mid-7th century on had also been dictated by Greek styles, whether or not Greek hands were at work on them. The Etruscans themselves made and decorated painted pottery with Greek and local shapes and with mainly Greek decoration adapted to Etruscan taste which, in these matters, had

been wholly formed by Greek example. A few subsidiary patterns derive from Phoenician art which was more influential in the luxury crafts. When we meet the work of a single hand, as that of the Swallow Painter who made Wild Goat vases in Etruria around 600 BC, we cannot tell whether he was a Greek from the west or the homeland; nor does it much matter. But once distinctive Etruscan hellenizing styles are established (mainly the Etrusco-Corinthian), we have to look for other explanations for any apparently pure Greek-style pottery made in Etruria. The stylistic judgements used to detect them are not wholly subjective but the probable sources need to be defined. What we observe is generally the operation for a limited period of a very few (sometimes only one) potter/paint-ers providing Greek pottery within Etruria itself. If any of these immigrant styles are longer-lived we may suspect that the craftsmen who produced them need no longer have been Greeks, but they had been trained in a Greek tradition and their ancestry (which may well have been mixed) is on the whole irrelevant. And, of course, what they make contributes to the visual experience of their customers and helps form and adjust an Etruscan tradition in vase painting. In black figure we are dealing almost exclusively with pottery of East Greek inspira-tion. From the 540s on East Greece was being pressed and absorbed by Persia, and emigration west was seen to be a desirable escape. This certainly accounts for heavy Ionian influence in the arts of mainland Greece and Italy, but it should be remembered that, before the Persians, the Lydians posed a similar threat, that the Swallow Painter may have come from the east, and that the influence of East Greek art in Etruria began around 600 BC.

The NORTHAMPTON GROUP comprises small neck amphorae and one belly amphora from Etruria, of around and after 540 BC [485–6], decorated in a very fine and colourful manner with features which relate closely to north Ionian black figure [340–51]. Very similar vases are known in the east, from the Black Sea, and one dedicated at Karnak in Egypt – appropriately, for its subject, which is best shown here though surely made in the east [487]: the carriage of a Dionysos ship matches the local Egyptian festival carriage of the boat of Amun. These must represent homeland production of the same school. The name piece [485] – the 'Northampton Vase', once at Castle Ashby – has a different clay analy-sis from the Karnak one, but is related to the clay of another western group, the Caeretan Hydriae (see below). The Northampton Vase is justly regarded as a masterpiece of Greek potting and painting. Its use of colour recalls Clazomenian but there is also real decorative flair in composition and miniaturist drawing. Notice the coloration, the satyr physique (some with hoofs) and the supple figure outlines and round heads.

Closely related are two big hydriae: the Ricci hydria [488], with a scene of Athena or Hebe leading Heracles to her chariot, done in a very Ionian manner, and on the shoulder a detailed study of the preparations for a sacrifice to Dionysos. The other has a centauromachy and stag hunt. The painter of these also made most of the mainly later GROUP OF CAMPANA DINOI [489], in

which a second painter was also involved [490–2]. These pose the question of whether they represent a later stage of work in the 'Northampton' pottery, or are a separate immigrant phenomenon, or even made by local imitators. Some believe that all were imported from Greece but their clay tells against this.

CAMPANA HYDRIAE, with round bodies and animal friezes which have a touch of the Boeotian/Euboean about them [493], seem from their clay and sources to have been made in Etruria, in this case by immigrants from mainland Greece. Where we find that stylistic and shape parallels to work in Greece are so close, we can never be quite sure that we are not dealing with imports, and have to rely on clay analysis in which, in this area, total confidence cannot yet be placed.

With the CAERETAN HYDRIAE we are on more certain ground and all the indications are that they were made by immigrant East Greek painter/potters at Caere in Etruria, in the last thirty years of the 6th century [494–9]. The clay has not been certainly matched yet, though it is like the Northampton Vase. The style is wholly Ionian and they are perhaps the most colourful and entertaining of all Greek painted pottery, possibly because, as we shall see, they derive from a painting tradition which was not created for pottery at all. They are all plump, slightly shouldered hydriae, with a few other shapes done more simply and without figures.

A most thorough study of them has shown that they are the work of two masters (brothers?) with assistants, some to do the ornament, though there are those who continue to believe that one man may be responsible for them all. The decorative bands on the vases are no less distinctive than the figure drawing. Strips of tongues at various places on the vases are big and colourful. The lotus and palmette friezes are bigger and bolder than any seen on other Greek work. The same is true of the ivy, and for this it has been shown that the painters used templates to ensure regularity in the size and shape of the big leaves. The technique is not one observed elsewhere on Greek pottery yet it was as revolutionary and potentially valuable as the multiple brush-compass had been centuries before. The figure style is Ionian for the shape and detail of heads and the flowing figure outlines. Men are black, women white, as usual, but some men can be white or red, and some women red. This flexibility in the interests of a lively polychromy was in part presaged by Corinthian painters (LC) and has been observed in East Greece too. There are various shades of red as well as a variety of yellow and cream. Bold outline incision is used to help define the figures, a practice not in regular use elsewhere until this period (on Attic vases).

The iconography is rich, much of it in line with what other Greek vase painting has led us to expect, but much also highly original and possibly revealing East Greek traditions which, as already noted, were inadequately recorded for us at home through an aversion to much narrative decoration on pottery. Thus, the Heracles and Hydra [494] and the Return of Hephaistos [495] are composed in the conventional way. But on [496] the magnificent sea-monster (ketos), marine

life and anonymous hero are an original conception, and on [497] there is the finest Kerberos in Greek art being delivered by Heracles to Eurystheus, cowering in a pot, a motif reserved elsewhere in Greek art for Heracles' delivery of the Boar to him, but splendidly appropriate here. On [499] Heracles dealing with the Egyptian servants of King Busiris, who intended to sacrifice the hero, is unlike the usual Greek treatment in that the hero picks up and tramples on his adversaries in just the way a Pharaoh treats his enemies on Egyptian reliefs. On the back of the vase Nubian blacks hurry to assist their weaker, paler-skinned companions. This awareness of Egyptian iconographical conventions is not unique in Greek 6th-century art, but on a Caeretan hydria it evokes other considerations which concern the origins of the style. There are no vases like these in Ionia yet their Ionian character is unmistakable. The closest we come to it in the east is on a painted wooden plaque from Saqqara in Egypt [500] which must be the work of an immigrant Greek in a country where we have seen the products of Greek potters already at this date. The artist must have been a companion of the Caeretan painters, also an émigré from home, not necessarily en route for Etruria, of course, but hinting that such painting was practised at home on panel or wall and only adapted to pottery in Etruria where there was a market for such colourful Greek ware.

Finally, there are the PONTIC vases. These begin before 550 BC and continue to the end of the century as an essentially Etruscan school. But the probability is that they were initiated by another Greek immigrant from Ionia since their style is pure Ionian, figures and animals, and there is nothing in the local pottery production to explain their appearance unless they were introduced from outside. Most are neck amphorae, following the model of the Attic 'Tyrrhenian' amphorae which were themselves designed for the Etruscan market (ABFH 36f.). The Pontic are similar in providing colour, myth and animal friezes. The later range of shapes is wider and more observant of Etruscan needs. I show just one of the early examples [501] to demonstrate the Greekness of the style and its relationship to the later Ionian work we have just discussed. Notice the big patterns of squares, which were an Anatolian speciality, and the richness of colour. They were at first called Pontic because some (relatively late specimens) were observed to show Scythian horsemen and it was thought that only Greeks of the Black Sea (Pontus) could have known them. They have a direct effect on the styles of native Etruscan black figure, which continues well into the 5th century.

Black figure is a strange technique for vase painting. It depends on a clearly defined silhouette against a pale ground, and finely incised linear detail. Polychromy was an occasional additive, probably inspired by painting on other surfaces, often at a greater scale. It made individual figures more expressive and identifiable through dress and attribute, but it belonged to a period in which Greek art in general still relied on pose and gesture to convey action and

emotion, and it did not lend itself to changing that convention in the direction of anything more realistic. This was to depend on work with the brush, rather than the graver, a technique that had also been practised on vases in the 7th century, but without leading to any breakthrough in expression. Instead, the painters eventually surrendered to black figure. That the technique pervaded the whole Greek world in the 6th century, and was copied outside it (in Italy), is an indication of the close awareness of Greek craftsmen of developments in other parts of Greece, and the volume of trade in pottery that ensured that the really prolific wares were familiar everywhere.

As a successful mode for narrative its value was mixed. The clearly defined silhouette figures could not be allowed to overlap each other much without obscuring the subject, and this meant that the overall composition of scenes in terms of mass, and sometimes colour, became of prime importance. Very often a compositional formula could itself be used as a narrative element and so provide an immediate visual clue to subject. Greek vase painters became skilled at presenting complicated narrative compositions without abandoning the sense of balance and symmetry that makes each scene or frieze acceptable as decoration even before its subject is discerned. This quality, practised incessantly in a minor craft, probably had its effect in major arts as well, notably that of relief sculpture, which generally started as a drawn surface. While the same effect could be created by painting other than on vases, we have little evidence for this until relatively late, and even the 7th-century architectural paintings seem not to go beyond simple square panels, not friezes. Bronzes certainly exploited frieze composition but not, so far as we can judge, much narrative (except probably in East Greece from the later 7th century), while the panel and frieze compositions were already very sophisticated on Greek Geometric vases even before much Orientalizing was accepted. Athens took the first step towards realistic drawing with the inception of the red figure technique in the 520s BC, but black figure was not forgotten, and the following chapter explores a little of its afterlife.

437 Boeotian amphoriskos. (Bonn 395; H. 16)

438 Boeotian alabastron by the Horse-Bird P. (Bonn 604; H. 21)

439 Boeotian (?) cup by the Tocra P. (Tocra 822)

440 Boeotian skyphos from Tanagra by Teisias. (Toronto 919.5.134; H. 19.1)

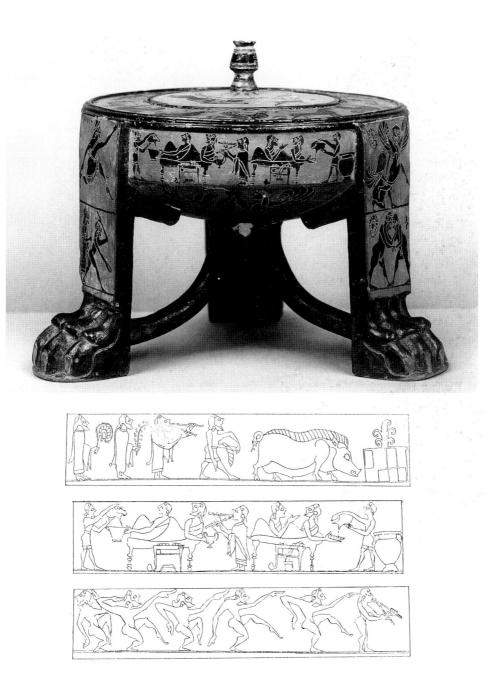

441.1,2 Boeotian tripod kothon, and details, from Tanagra. (Berlin F1727; H. 14)

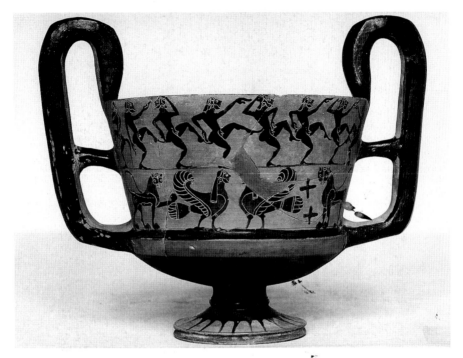

442 Boeotian kantharos. (Munich 419; H. 18.8)

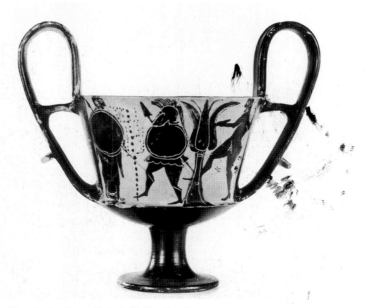

443 Boeotian kantharos. (Leipzig T1863; H. 15)

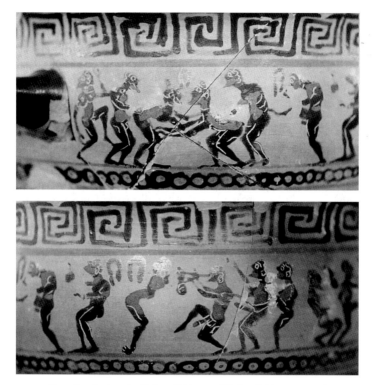

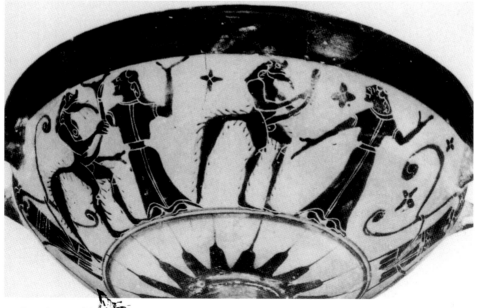

444.1,2 Boeotian skyphos details from Rhitsona. (Thebes, Rhitsona 31.187)

445 Boeotian cup. (Hamburg 1963.21; W.21.7)

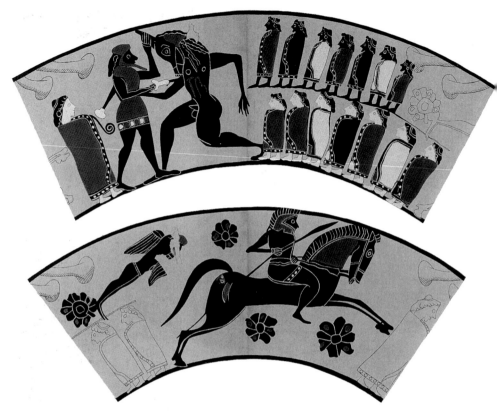

446.1,2 Boeotian skyphos. Theseus and Minotaur. (Louvre MNC675)

447 Boeotian oinochoe by Gamedes. (Louvre MNB501; H. 31.8)

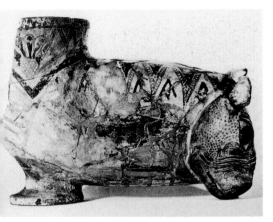

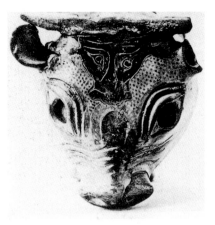

48.1,2 Boeotian figure-vase by Polon. (Louvre CA938; L. 20)

49 Boeotian figure-vase. (Berlin 3391; H. 19)

50 Boeotian lekane. (London B80; W. 30)

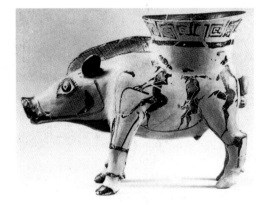

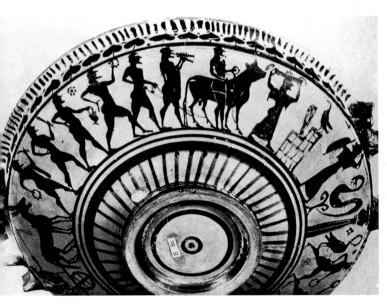

229

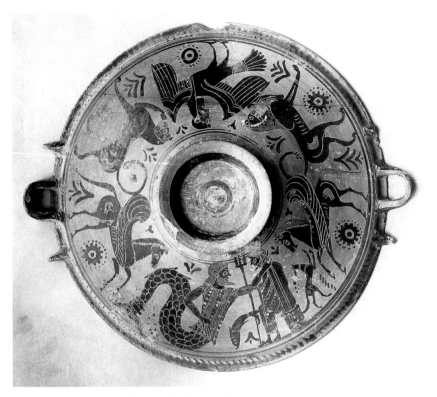

451 Boeotian lekane by the Triton P. (Berlin 3390; W. 32)

452.1,2 Boeotian lekane by the Protome P. (Heidelberg 179; W. 26)

453

454

457

455

453 Boeotian black polychrome kantharos from Eretria. Artemis and fawn. (Bonn 572; W. 22.8)

454 Boeotian skyphos by the Camel P. (Munich 2244; H. 11.8)

455 Boeotian skyphos. Gorgoneion. (Boston 66.267; H. 14)

456 Boeotian cup. Late 5th cent. Hunter, hound and monster. (Oxford 1966.1006)

457 Boeotian skyphos. Pottery and punishment. (Athens 442; H. 13)

456

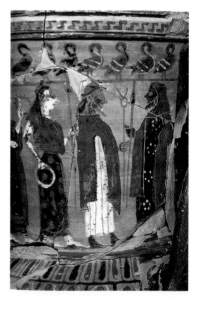

458.1,2,3 Eretrian amphora, and detail. Judgement of Paris; wedding. (Athens 1004; H. 88)

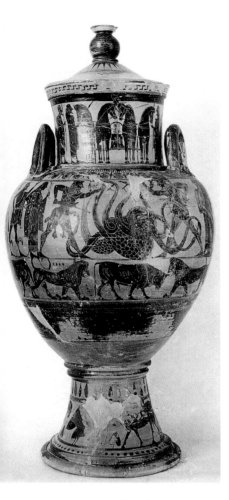

461 Eretrian amphora. (Athens 2635)

459 Eretrian amphora. Heracles and Hydra. (Athens 12075; H. 89)

460 Eretrian hydria. (Reading 51.1.2)

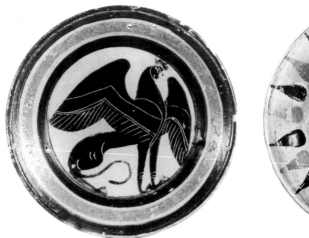

462 Eretrian plate. (Columbia 72.23)

463 Eretrian plate. Nike. (Louvre CA579; W. 18)

464 Eretrian plate. (Heidelberg 68/2; W. 31.2)

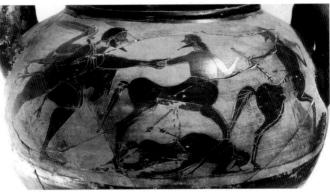

465.1,2 Eretrian (?) amphora from Eretria. Goddess and Aristaios; Heracles and centaurs. (Eretria ME16618)

466 Alabastron, Andrian (?) (Göttingen Hu534a; H. 18)

467 Thasian plate. Heracles and Amazon. (Thasos 1703; W. 32.2)

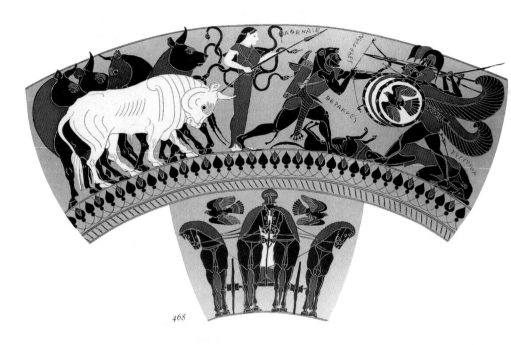

468

468 Chalcidian neck amphora from Vulci by the Inscription P. Heracles fights Geryon; the herdsman Eurytion is struck and the dog Orthros is dead. (Paris, Cab. Med.202)

469 Chalcidian neck amphora from Vulci by the Inscription P. Diomedes wounded; fight over dead Achilles (heel pierced). (Lost)

470 Chalcidian amphora from Caere by the Inscription P. Perseus and the Nymphs. (London B155; H. 48)

469

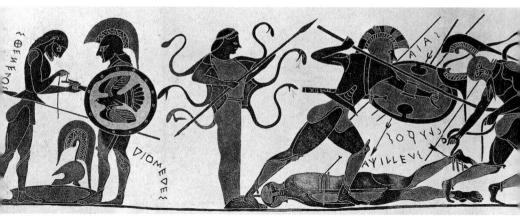

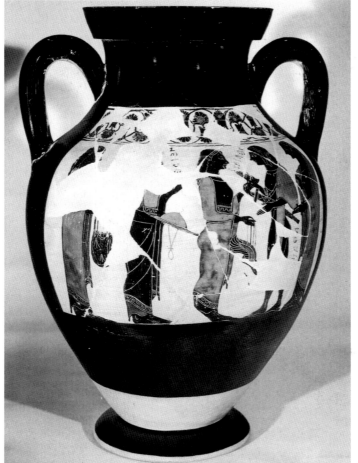

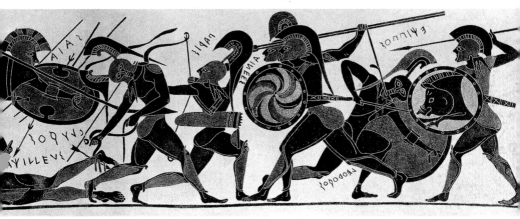

470

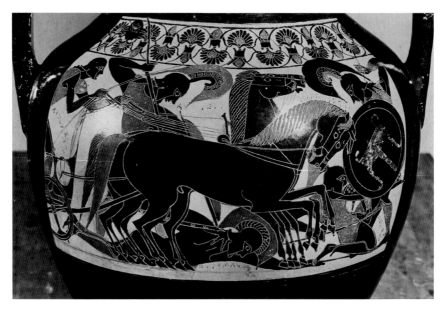

471 Chalcidian amphora by the Inscription P. (Melbourne 1643/4)

472 Chalcidian amphora from Vulci by the Inscription P. (Leiden 1626; H. 39)

473.1,2 Chalcidian hydria by the Inscription P. Zeus and Typhon. (Munich 596; H. 46)

73.2 Atalanta wrestles Peleus

474 Chalcidian crater by the Inscription P. Helen and Paris, Andromache and Hector. (Würzburg 315)

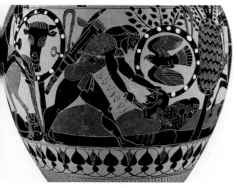

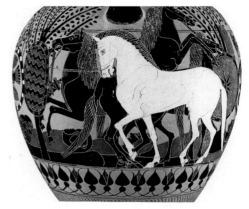

475.2

475.3

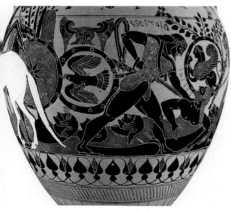

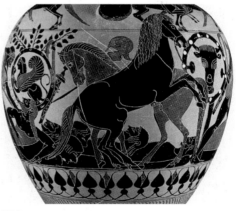

75.4

475.5

475.1-5 Chalcidian amphora by the Inscription P. Odysseus and Diomedes attack sleeping Rhesos.
(Malibu 96.AE.1; H. 39.6)

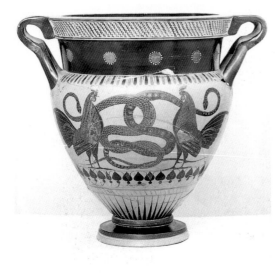

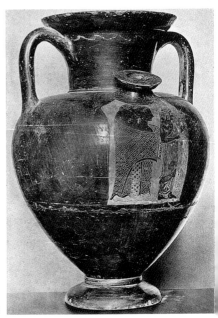

476 Chalcidian crater from Vulci by the Inscription P.
(Würzburg 146; H. 43)

477.1,2 Chalcidian psykter-amphora from Caere, and
detail, by the Inscription P. (Vatican 50401; H. 42)

477.1

478 Chalcidian deep cup by the
Inscription P. (Athens, Goulandris 718,
once Castle Ashby; H. 9.7)

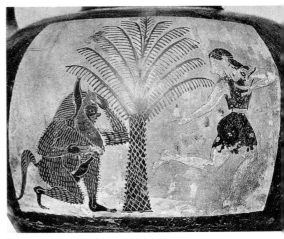

477.2

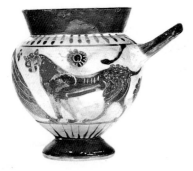

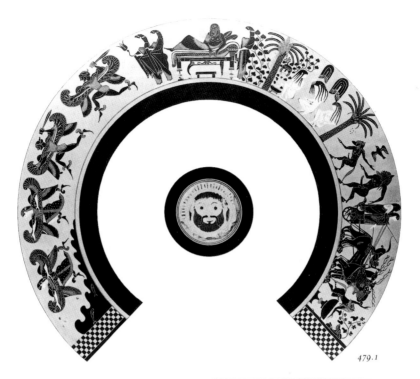

479.1

479.1,2 Chalcidian cup by the Phineus P. Boreads
pursue Harpies; Phineus' feast; Dionysos' chariot.
Detail, exterior. (Würzburg 354; W. 39.4)

480 Chalcidian cup by the Phineus P. (Munich 590;
H. 6)

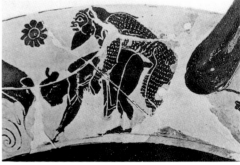

479.2

480

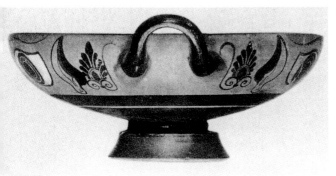

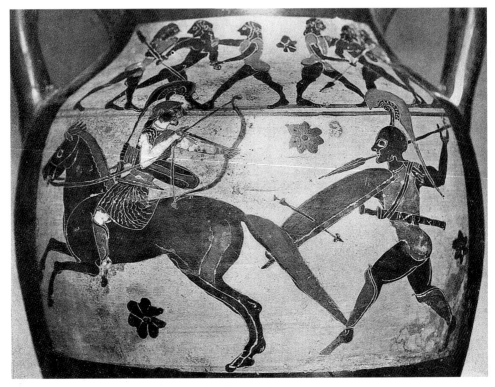

481 Chalcidian amphora. Amazonomachy. (St Petersburg 1479)

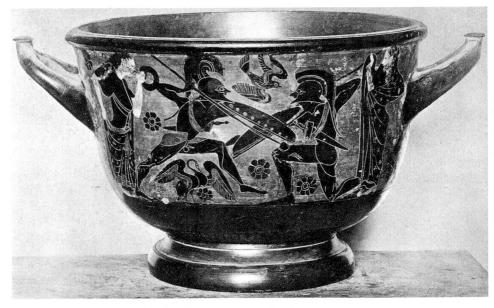

482.1,2 Chalcidian skyphos, and detail. Fight. (Naples SA120; H. 19)

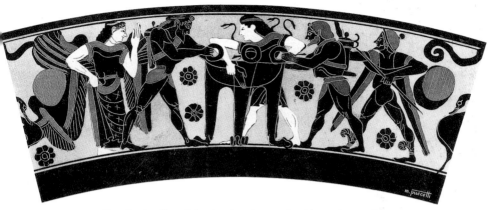

482.2 Heracles, Apollo and the tripod, with winged goddess Athena and Hermes

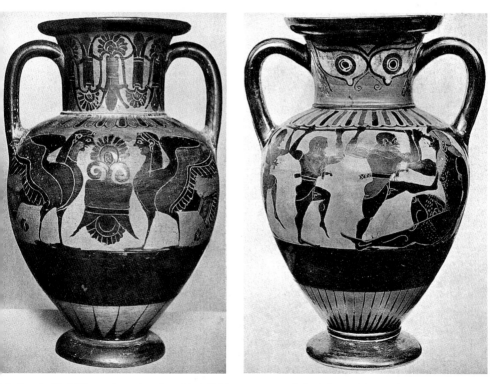

483 Pseudo-Chalcidian neck amphora from Caere(?) Memnon group. (St Petersburg 1310; H. 28)

484 Pseudo-Chalcidian neck amphora from Vulci. Polyphemus Group. Blinding of Polyphemus. (London B154; H. 30)

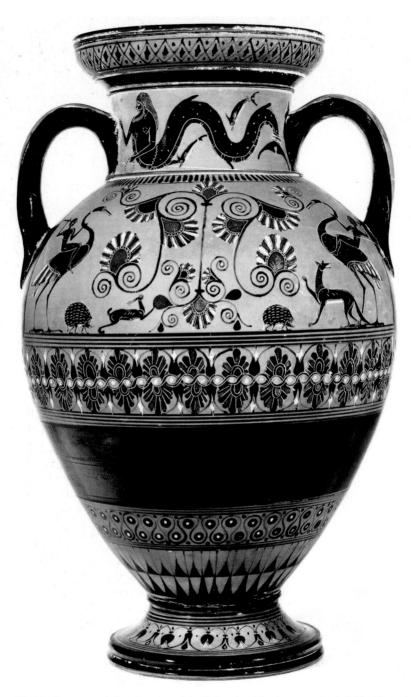

485.1,2 The Northampton Vase from Etruria, and detail. (London, Niarchos, once Castle Ashby; H. 32.5)

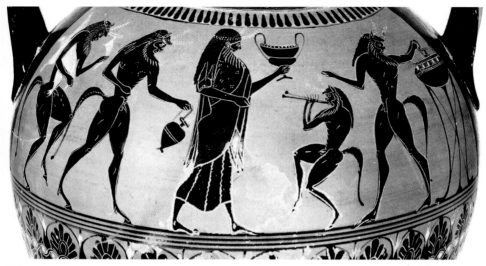

485.2

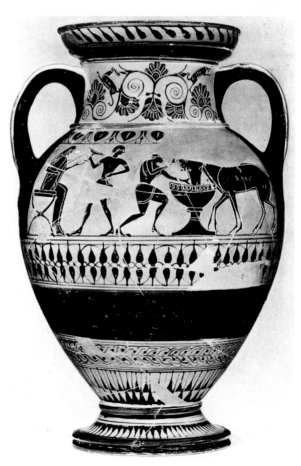

486 Northampton Group
amphora. (Munich 586; H. 23.4)

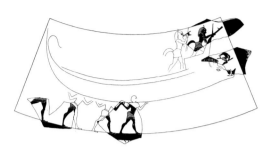

487.1,2 Ionian amphora frs. from Karnak.
(Oxford 1924.264)

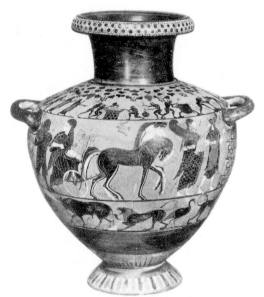

488.1,2 The Ricci hydria from Caere, and
detail. Sacrifice with preparations for cooking;
Heracles led to a goddess' chariot. (Rome, VG;
H. 44.5)

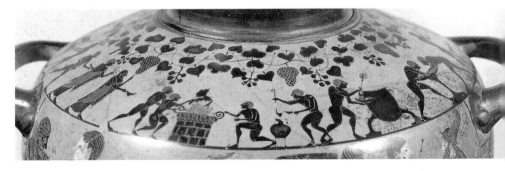

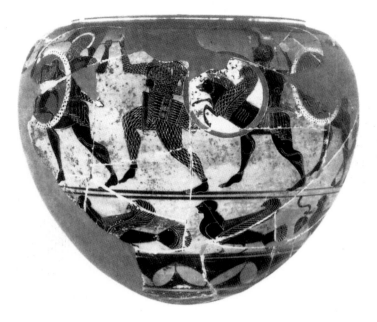

489 Ionian 'Campana' dinos. (Louvre E739; H. 23)

490 Ionian 'Campana' dinos with stand. (Vienna)

491 Ionian 'Campana' dinos. Return of Hephaistos. (Würzburg H5352; H. 20.8)

492 Ionian 'Campana' dinos. (Boston 13.205; H. 22.2)

493 'Campana' hydria. (Louvre Cp11032; H. 41.3)

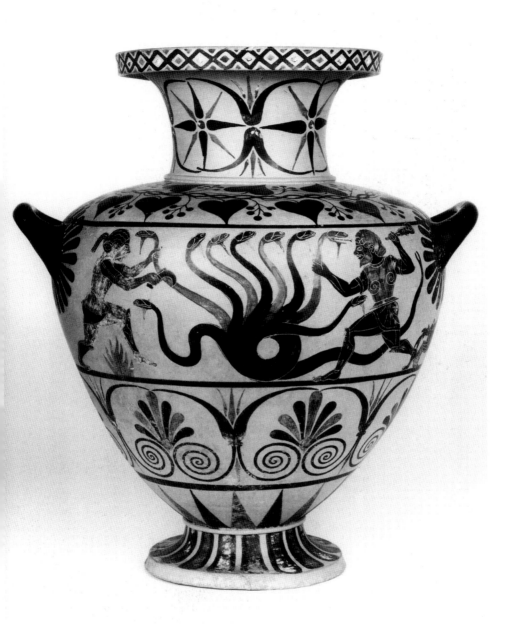

494 Caeretan hydria by the Eagle P. Heracles and Hydra. (Malibu 83.AE.346; H. 44.6)

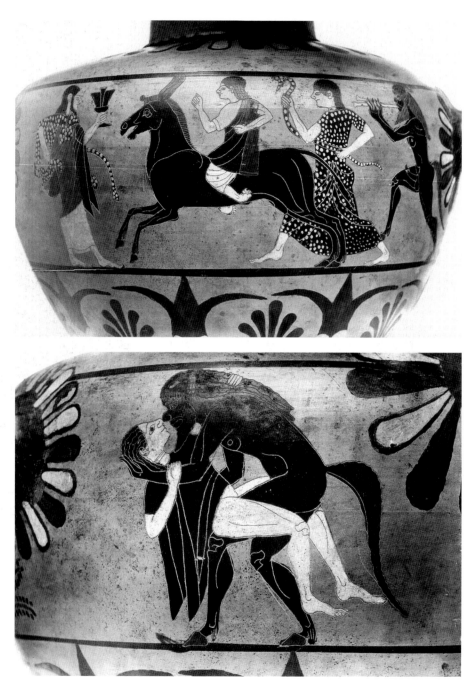

495.1,2 Caeretan hydria from Caere by the Eagle P. Return of Hephaistos. (Vienna 3577; H. 41.5)

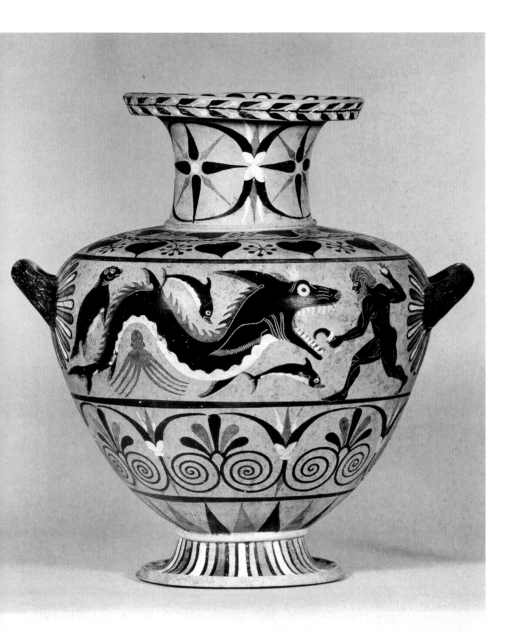

496 Caeretan hydria by the Eagle P. Hero and *ketos*. (Paris, Niarchos; H. 40.4)

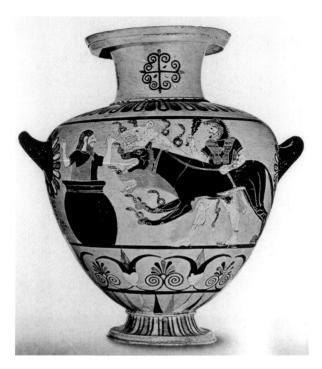

497 Caeretan hydria by the Eagle P. Heracles and Kerberos. (Louvre E701; H. 43)

498 Caeretan hydria from Caere by the Eagle P. (Dunedin F53.61; H. 44)

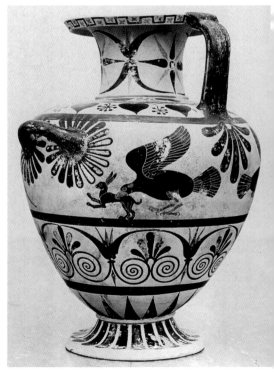

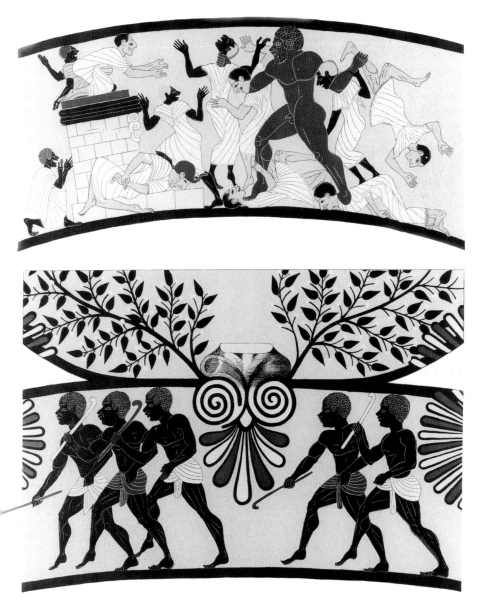

499.1,2 Caeretan hydria from Caere by the Busiris P. Heracles and Busiris; Nubians. (Vienna 3576; H. 45)

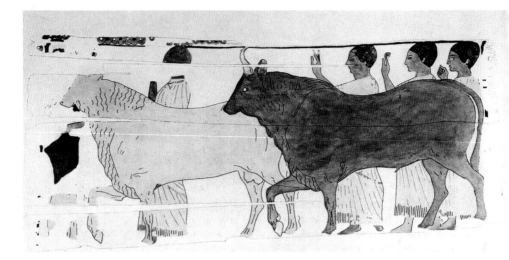

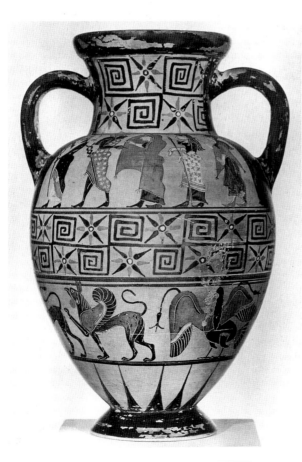

500 Wooden plaque from Saqqara.
(Cairo, Saqqara H5-2571; W. 46)

501 'Pontic' amphora from Vulci.
Judgement of Paris. (Munich 837;
H. 33)

Chapter Seven

AFTERMATH

Attic potters continued to produce black figure vases to at least the middle of the 5th century BC, and even later with their Panathenaic amphorae (*ABFH* fig. 308). In the rest of Greece most black figure production in the same period was dependent on Attic and has been described or mentioned in the last chapter. The vital new technique was red figure. This was almost an Attic monopoly until the studios of South Italy and Sicily started later in the 5th century. But red figure was also copied in a desultory way elsewhere in Greece (and Etruria), notably in Boeotia. Recent scholarship has detected production elsewhere, as in Corinth, Elis, Laconia, Chalkidike. It was limited in both quantity and quality, but it does indicate the willingness of local potters to experiment and attempt to capture a little of the local market from the ubiquitous Attic. They demonstrated this in other ways too, which is the concern of this chapter, since they were ready to continue or revive silhouette, outline and black figure techniques.

Vases decorated with big black palmettes and usually no figures at all became increasingly popular through the 5th and into the 4th centuries. Some are Attic but centres of production for them are identified in Boeotia and Euboea, and there are related examples to be found in various parts of the Greek world, and the west. Most are cups or pyxides, and they provided an alternative at low cost to the plain black vases which were being made even more prolifically through the same period, some of them to a very high standard of potting and finish. While many of the black vases can be related to popular new versions of their shapes in metal, the palmette cups and others seem to derive more from the older traditions of vase decoration.

Some potters, however, revived figure decoration in the old techniques. There are groups which seem mainly the inspiration of one man, and do not last long; others serve their markets for several generations. The inspiration for some can be seen to be service for a religious centre, providing votives or souvenirs, such as are more readily identifiable in clay figurines. Others have no such apparent motive but are a matter of personal invention. Others simply offer a slightly more pleasing version of plain wares. I am selective of those I discuss and illustrate here.

In CORINTH plain patterned vases were long in production. Some time around the mid-5th century a potter started making small cups, plates and pyxides decorated on interior or lid with mainly single figure subjects executed in part outline with a little incision. Many of the subjects are deities, some

designed for local dedication. I show a Demeter and a rustic but humanoid Pan [502–3]. There are other themes devised with no little originality and perhaps deliberate wit: a comic figure [504] and an irate self-abusing sphinx on a column louring at a puny Oedipus with drawn sword [505]. They are known as the WIDE GROUP after the scholar who first studied them (when they were taken to be Boeotian).

In Boeotia old styles of silhouette, black figure and palmettes had a long career. One new class, however, emerges before the last quarter of the 5th century and lasts to the mid-3rd. It is called the CABIRION GROUP, partly because many examples were found at the Cabirion sanctuary near Thebes, partly because some of the scenes relate to the cult. The style is crude black figure, with some outline and some figures in plain silhouette; these can be careful, and some that seem slapdash conceal a lively comic sense. The commonest shape is a deep skyphos with vertical ring handles, strictly a kantharos but harbinger of a popular Hellenistic shape generally called a skyphos. There are also small lebetes, pyxides and cups and some other shapes, but not a working set for life or feast. Some scenes are serious, notably symposion scenes in the sanctuary, on [506] with Kabiros himself as president; but many are not – compare the symposion of [507] – and are either impertinent versions of serious myth – Odysseus challenging Circe with her poisoned cup [508], or present occasions of near farce acted by comic figures. On [509] a shaggy female monster is chasing a traveller who has dropped his load and races to the safety of a tree where two are already sheltering, having abandoned their plough. It is generally thought that the scenes reflect performances of some sort in the theatre at the Cabirion, not unlike the satyr plays of Athens, but we know nothing of them from literature. The vases are not all from the Cabirion but those that travelled might be souvenirs. Examples placed in the mass tomb (*polyandrion*) at Thespiae in Boeotia must be pre-424 BC. The vases with figures are mainly of the first hundred years of production, and the master of the comic style is known to scholars as the Mystes Painter [508, 510], working mainly in the first quarter of the 4th century. There are many Cabirion cups more simply, but effectively, decorated with florals, ivy, etc., while a vine often appears over a figure scene.

Elsewhere there are local manifestations of figure drawing of varying merit. In RHODES are some classical pots with outline birds and florals [511] and in the 4th century some black figure vases rather in the style of Athens' Panathenaic prize amphorae, but here showing the god Helios. In CHALKIDIKE there is some modest work of the 5th century.

502 Corinthian Wide Group plate from Corinth. Demeter. (Athens 5825; W. 17)

503 Corinthian Wide Group pyxis. Pan. (Reading 47.6.2; W. 10.5)

504 Corinthian Wide Group cup. (Athens, Goulandris 30; W. 9.5)

505 Corinthian Wide Group plate. Oedipus and Sphinx. (Oxford, loan; W. 9.2)

506.1,2 Boeotian Cabirion Class skyphos fr. from the Cabirion. (Athens 10426)

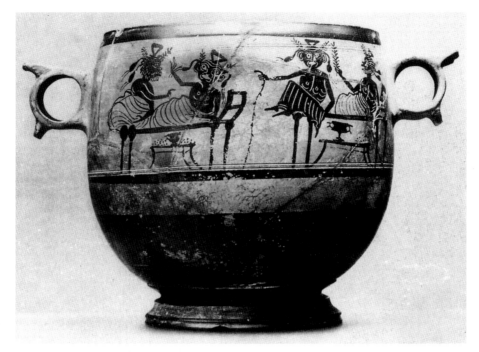

507 Boeotian Cabirion Class skyphos from the Cabirion. (once Berlin 3286; H. 21)

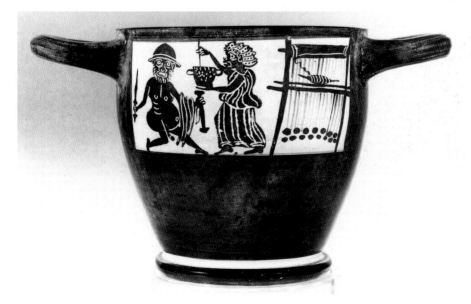

508 Boeotian Cabirion Class skyphos by the Mystes P. Odysseus and Circe. (Oxford V262; H. 15.4)

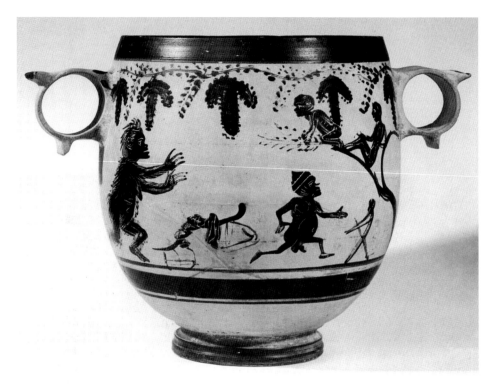

509 Boeotian Cabirion Class skyphos. A rustic adventure. (New York 1971.11.1; H. 22)

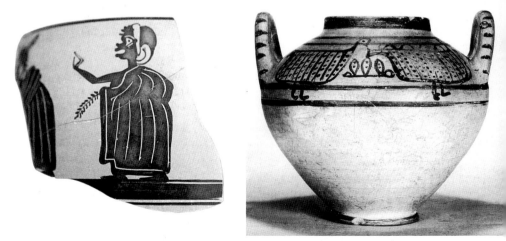

510 Boeotian Cabirion Class skyphos fr. from the Cabirion by the Mystes P. (Thebes K1751)

511 Rhodian stamnos. About 400 BC. (Leipzig T1904; H. 13)

Chapter Eight

EARLY GREEK VASE PAINTING, ART AND LIFE

The wares studied in these chapters perhaps say more about the role of decorated pottery in ancient Greece than the more familiar black and red figure vases of Athens from the mid-6th to 4th centuries BC or the 5th/4th-century vases of South Italy and Sicily. The latter may be the most informative about the industry, iconography and trade of their day, but the wider geographical range and diversity of pottery in periods when there were no such monopolies of production pose more questions and offer the possibility of answers. This is a period in which the pottery is itself interesting both for what it tells about the development of an important craft, and for its demonstration of the beginnings of Greek narrative in art and of figure and decorative styles less fully demonstrated in other media – crucial to our understanding of what comes after. These are years in which there are no contemporary historical records, though there is fine literature, epic and lyric. The production and use of decorated pottery is the only universal (for Greeks), prolific and relatively sophisticated source which might enable us to draw comparisons about the visual and social experiences of ordinary people in different parts of the Greek world and in their colonies, over centuries. They are sufficiently differentiated to invite explanations, sometimes of broader historical relevance. This may seem a bold claim, but it is what archaeology is about, and we are less likely to be misled by evidence that is full and articulate than by accidental survival from later periods of 'historical' accounts, or by the very partial survival of other artefacts of whatever quality or value. The only comparable medium, for later periods, is coinage, and that is less eloquent. 'Pots are for people' is a principle easily forgotten in the search for specialist purposes, which may then miss their role as a source of information about more than trade, narrative or religion. This short book can do little more than hint at the richness of the subject.

Function

1 Practical

From the brief account of shapes in Chapter 1 it can be seen that most decorated pottery served either the feast (drinking rather than eating) or dispensing of oil. Wine and oil were the staple products of Greek antiquity; solids like meat, fish and corn called for no special products from the potter, except for cooking.

It is not surprising that implements of social importance, and sometimes social significance, should attract special treatment which in other cultures may have been reserved for metals. Metals were available in Greece too but are less inform-ative, less well preserved, and gold and silver were largely in the possession of the fat cats. Other needs were served by the potter, often on shapes derived from media which were either cheaper (wood, skin, horn, bone) or more expensive (metal, ivory). The potter also saw to some of the needs of storage and carriage of wine and oil, though as the trade developed the carriage vessels were left plain.

Production of the wine and oil vases was the concern of both the producing states and the customers. On the whole the states most probably engaged in per-fumed oil production were the main producers of the vessels in which it was retailed (Rhodes, Corinth), while most Greek lands were both producers and consumers of wine. We are not to think of the wine vessels as furniture only for the formal symposion of reclining guests, which at any rate was not adopted in Greece until the end of the 7th century and which, even in Classical Athens, was probably only an occasional treat for the élite and for festive occasions. Wine drinking is and was always a social activity of some importance, second only to consumption of food, and like eating demanded comparable ritual behaviour. The communal crater in which the wine was mixed with water becomes an important focus of such activity and we may imagine that the cup becomes an important private possession. The decorated cup certainly seems to be, at first an indicator of Greek presence, then a commodity valued by others who become taken by the Greek way of life.

2 Cult

The status of decorated pottery is perhaps best demonstrated by production of special wares for public, and some private, occasions of a religious nature. There is nothing unusual about the vases used to contain a burial, whether of a child or ashes, but the use of one as a grave marker is, especially when we can observe differentiation of shape, and to a far lesser degree of decoration, according to the sex of the deceased. Moreover, in Geometric Athens the vessel can be enlarged to monumental proportions, on which the figure decoration can be explicit about rites. There is no question here of pottery substituting for metal or stone. The size also of course conferred status, but Greek burial was in most periods as much a statement about surviving family status as about piety or even respect for the dead.

Other vases with funeral scenes on them are rare in our period, mainly found in 7th-century Athens (and later in Athenian black figure). They, and others of a rather ornate character of the same date, were made for the grave. Virtually all other vases found in graves were not designed for this purpose but the choice of shape was – to feed the thirsty dead, to carry sustenance for a journey to the other world (a Greek would find it difficult to explain this as logically as an

Egyptian could), or for their service in purification rites, occasionally perhaps as a prized possession of the dead.

Miniature vessels were suitable for deposition in graves, but also for dedication in sanctuaries as economical substitutes for grander offerings in the same or other materials. Occasionally we can see that appropriate decoration was also provided for votive pottery, generally depiction of the deity or offerant, but this is mainly a phenomenon of later years. The production of outsize versions of common shapes, such as cups, might be for dedication or simply for secular show. The practice can be observed in metal too (the Vix crater, which surely never held wine; GO fig. 261).

3 Profit

Potter/painters had to make a living. Even into the Classical period it seems that craftsmen, whom we might wish to designate artists, could command no more than any manual worker for time and labour. But a potter made a capital investment in kilns, had to arrange for delivery of clay (usually never far away) and perhaps employ painters. In his own community there may have been an element of competition for quality of wares and decoration, though probably little enough in our period. Occasional pieces would travel, with colonists or visitors, Greek and non-Greek, and could create a demand which would stimulate surplus production and generate profit. It would not then take long for potters to begin to observe market preferences and respond to them. In a small way this is happening in our period, though detailed market preferences in terms of shapes and decoration are a phenomenon of the advanced 6th century. Generally people will stay loyal to what they are used to and are more likely to be tempted by an interesting or more elegant variant than by anything truly exotic. This is why the Greek colonies remained good customers for the sort of pottery that their founders had used, mainly from their home city. And when sources dried, as with the Euboean colonies around 700 BC, they turned to the next most familiar and available ware, Corinthian, contributing further to that city's burgeoning production and profit. Where a local pottery industry developed it was to produce ware of familiar shapes and decoration. New styles introduced by enterprising immigrants (as in 6th-century Etruria) either did not survive more than one generation, or were well absorbed and helped mould local taste and production. In a relatively innocent market like Etruria the possibilities of profit were considerable, but otherwise this is obviously not a period for big profits for potters at home. But Corinthian pots travelled in tens of thousands, just as Attic did later probably by the million over more than two centuries of production. The distribution of considerable numbers of even the early major wares shows how ready merchants were to carry it; usually, one imagines, the wares of their home towns but with a wider and more professional market developing, and there were always some merchantmen from towns with nothing to offer and

ready to carry the wares or merchants from others. In the early period this was probably mainly a matter of a merchant accompanying his wares (as *emporos*), perhaps even the potter or a member of his family. At this time pottery was not a major element in trade, which must have been more concerned with food and raw materials, but it was not imperceptible. The problem of prices, at home and for customers, can only be pursued with 6th-century and later Attic pottery, not for the vases studied in this volume. We may imagine that wholesale prices reflected time spent in production (the cost of raw material was negligible beside time and equipment); retail prices depended on the purse of the buyer.

Status in antiquity was measured politically by power, and commercially by wealth. We may not know how wealthy early potters might have been, and may presume that they were no better off than other artisans, cobblers and masons. Their profession was a muddy and smoky one, not much regarded by fellow citizens. We can judge a little what they thought of themselves since the appearance of a potter's or a painter's signature must indicate a measure of pride in performance, and they are too occasional and irregular to be regarded as positive advertising. There are examples in most of the best known wares, from the early 7th century on.

That possession of a decorated pot indicated wealth is a very different question. To a non-Greek whose own pottery was plain and whose metalwork was not elaborately decorated, such colourful wares with lively figure scenes must have seemed desirable and could be readily displayed and used. Even to a rich non-Greek a fine Greek vase might well have seemed a desirable acquisition by way of gift, though he would have recognized the greater intrinsic value of gold or silver. Gift-exchange may be a rather overworked concept these days. Most gifts carried an implicit price-tag to hint at the appropriate or expected level of exchange; and there is heartache if the balance is ignored: recall Glaukos exchanging gold for brass in Homer, where his poor business sense is attributed to Zeus taking away his wits. To a poorer Greek, who might also be able to make something of the depicted scenes on an imported vase, much the same satisfaction must have been felt. But we are dealing with a very low level of wealth-display, like a household with one silver teapot. I imagine no one in antiquity collected decorated vases *per se*, as they might have done metal vases, except possibly in Etruria where whole sets seem to have been assembled, then buried with other possessions for the dead. But before metal vessels for the symposion became relatively cheap, a fine set of decorated cups and a crater were probably deemed to make a brave show for the better families, as indeed they do still in our museums.

Narrative

The manner and conventions of composing narrative scenes on pots have been observed in passing already. Why they were thought desirable is a different

matter, given that most other ancient cultures seem neither to have shared this interest nor to have used other common media to comparable effect. In our period most scenes of contemporary behaviour are strictly concerned with religion, especially the conduct of burials, and even the fighting scenes may be thought to reflect on the prime pursuits of the dead (as later also hunting and feasting) as much as they did on the pursuits of the living. Less specific narrative scenes had never been far from Greek consciousness, as in Protogeometric Crete, and in time artists exploited new conventions of drawing, with some inspiration from the sight of foreign objects, to extend their repertoire into depictions of their myth-historical past. The importance of this corpus of story, which would have been already highly developed by the Geometric period, largely explains both the importance and great sophistication of Greek poetry, especially epic (in comparison with that of the near east), as well as their narrative arts. Their willingness to deploy these scenes on painted pottery may have been encouraged by use of the medium in the Geometric period for cult and burial scenes, especially in Athens where the figure scenes are most highly developed and where we may suspect that vase painting was the senior medium for such display, outdoing figurative arts in other, more valuable media such as metalwork or seal engraving. This seems long to remain true, and figure decoration on metalwork was mainly expressed in appliqué plaques for furniture and on armour, without generating any major figurative tradition.

Recognition of scenes depended on depiction of characteristic attributes, formulae for action, and the use of designating inscriptions, which was however as occasional and irregular as the potter/painter signatures. Sources were the common stock of myth-history which was best known from an oral tradition, and shortly to be formalized in written literature and on the stage, though neither the written nor acted word could have been as influential as the heard. This accounts for the many variant versions that occur, dependent in part on differing traditions which need be the result of nothing more formal than defective memory or individual invention, but could also be prompted by the context in which a story is told, and even by compositional convenience. Stories can be created and adjusted in pictures as readily as they can in words remembered (and misremembered) or written. It is not surprising therefore that the choice of scenes and their detail depended not at all on texts. This long remains true in the history of visual narrative in Greece. Homer was no more responsible for Greek narrative art than he was for the Greek alphabet.

Pattern and design

The patterns derived from basketry and weaving, and the floral patterns adjusted from eastern models may seem subsidiary in vase painting but they last longer in Greek art than any figure-drawing conventions. Design in figure scenes was important, as we have seen, and the desire for symmetry and balance did not mil-

itate against expression of complicated narrative, any more than the competing interests of idealism and realism impeded the creation of Classical art in the 5th century. Drawing techniques and their dependence on other media have been noted, not least the way that the incising techniques of near eastern art were adapted to drawing on pottery, and the possibility that the major outline-drawn figure styles of the east and Egypt helped determine the alternative technique of outline drawing in 7th-century Greece. The complementary interests in line or in mass long remained important in the history of Greek painting, though not in vase painting.

Design in shapes was almost entirely dependent on function. It was influenced by what was possible in clay (which is virtually anything, it is so versatile) and by shapes in other media where the relevant functions had been longer or more readily served. These included wood, and especially the vessels produced or decorated in the carpenter's turning techniques on a lathe, which related readily to what could be done on a potter's wheel, notably in the 'turning' (we use the same term) of mouldings at foot or base. Skin was even more influential for liquid containers of all sizes, recognizable from their baggy forms. Horns and gourds were other sources. In our period metal vases probably follow rather than lead, though they come to inspire details which are functional in metalwork (rivets, handle-attachments, etc.) but decorative on pottery. The more spectacular metal vases invite imitation in clay, but often for purposes which the metal never served (e.g., the big clay relief storage vases, which are not considered in this volume). Foreign shapes were not particularly influential – there was little occasion for them to be, although the shallow cups may have been inspired by flat eastern bowl-cups to which the Greeks added the customary foot and handles which the easterner spurned. Close observation of capacity seems not to have been important, and even for carriage vases was irregular; the Greeks rather lagged behind their neighbours in such matters though local standards developed which we best detect once coinage begins, and for weight as much as volume.

Pottery and people

Can we learn more from this Greek obsession with figure decoration on pottery, beyond what relates to production, marketing and decoration? That the differing styles of major areas of Greece, which can be most readily observed in the early period, meant more than accidental local preferences might be agreed, but just what they meant is another matter. In very general terms they correspond to other groupings in the Greek world; with the broad ethnic of Dorian, Ionian, Aeolian, and perhaps more particularly with the narrower bonds of dialect. But there is not much to choose between the styles favoured by Dorian Rhodes and its Ionian neighbours. Geography counts for much: Attica-Boeotia-Euboea, for example. Here and there political affinities amount to little even where they

provide a context for imports which might have been copied; Samos accepts but does not copy Spartan pottery. Blood is thicker than the tradesman's currency, and it is the bond of mother-city to colony, or the close presence of craftsmen (as in Etruria) that influence local production.

A town's pottery can be as distinctive as, in later years, its coinage. Every coin is in its way an instrument of state propaganda. I am sure no state's pottery was spurned because of its origin, nor necessarily favoured. Could a 6th-century Athenian recognize Corinthian pottery as Corinthian? Only an Athenian potter, I imagine, would have been able to, and ready to copy what he needed without acknowledgement. But any Athenian might well identify a Corinthian pot as foreign, especially if he was literate and it was inscribed, and it is the strong local identity of pottery styles as recognized by those for whom it was made (we can ignore here trade to others, sometimes far away) that can make it a statement or at least acknowledgement of state identity. Conservatism is always a very strong factor in the lower crafts, and examples of centuries-long wedding of shape and decoration, as in Chian chalices, demonstrate devotion to the locally familiar.

Inasmuch as Attic or Corinthian or Argive pottery was a distinctive product of each state, so any messages carried by its figure subjects would probably be less well read elsewhere. This need not affect trade in such goods, especially when the subject matter was the common stock of Greek story-telling, even if adjusted for particular cases, but it does give us the opportunity to speculate about social differences wherever the figural messages do seem to represent some special local attitudes. Obvious examples are the differences between the figure repertoire of Attic and Argive Geometric pottery. In the 6th century the lack of much overlap between the hey-days of Corinthian and Attic black figure denies us any such easy opportunity for comparison, but the way in which the iconography of Attic vases developed, which was quite unlike that of any other part of Greece, does invite speculation about the choice and origins of some subjects. It stops far short of making pottery a vehicle of state propaganda, of course, but it is revealed as an expression of local preoccupations, political and religious, and to a far lesser extent comparable lessons might be learned from study of the subject range of pottery in Laconia, for example; not East Greece, however, where the messages of figural arts were always better carried by other media. It is absurd to think that Archaic Greece was not sophisticated enough to reflect such preoccupations in its popular art, when it is readily apparent, and soon became even more so, in its public art, on temples and public monuments.

It is not for the modern scholar to pronounce on what of antiquity seems better or more beautiful, and attempts to do so are chastised. Nor should we attempt to judge ancient arts and crafts by standards, expectations and theories devised for a modern age in which art has totally different purposes, where any at all. But we have the evidence for what was thought in antiquity to be better or more beautiful, and we might do well to look for it and understand it. The success of some pottery wares, or of some workshops within states, could not

always have been a result of commercial astuteness. And differences between wares imply, at least in part, differing aesthetic tastes. Ubiquitous objects like profusely and significantly decorated pots, might have even more to offer than formal sculpture when it comes to understanding antiquity and ancient Greek taste. If many scholars today have come to misprize their own judgement in these matters, let us not altogether ignore what evidence we have for the preferences of antiquity, which we have to assess from what they made and used, and nowhere better than from their prolific and well-preserved decorated pottery.

CHRONOLOGICAL CHART

GEOMETRIC

	900		800	Dipylon P.	700	
ATTIC	EG ———	— – – 'MG I ———	—	MG II ———	– – LG I ———	– LG II ———
EUBOEAN	Subprotogeometric/ MG			– – LG Cesnola P.		
CYCLADIC	Subprotogeometric/ MG			– – LG		
BOEOTIAN	EG ———	– –	MG		– – LG	
CORINTHIAN	EG ———	— –	MG		– – LG	Thapsos Group
ARGIVE	EG ———	— – '	MG		– – LG	
EAST GREEK	EG ———	– – MG '———		– – LG	Bird Bowls	
CRETAN		Protogeometric B ———	– – E/MG	– – LG		

ORIENTALIZING

	700			600	
PROTO-CORINTHIAN	EPC ———	MPC ———	– – LPC ——— Trans. EC		
PROTOATTIC		EPA ——— MPA Black and White _ LPA Black figure			
LACONIAN		Subgeometric ——— – – –'Lac. I ——— Lac. II			
EUBOEAN		Amphorae A—	B ———	C ——— D ———	
BOEOTIAN		Subgeometric ——— – – –			
CYCLADIC	Parian Linear Island Leiden Group				
	Naxian Ba——— C ———				
	Ad D	'Melian' ———			
CRETAN	EO ———	– – LO – –			
EAST GREEK	Bird bowls ———				
		Wild Goat Style			
		EWG ——— MWG ———			
THE WEST	Fusco craters Aristonothos				

BLACK FIGURE

	600			500
CORINTHIAN	EC——— MC——— – LC——— –		Altars Plaques	
LACONIAN	Lac. II——— – – – Black figure cups ———			
BOEOTIAN	Bird bowls ———			
	Imit. Attic/Cor.	Lekanai ———		
EUBOEAN	Amphorae D——— – –	Black figure ———		
EAST GREEK	Bird-Eye-bowls ———			
	LWG / BF ——— – –			
	CHIOS { Sphinx and Lion BF chalices ——— – – –			
	Animal chalices Grand chalices			
	Plain chalices ——— – –			
	RHODES Vroulia cups	Situlae ———		
	MILETUS	Fikellura ———		
	SAMOS	Little Masters		
	CLAZOMENAE	Black figure ———		
		Sarcophagi ——— – – –		
THE WEST	Pontic ——— – –			
	North'n Group — Campana dinoi			
	Chalcidian ———			
		Caeretan		

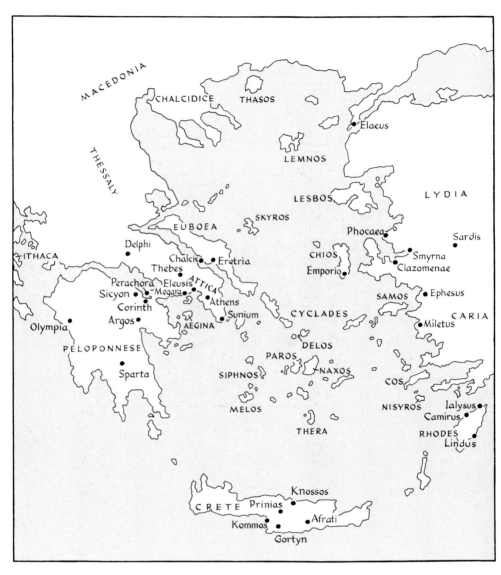

The Aegean World

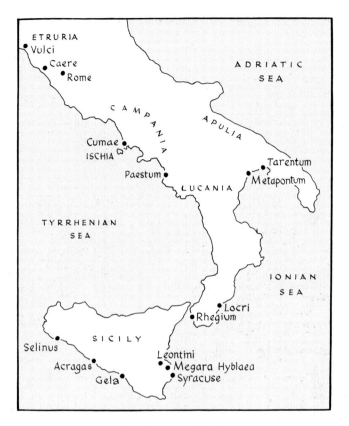

South Italy and Sicily

ACKNOWLEDGEMENTS

The publisher and author are indebted to the many museums and collections named in the captions for photographs and permission to use them. Other sources are named publications, the archives of the Cast Gallery, Oxford, and:

American School of Classical Studies, Athens – *27, 59, 108, 116, 171*; British School at Athens (M.R. Popham for Lefkandi)- *14–25, 78, 80–2, 86, 140–2, 187, 193, 195, 202–3, 212, 220, 259–64, 350*; German Institute, Athens – *45, 51, 58, 95, 98, 102, 213*; German Institute, Rome – *417*; Giraudon – *40, 294, 431*; Hirmer Verlag – *44, 48, 65, 130, 150, 178, 189, 282, 290, 310, 327, 399, 404, 420, 426*; H.W. Catling – *262*; R.L. Wilkins – *478, 485*; author – *61, 66–7, 69, 79, 105, 113, 135, 143, 145–9, 151, 153–7, 170, 177, 182, 184, 198–9, 257–8, 267–8, 273, 276, 291, 295, 298, 307–9, 312, 318, 321–2, 334, 359, 366, 368–9, 383, 387, 395, 400, 406, 412, 424, 439, 444, 465, 502, 510*

P. Blome, L. Burn, J.N. Coldstream, R.M. Cook, N. Kourou, J. Mertens, L. Mildenberg, M. Pipili, C.W.Neeft, M.R. Popham, M. Shaw, R. Vollkommer have helped with photographs or information. Donna Kurtz read the text and made many valuable suggestions. *487*, the maps and Chronological Chart are by Marion Cox.

ABBREVIATIONS

PG, SPG Protogeometric, sub-Protogeometric

EG, MG, LG Early, Middle, Late Geometric

PSC pendent-semicircle

PGP Protogeometric B

EPC, MPC, LPC Early, Middle, Late Protocorinthian

EPA, MPA, LPA Early, Middle, Late Protoattic

EO, LO Early, Late Orientalizing

EWG, MWG, LWG Early, Middle, Late Wild Goat

EC, MC, LC Early, Middle, Late Corinthian

10.Congr. *10th International Congress of Classical Archaeology* (ed. E. Akurgal, 1978)

ABFH J. Boardman, *Athenian Black Figure Vases* (1974)

AE *Archaiologike Ephemeris*

Agora *The Athenian Agora* I-

AJA *American Journal of Archaeology*

AK *Antike Kunst*

AM *Athenische Mitteilungen*

Amsterdam *Ancient Greek and Related Pottery, Amsterdam* (ed. H. A. G. Brijder, 1984)

Ann *Annuario della Scuola Archeologica di Atene*

ARFH I, II J. Boardman, *Athenian Red Figure Vases. The Archaic Period* (1975) . . . *The Classical Period* (1989)

BABesch *Bulletin van de Vereeniging..*

BCH *Bulletin de Correspondance Hellénique*

BdA *Bollettino d'Arte*

BICS *Bulletin of the Institute of Classical Studies, London*

BSA *Annual of the British School at Athens*

Chios 1984 *Chios, a conference at the Homereion, Chios 1984* (edd. J. Boardman and C. E. Vaphopoulou-Richardson, 1986)

Cook, *GPP* R. M. Cook, *Greek Painted Pottery* (1997)

Copenhagen *Ancient Greek and Related Pottery, Copenhagen* (edd. J. Christiansen and T. Melander, 1988)

Corinthiaca *Corinthiaca* (Studies, D.A. Amyx, ed. M. A. Del Chiaro, 1986)

CVA *Corpus Vasorum Antiquorum*

Delos *Exploration Archéologique de Délos*

Ergon *To Ergon tes en Athenais Archaiologikes Etaireias*

GO J. Boardman, *The Greeks Overseas* (1980)

GSAP J. Boardman, *Greek Sculpture. The Archaic Period* (1978)

IstMitt *Istanbuler Mitteilungen*

JdI *Jahrbuch des Deutschen Archäologischen Instituts*

JHS *Journal of Hellenic Studies*

Jones R. E. Jones, *Greek and Cypriot Pottery* (1986)

Kerameikos *Kerameikos: Ergebnisse der Ausgrabungen* I-

LIMC *Lexicon Iconographicum Mythologiae Classicae* I-VIII (1981–97)

MEFRA *Mélanges de l'Ecole Française de Rome. Antiquité*

MonPiot	Monuments et Mémoires, Fondation Piot
OJA	Oxford Journal of Archaeology
OpuscAth	Opuscula Atheniensia
PACT	Journal of the European Network of the Scientific and Technical Group for Cultural Heritage

PAE	Praktika tes en Athenais Archaiologikes Etaireias
Simon/ Hirmer	E. Simon and M. & A. Hirmer, Griechischen Vasen (1976)
Tocra	J. Boardman and J. Hayes, Excavations at Tocra I, II (1966, 1973)

NOTES AND BIBLIOGRAPHIES

1 INTRODUCTION

The best one-volume account (Protogeometric to Hellenistic, 11th-1st century BC) is R. M. Cook, *Greek Painted Pottery* (1997); this has slightly more than the present volume on major styles and shapes, less on smaller classes, nothing on iconography, far fewer pictures. B. A. Sparkes, *Greek Pottery: an Introduction* (1991) is a matter-of-fact survey of subjects other than historical development, notably technique; also I. Scheibler, *Gr.Töpferkunst* (1983) – similar

Clay analysis: R. E. Jones, *Greek and Cypriot Pottery* (1986)

Historical background; *Cambridge Ancient History* (ed.2) III, IV and Plates Volumes; O. Murray, *Early Greece* (1980); L. H. Jeffery, *Archaic Greece* (1976); J. Boardman, *The Greeks Overseas* (1980)

Chronology: J. N. Coldstream, *Greek Geometric Pottery* (1968) ch.13; A. M. Snodgrass, *The Dark Age of Greece* (1971) ch.3 (to 700); D. A. Amyx, *Corinthian Vase Painting* (1989) ch.3; Sparkes, op.cit., ch.3; J. C. Waldbaum and J. Magness, *AJA* 100, 23ff. (near east around 600)

Kitchen ware: B. A. Sparkes, *JHS* 82, 121ff.

Oil/wine carriage: V. R. Grace, *Amphoras and the Ancient Wine Trade* (1979); A. W. Johnston, *BSA* 73, 103ff.

Monochrome: V. R.d'A. Desborough, *The Greek Dark Ages* (1972) 142–4; N. Kourou, *BCH* 111, 31ff., in *Copenhagen* 314ff. (for opium?) and *PACT* 40, 43ff.; K. Reber, *Untersuch.zur handgemachte Keramik* (1991)

Relief ware: J. Schäfer, *Stud.zu den gr.Reliefpithoi* (1957; Crete, Rhodes, islands); E.S.-Bournia, *Nax.anaglyphoi pithoi* (1984, Naxos), *La céramique à rel...Chios* (1992); S. Weinberg, *Hesperia* 23, 109ff. (Corinth); *BCH* 102, 736 (Paros); M. Caskey, *AJA* 80, 19ff. (islands); *AE* 1975, pl.72 (Eretria); M. Brouskari, *Acrop.Mus.* (1974) figs.154–5; *BCH* 85, 685ff. and *AK* 17, 89ff. (Laconian); L. Anderson, *Rel.pithoi from the Archaic Period* (diss.1975)

Iconography: *LIMC* (1981–97) may be consulted for all detail, lists and illustrations. G. Ahlberg, *Myth and Epos* (1992), full illustration to about 600 BC. T. H. Carpenter, *Art and Myth* (1991) gives a well illustrated survey of all subjects. K. Schefold, *Myth and Legend* (1966; now in an updated German edition) and *Gods and Heroes* (1992) gives a full, discursive account, with many pictures. On narrative principles, A. M. Snodgrass, *An Archaeology of Greece* (1987) ch.5; J. Boardman in *Eumousia* (Fest.Cambitoglou, 1990) 57ff.

2 THE PROTOGEOMETRIC STYLE

General: V.R. d'A. Desborough, *Protogeometric Pottery* (1952) (pl. 6.2 [4], 13 [12]) and *The Greek Dark Ages* (1972) to consult for all wares and sites, though now somewhat dated; A. M. Snodgrass, *The Dark Age of Greece* (1971); I.Lemos, forthcoming comprehensive monograph

Attic: *Kerameikos* I (1939) [1–3, 5, 10]; IV (1943) [6, 8, 9, 13]

Euboean: M. R. Popham et al., *Lefkandi* I (1979/80) (pls. 106, 270 [15]); II.1 (1990) (pl. 54 [14]); III (1996) (pls. 111, 114 [16, 17])

Thessaly: Marmariani, *BSA* 31, 1ff. (pl. 11 [*18*])

Cretan: J. K. Brock, *Fortetsa* (1957) ([*19–21, 24–5*]); H. Sackett, *BSA* 71, 117ff. [*23*]; J. N. Coldstream in *Pepr. 4. diethn. Kretolog.Congr.* (1980) 70ff. [*22*]

3 THE GEOMETRIC STYLE

J. N. Coldstream, *Greek Geometric Pottery* (1968; review, J. Boardman, *Gnomon* 1970, 493ff.) is the standard work and many of the illustrations here can be traced in his indexes. It was updated by him in *Geometric Greece* (1977), and in *Greek Renaissance* (ed. R. Hagg 1983) 17ff. on regional styles. B. Schweitzer, *Greek Geometric Art* (1971). Cook, *GPP* for more detail about shapes and non-figure decoration than is given here. *From Pasture to Polis* (ed. S. Langdon, 1993) for background; Geometric Greece to Iran – I. N. Medvedskaya, *Iranica Antiqua* 21, 89ff., overstated

Attic: J. M. Davison, *Attic G.Workshops* (1961); J. M. Cook, *BSA* 42, 139ff. (late LG); *Hesperia* 18, 275ff., 21, 279ff. (EG); P. Kahane, *AJA* 44, 464ff. [*42–3*]; B. Burell, *Att. geom. Schalen* (1978) [*72–3*] (cups); F. Villard, *Mon. Piot* 49, 17ff. (latest LG); *Kerameikos* V.1; *Agora* VIII (LG; no.304 [*59*]); *CVA* Louvre 16 (pl. 42.3 [*70*]); B. Bohen, *Kerameikos* XIII (1988) and *AM* 91, 15ff. (pyxides) [*36–8*]; N. Kourou, *Eilapine* (Fest. Platon 1987) 101ff. (pomegranates) [*62*]; D. Feytmans, *Les louteria att.* (1965, spouted craters); J. N. Coldstream, *Hesperia* 64, 391ff. [*30*]; E. Kunze, *Fest. Schweitzer* (1954) pl.4 [*49*]; loop feet in Greece, H.-G. Buchholz, *JdI* 83, 58ff.

Euboean: J. Boardman, *BSA* 47, 1ff.; 52, 1ff.; in *Lefkandi* I (1980) 57ff., *Minotaur and Centaur* (1996, ed. D. Evely et al., Studies Popham) – varia incl. Chalcis; J. R. Gisler, *Archaiognosia* 8, 11ff. (Cesnola P.) [*76*]; J.-P. Descoeudres, *BCH* 96, 269ff. [*83*]; L. Kahil in *Studies Webster* II (ed. J. H. Betts et al., 1988) 97ff. [*84*]; C. Briese and R. Docter, *MadriderMitt.* 33, 25ff. (Spain). Jones, 628ff., 690ff.

Cycladic: *Delos* XV; N. Kourou in *Amsterdam* 107ff. (Naxian); see next ch.

Boeotian: A. Ruckert, *Frühe Keramik Böotiens* (1976) – the standard work

Corinthian: *Corinth* VII.1 (pl. 9 [*107*]); XV (nos. 1361–2 [*110–1*]); *Hesperia* 18, pl. 19 [*114*]; N. Kourou in *PACT* 40, 27ff. (MG, LG east and west)

Thapsos Group: C. W. Neeft, *MEFRA* 93, 7ff. [*117*]; J. W. Hayes, *Greek and Greek-style...Toronto* (1992) no.31 [*118*]; N. Kourou, *Ann* 61, 257ff. [*120*] and

PACT 40, 38ff.; C. Dehl in *Fest. Hausmann* (1982) 182ff.; Jones, 681–3

Argive: P. Courbin, *La céramique geom. de l'Argolide* (1966); C. Morgan/T. Whitelaw, *AJA* 95, 79ff. (local variants)

Laconian: E. A. Lane, *BSA* 34, 99ff.; I. Margreiter, *Frühe lak.Keramik* (1988)

East Greek: bird bowls – Coldstream, *GGP* 298ff., J. Boardman, *Greek Emporio* (1967) 132ff. and F. Brommer in *Studies Trendall* (1979) 39ff.; *Archaeometry* 35, 197ff. (not Miletus). K. F. Johansen, *Exochi* (1957, Rhodes) [*134, 136*]; spaghetti [*133*] – J. Boardman, *Ann.Arch. e Storia ant. (Napoli)* 1 (1994) 97. *Anat. Iron Age Colloq.* 3 (1994) 166 (crater, Sardis)

Chios: J. Boardman, *Greek Emporio* (1967). Samos: H. Walter, *Samos* V (1968)

Carian: C. Özgünel, *Belleten* 40, 3ff. and *Carian Geom. Pottery* (1979)

Cretan: J. K. Brock, *Fortetsa* (1957); J. N. Coldstream, *Knossos, the North Cemetery* (1997) [*147*] and *Peprag. 4. diethn. Kretolog. Congr.* (1980) 67ff. [*151*]; D. Levi, *Ann* 10/12 (1931, Afrati); R. Hampe, *Kret. Löwenschale* (1964); M. Tzipopoulou, *BCH* Suppl. 23, 145ff. (Eteocretan handmade); Jones, 705

West Greek: D. Ridgway, *The First Western Greeks* (1992) and with G. Buchner, *Pithekoussai* I (1993); A. Akerström, *Der geom. Stil in Italien* (1943); Jones, 673ff.

Iconography: J. Carter, *BSA* 67, 25ff. (beginnings); G. Ahlberg, *Fighting on Land and Sea* (1971), *Prothesis and Ekphora* (1971), *Myth and Epos* (1992) and in *Acta Archaeologica* 58, 55ff. (games); eadem, *OpuscAth* 7 (1967) 117ff. and E. Rystedt, *OpuscAth* 19, 125ff. ('rattles') [*51, 61*]; R. Tölle, *Frühgr. Reigentänze* (1964); M. Wegner, *Musik und Tanz* (1968); J. L. Benson, *Horse, Bird and Man* (1970; Bronze Age and Egyptian sources; rev. by Coldstream, *Gnomon* 1974, 273ff.); T. Rombos, *The Iconography of Attic LG Pottery* (1988); J. Boardman in *Anc. Greek Art and Iconography* (ed. W. G. Moon 1983) 15ff. and S. Langdon, *AJA* 93, 185ff. (Argive)

4 THE ORIENTALIZING STYLE

Background: J. Boardman, *The Greeks Overseas* (1980); E. Akurgal, *The Birth of Greek Art* (1968); Cypriot figural – V. Karageorghis and J. des Gagniers, *Le cér.chypr. de style figuré* (1974)

Protocorinthian: K. F. Johansen, *Les vases sicyoniens* (1923) (fig. 42 [*175*]) – Johansen rather half-heartedly held that the vases were made in Sicyon; H. Payne, *Necrocorinthia* (1931) and *Protokorinthische Vasenmalerei* (1933) [*163–5, 167, 172–4, 176, 178, 180, 185–6*], pls. 27–9 (Chigi vase [*176*]; cf. *IstMitt* 42, pls. 10–13, another fine lion hunt, Erythrae). Payne's typology and painter-lists are fundamental but there are further attributions, not altogether agreed – J. L. Benson, *Die Geschichte der Kor.Vasen* (1953); T. J. Dunbabin/C. M. Robertson, *BSA* 48, 172ff.; D. A. Amyx, *Corinthian Vase Painting* (1989) with C. W. Neeft, *Addenda to Amyx* (1991) giving essential index. *Idem*, *PC subgeom. aryballoi* (1987); J. L. Benson, *BABesch* 61, 1ff. (EPC), *Earlier Cor. Workshops* (1989) and in *Corinthiaca* 97ff. (MPC); W. Kraiker, *Aigina* (1951) [*169, 179*]; C. Dehl, *Die kor. Keramik...in Italien* (LG-MPC, 1984). Figure-vases – Payne, ch.12; Amyx, 512ff. Ithaca – *BSA* 43, 1ff. (no.502 [*187*]); 48, 255ff.

Protoattic: J. M. Cook, *BSA* 35, 165ff., for the basic typology and painters; K. Kübler, *Altattische Malerei* (1950); R. Hampe, *Ein frühattischer Grabfund* (1960; and *CVA* Mainz Univ. 1; EPA painters); M. Denoyelle, *AK* 39, 71ff. (Analatos P.); *CVA* Berlin 1 (Aegina find) [*206–7, 209*]; E. Brann, *Hesperia* 30, 305ff.; S. P. Morris, *The Black and White Style* (1984; full study of painters; attributions to Aegina); *Agora* VIII (1962); *Kerameikos* VI.2 (1970) [*201–4*]; *Arch. Reports 1962/3* 56 [*200*]; C. Brokaw, *AM* 78, 63ff. (LG/EPA); K. A. Sheedy, *AM* 105, 117ff. and 107, 11ff. (EPA); E. Vermeule, *AJA* 75, 285ff. [*211*]; plaques – J. Boardman, *BSA* 49, 183ff. [*191–2*]

Argive: Schefold, pl.7b [*213*]; *Archaeologia* 82, 33 [*215*]; *BSA* 48, pl. 17; P. Courbin, *BCH* 79, 1ff. [*216*]; J.-F. Bommelaer, *BCH* 96, 229ff.; craters – *BCH* 85, 676; 95, 739ff.; 96, 229ff. [*214*]

Laconian: R. M. Dawkins, *Artemis Orthia* (1929) [*217, 221*]; A. Lane, *BSA* 34, 99ff. [*220*] – for the basic typology; *CVA* Berlin 4, pl. 181 [*223*]; I. Margreiter, *Frühe lak.Keramik* (1988); *Ann* 33/4, 7ff. (Taras [*219, 222, 224*])

Euboean: J. Boardman, *BSA* 47, 1ff. [*225–8*]; 52, 15ff. [*229*]; *BSA* 91, 323 (Mende)

Skyros: A. G. Kalogeropoulou, *Ann* 61, 137ff. [*230*]

Boeotian: Ruckert, op. cit.; bird bowls – A. Andreiomenou, *To kerameikon ergasterion tes Akraiphias* (1980), alabastra – R. Hampe, *Heidelberg. Neuerwerb. 1957–70* nos. 43–5; E. Simon, *Rev. Arch.* 1972, 205ff. [*235*]

Cycladic: summary of groups in Cook, *GPP* 340; illustration in *Delos* X, pl.3 [*251*]; Delos/Rheneia

finds – *Delos* XV (Group Ad) and XVII (Groups Ba, Bc, C, D). Thera – *Thera* II (1903); *AM* 28, 1ff. and reports in *Ergon* and *PAE* 1966–82; *PAE* 1982, 268–9; I. Strom, *Acta Archaeologica* 33, 221ff.; N. S. Zapheiropoulos, *Ann* 61, 153ff.; H. Payne, *JHS* 203ff., Leiden Group [*241–2*]. Delos Ad, D – K. A. Sheedy, *BSA* 80, 153ff. Naxos – C. Karusos, *JdI* 52, 166ff. [*249*] and *Ergon* 1960, 187 (signature); Ph. Zapheiropoulou, *Ann* 61, 121ff.; *PAE* 1982, 176 [*247*]. Parian/Melian – D. Papastamos, *Melische Amphoren* (1970) the big amphorae, and Ph. Zapheiropoulou, *Problemata tes meliakes aggeiographias* (1985), no. 585 [*254*], the Rheneia finds, high dating; Jones, 656. Thasos – *Études Thasiennes* VII (1960); *BCH* 84, 347ff. [*256*]; 85, 98ff., plates. N. Oakeshott, *JHS* 86, 114ff. – double handles like horns. *Mer Égéen. Grèce des Iles* (Paris exh. 1979) all types, nos. 56 [*240*], 57 [*239*], 58 [*242*], 59 [*256*], 60 [*250*], 61 [*252*]. W. Ekschmitt, *Kunst und Kultur der Kykl.* II (1986), historical summary of styles, pictures; Jones, 643ff.

Cretan: Knossos – J. K. Brock, *Fortetsa* (1957); J. Boardman, *Cretan Coll. in Oxford* (1961) and *BSA* 56, 78ff. (Fortetsa P.) [*261*]; H. W. Catling, *Ann* 61, 31ff.; E. Moignard in J. N. Coldstream, *Knossos, the North Cemetery* (1997) [*262*]; D. Levi, *Hesperia* 14, 1ff., general, and *Ann* 10/12 (1931), Afrati [*265–9*]; *Ann* 17/18, 232 [*273*]; M. C. Shaw, *AJA* 87, 443ff. [*274*], Kommos; *CVA* Berlin 4, pl. 152 [*275*]; *Tocra* I 78ff., II 36ff., 73 [*276*]

Western Greek: Sicilian pithoi – F. Villard, *MonPiot* 62, 13ff.; P. Blome, *AK* 34, 156ff. [*277*]. Syracuse – *BCH* 60, 144ff. (Fusco) [*280*]; *Ann* 60, 135ff. Megara – *Megara Hyblaea* II (1964); *Guide* (1983) figs. 67–9; *Kokalos* 10/11, 603ff. [*279*]. Gela – *Ann* 61, 53ff. S. Italy – *I Greci sul Basento* [*281*]; P. Orlandini, *BdA* 49, 1ff; 66, 1ff. (Incoronata). Aristonothos – Simon/Hirmer, pls. 18–9 [*282*]

Iconography: see notes to last ch. (Schefold; Ahlberg, *Myth and Epos*)

5 EAST GREECE: ORIENTALIZING AND BLACK FIGURE

East Greek/Rhodian: R. M. Cook, *East Greek Pottery* (with P. Dupont 1997) – his articles are fundamental; on classification, *OJA* 11, 255ff.; illustration and grave groups in the series *Clara Rhodos*. C. Kardara, *Rhodiake Aggeiographia* (1963), the main WG series; H. Walter, *Samos* V (1968) PG to 7th cent.; E. Walter-Karydi, *Samos* VI.1 (1973) 7th/6th cent. valuable for pictures from all sources but some strange identifications, pls. 73–6 (dishes),

76 (Vroulian cups), 106–118, 130–1 (M/LWG), 132–40 (plates); situlae – *CVA* BM 8 [*303–4*]; stamnoi – J. Jully, *MonPiot* 61, 1ff., and S. Paspalas (forthcoming)

Egypt: H. Prinz, *Funde aus Naukratis* (1908) pl. 3b [*305*]; T. G. Schattner, *JdI* 110, 65ff. and *GO* fig. 164 (cartouches) [*306*]; A. Möller, *Naukratis* (forthcoming)

Chian: J. Boardman, *Greek Emporio* (1967), on Naucratis in *BSA* 51, 55ff. and in *Chios 1984* 251ff.; A. A. Lemos, *Archaic Pottery of Chios* (1991) comprehensive; early WG – *Samos* V nos. 612–3; b.f. chalice-kantharoi – N. A. Sidorova, *Arkh. Isk. Bospora* (1992) 142f. Jones, 662f.

Samian: *Samos* V and VI.1 (see above); *AM* 72, 35ff. and 74, 26ff.; H. Kyrieleis in *Chios 1984* 187ff. (imit. Chian). Little Masters – E. Kunze, *AM* 59, 81ff. [*328*]; *Samos* VI.1 pls. 41–57 [*326–9*]; Simon/Hirmer, pl. 37 [*327*]. J. Manser, *AK* 30, 162ff. (early face cups); E. Paribeni, *Prospettiva* 5, 53ff. (face cups); *Samos* VI.1, pls.55–7 [*330*]. Jones, 665

Milesian: Fikellura – R. M. Cook, *BSA* 34, 1ff. (principal study), *Anadolu* 21, 71ff., *CVA* BM 8, *OJA* 11, 255ff.; G. Schaus, *BSA* 81, 251ff.; C. H. Greenewalt, *California Studies* 153ff. (early in W. Lydia?); *Samos* VI.1 pls. 1–21, 39–40, 68–72, 81–9; Miletus finds, reports in *IstMitt*. Jones, 665f., 702f.

Clazomenian: R. M. Cook, *BSA* 47, 123ff., *CVA* BM 8, and *Clazomenian Sarcophagi* (1981). Early sarc.? *AJA* 101, 287; *Samos* VI.1, pls. 127–8. Related b.f. – J. M. Cook, *BSA* 60, 114ff. (Smyrna) [*350*]. Jones, 664

Aeolian: E. Walter-Karydi, *AK* Beiheft 7, 3ff.

Striped wares (Ionian cups): *Tocra* I, 111ff.; *CVA* Munich 6, pl. 303 [*357*]

Lydian: C. H. Greenewalt, *California Studies* 1, 139ff.; 3, 55ff.; 6, 91ff. (and Ephesus, but see Jones, 666 and *10 Congr.* 721ff.), ibid., 37ff. (earlier vases)

Phrygian: E. Akurgal, *Phryg. Kunst* (1953); *Anadolu* 18, 63ff.; *10 Congr.* 129ff., 227ff.

Carian: R. M. Cook, *OJA* 12, 109ff.; *Animals in Ancient Art* III (ed. A. S. Walker 1996) no. 61 [*361*]

Lemnian: *Ann* 15/16 and A. Della Seta, *AE* 1937, 629ff.

E. Greek figure-vases: C. M. Robertson, *JHS* 58, 41ff. and W. Biers, *Getty Vases* 4 (1989) 5ff. (group as [*360*]); R. A. Higgins, *BM Catalogue of Terracottas* II; J. Ducat, *Les vases plast. rhodiens* (1966); S. Karousou,

Anadolu 21, 55ff. (sandalled feet); *CVA* Berlin 4, pl. 167 [*358*]. Jones, 673

6 THE BLACK FIGURE STYLES

CORINTHIAN

See notes on last chapter, notably Payne, Benson, Amyx with Neeft, for reference to virtually all pieces shown. I follow Amyx's lists which are the latest. Also: *Corinth* VII, 2 (1975) (no. 312 [*397*]); XIII (1964) (pl. 83, copy of E. Greek bird bowl shape); C. W. Neeft, *BABesch* 52/3, 133ff. (EC Dolphin P.); J de la Genière, *BCH* 112, 83ff. (col. craters export to Caere). D. A. Amyx, *BCH* 99, 401 (copies of Attic Deianeira lekythoi); *California Studies* 2, 1ff. (EC animal aryballoi); 4, 1ff. (MC Dodwell P.). J. L. Benson, *AK* 14, 13ff. (MC Chimaera Group); D. Callipolitis-Feytmans, *BCH* 86, 117ff. (plates); A. Harrison, *Hephaistos* 14, 193ff. (EC chronology); M. T. Campbell, *Later Cor. Pottery* (diss. 1986); F. Lorber, *Inschriften* (1979); figure-vases – J. Ducat, *BCH* 87, 431ff.

Iconography: K. Schefold, *Myth and Legend* (1966) *passim*; Carpenter, figs. 21 [*375*], 158 [*403*], 179 [*388*], 221 [*396*], 266 [*401*], 269 [*404*] and notes; H. von Steuben, *Frühe Sagendarstellungen in Korinth und Athen* (1968). Heracles and hydra [*388*] – P. Amandry and D. A. Amyx, *AK* 25, 106ff.; J. Boardman, *OJA* 1, 237f. Mission to Troy [*400*] – J. D. Beazley, *ProcBritAcad* 43, 233ff. Ajax [*391*] – M. Davies, *AK* 16, 60ff. Dancers [*363*] – M.& C. Roebuck, *Hesperia* 24, 158ff.; A. Seeberg, *Cor.Komos vases* (1971). Plaques [*409*] – H. A. Geagan, *ArchAnzeiger* 1970, 71ff. Altars [*410*] – M. H. Swindler, *AJA* 36, 510ff. Wooden plaque [*411*] – *Enc. dell'arte antica* VI 205f.

LACONIAN

E. A. Lane, *BSA* 34, 99ff.; B. B. Shefton, *BSA* 49, 299ff. (painters); and *Getty Vases* 4, 41ff., E. Greek influence; C. M. Stibbe, *Lakonische Vasenmaler* (1972) lists all vases shown here and I follow his attributions which do not entirely agree with the British but are more comprehensive; also in *Mededelingen* 36, 19ff. (cavaliers [*432*]); 40, 23ff. (kantharoi); *BABesch* 46, 75ff. (small cups); *Greek Vases in the Getty Museum* 5, 5ff. [*418*]; in *Enthousiasmos* (Fest. Hemelrijk, 1986) 29ff. (Rider P.). F. Pompili (ed.), *Studi sulla ceramica Laconica* (1986) (painters, and Stibbe on craters, Nafissi on distribution); *BdA* Suppl. 1992 (incl. Stibbe on lakainai and volute craters); J. Boardman, *BSA* 58, 1ff. (chronology); M. Pipili, *Laconian Iconography* (1987) with full illustration; G. P. Schaus,

AJA 83, 102ff. (foreign artists). Black – Stibbe, *Lac. Mixing Bowls* (1989) (F5 *[436]*), and *Lac. Drinking Vessels* (1994)

BOEOTIAN

The Ures work is basic, see below. B. A. Sparkes, *JHS* 87, 116ff.; K. Kilinski, *Boeot. Black Figure Vase Painting* (1990) – painter lists and bibl. for earlier illustrated articles; P. N. Ure, *Sixth and Fifth Century Pottery, Rhitsona* (1927) *[444]*; Tocra P. – *Tocra* I, nos. 821–6 *[439]*; Jones, 705f. *CVA* Louvre 17 (A. Waiblinger) *[446–8]* and analyses; A. D. Ure, *Metropolitan Mus. Stud.* 4, 18ff. (lekanai); I. Raubitschek, *Hesperia* 35, 154ff. (potters). Early silhouette – A. D. Ure, *JHS* 49, 160ff. *[450]*; 55, 225ff.; Teisias – Kilinski, *Hesperia* 61, 253ff. *[440]*. Gorgoneia – B. Freyer-Schauenburg, *Arch. Anzeiger* 1976, 203ff. *[455]*. Late silhouette – J. Boardman in *Stips Votiva* (Fest. Stibbe 1991) 7f. *[456]*. Jones, 636ff., 705

EUBOEAN

Eretrian: J. Boardman, *BSA* 47, 30ff. *[458–9, 461]*; 52, 18ff. *[463]*; 68, 273ff. (analysis, Dolphin Class, Chalcis); A. D. Ure, *BSA* 55, 211ff.; 58, 14ff.; 65, 265ff.; 68, 25ff.; *BICS* 6, 1ff.; 12, 22ff.; *JHS* 80, 160ff. (lekanai); *Arch. Reports* 1962/3, 57 *[460]*; D. von Bothmer, *Metropolitan Mus. Journal* 2, 27ff.; R. Hampe, *Heidelberg. Neuerwerb. 1957–70* no.52 *[464]*; K. Kilinski, *AK* 37, 3ff. Jones, 632ff.

OTHER GREEK

Andros *[466]*: Amyx, 682f.

Thasos: L. Ghali-Kahil, *Et. Thasiennes* 7 (1960) pls. 24–7 (lekanai); *BCH* 83, 430ff. (plates) *[467]*

Elaeus: A. Waiblinger, *Compte Rendu Acad. Inscr.* 1978, 843ff.; GO 265

THE WESTERN GREEKS

Chalcidian: A. Rumpf, *Chalk. Vasen* (1927) – basic and fully illustrated, but dated, as made in Chalcis. Also for Pseudo-Chalcidian: H. R. W. Smith, *Origin of Ch. Ware* (1932) – as Etruscan. J. Keck, *Stud. zur*

Rezeption fremder Einflüsse in der ch. Keramik (1988) (iconography); M. Iozzo, *Ceramica Calcidese* (1994; *Atti Soc. Magn. Grec.* 3/2) updates Rumpf; M. True in *Ages of Homer* (ed. J. B. Carter et al., 1995) 415ff. *[475]*. Jones, 686ff.

ETRURIA

Northampton Group/Campana Dinoi: *CVA* Castle Ashby no.1 *[485]*; F. Villard, *MonPiot* 43, 33ff. (dinoi) *[489–92]*; R. M. Cook and J. M. Hemelrijk, *Jb. Berliner Mus.* 5, 107ff. *[488–92]*; M. Martelli, *Prospettiva* 27, 2ff.; L. Cerchiai, *AK* 38, 81ff. *[488]*; F. Gaultier, *CVA* Louvre 24, 21ff. (dinoi) *[489]*. Jones, 686ff.

Campana Hydriae: *CVA* Louvre 17, pls. 52–5 *[493]*; Jones, 688f.

Caeretan Hydriae: J. M. Hemelrijk, *Caer. Hydr.* (1984), comprehensive; L. Marangou, *S. S. Niarchos Coll.* (1995) no. 18 (*[496]* sold for £2,000,000 in 1993); Jones, 688f.

Pontic: P. Ducati, *Pont. Vasen* (1932); L. Hannestad, *The Paris P.* (1974) *[501]* and *Followers of ...* (1976); J. Lund and A. Rathje in *Amsterdam* 352ff.; F. Gaultier, *CVA* Louvre 24, 28ff.

7 AFTERMATH

Palmette cups etc.: A. D. Ure, *BSA* 55, 211ff. and *BICS* 8, 1ff. (Euboean); *Hesperia* 15, 27ff. and *AK* Beiheft 9, 112ff. (Boeotian)

Wide Group: Amyx, 275f.; A. D. Ure, *JHS* 69, 18ff.; R. S. Stroud, *Hesp* 37, 302f. (sanctuary); D. Callipolitis-Feytmans, *BCH* 86, 141ff.; J. Boardman, *JHS* 90, 194f. *[503, 505]*

Cabirion Group: *Das Kabirenheiligtum bei Theben* I (G. Bruns 1940); IV (K. Braun 1981); P. Levi, *JHS* 84, 155f. *[509]*

Rhodes: *Arch. Deltion* 30A, pls. 1–4; 38A, pls. 101–2

Chalkidike: O. T. Jones, *AE* 1990, 177ff.

INDEX OF COLLECTIONS

Figures in roman type are museum numbers, those in *italic* refer to the illustrations in this volume

INDEX OF FIGURE SUBJECTS AND DECORATION

GENERAL INDEX

Figure numbers are in *italics*; principal references are in **bold**

Abdera, 149
Aegina, 89, 90, 110, 144
Aeolis, 51–2, 148–9
Aetos 666, 49
Afrati, 53, 113
Ajax P., *174*
Akraiphia, 109, 213
alabastron, 87, 113, 179, 216
Albertinum Group, *354*
altars, 185; *410*
Amphiaraos P., *401*
Analatos P., 89; *188–93*
Andromeda Group, *403*
Andros, 216
Animal Chalices, 145
Arcadia, 50
Argos/Argolid, 24–5, **50**, 55, **108**, 111, 114, 143, 177, 269
Aristonothos, 114; *282*
Arkesilas P., 187; *420–3*
Artemis Orthia, 108, 186
aryballos, 85–8, 179–80
Athens/Attic, 11, **12–16, 23–8**, 47–52, 84–91, 108–111, 114, 116, 146–9, ch. 6 passim, 257–8, 264–9
Athens 706, workshop, *57*
Athens 894, workshop, *70*

basketry, 10, 23–4, 54, 267
Benaki P., *68*
Bird workshop, 52
bird-bowls (Boeotian), 109; *233*
bird-bowls (E. Greek), 51, 141–2; *136–8*
Birdseed Group, *73*
Black Sea, 143, 145, 147
black vases, 11, 213, 257
Black and White Style, 89–90, 108, 111
black figure, 84–6, 113–4, 143, 145–9, ch. 6

black figure, imitation, 112, 146–7, 149
black-incised, 113, 142–3, 215
Bocchoris, 10
Boeotia, 47–9, 109–10, 213–6, 268
Boreads P., 187; *416–9*
Borelli P., *353*
Bronze Age (Minoan/Mycenaean), 8, 11, 13–14, 16, 50, 52, 55, 83, 112–3, 144
bucchero, 51–2, 149, 217
Busiris P., *499*

Cabirion Group, 258; *506–10*
Caere, 114
Caeretan hydriae, 221–2; *494–9*
Camel P., 215; *454*
Campana hydriae, 221; *493*
Campana dinoi, 220–1; *489–92*
Campania, 53, 219
Caria, 52, 150
Carthage, 53
Cavalcade P., *391*, *399*
Cesnola P., 28; *76*
Chalcidian, 181, 217–9
Chalcis, 28, 216–7
chalice, 51, 145–6, 180, 269
Chalkidike, 257–8
Chigi P., 87; *173*, *176*, *178*
Chimaera Group, 180, 182; *384–5*
Chimaera P., *434*
Chios, 11, **51**, 112, **144–6**, 150, 180, 185, 187, 269
chronology, 9, 10, 23, 178–9, 258; chart, 271
clays, 11, 14–5, 47, 144, 147, 182–3, 218
Clazomenae, 148–9, 220
Copenhagen Sphinxes P., *384–5*
Corinth, 11–12, 28, **48–9**, 50, 53, 84, **85–8**, 89, 108, 111–5, 143, 145, 147,

149–51, **177–85**, ch. 6 passim, 257–8, 264–5, 269
crater, (column) 181; (stirrup) 25, 180–1, 213, 217; (volute) 181, 188
Crete, 13, **16**, 25, **52–3**, 83–4, 111, **112–3**, 114, 267
cult vases, 27, 264–5
Cumae, 114
Cumae Group, 86; *167*
Cyclades, 15, 47, 110–2, 142–3
Cyprus, 9, 13–15, 25, 28, 51–2, 83, 112–3, 144
Cypselus chest, 183
Cyrene, 185, 187

Dancers Group, 214
Daphnae (Tell Defenneh), 144, 148
dedications, 11, 108, 144, 187, 213, 257–8, 265
Delos, (Aa,c,e, Bb) 47; (Ad, Ba, C, D) 110–2
Delphi, 10, 49
Dolphin Class, 216
Droop cup, 186
duck-vases, 14, 16; *25*

Eagle P., *494–8*
East Greece, 16, **51–2**, 84, 115–6, **ch. 5**, 177, 180, 186, 217, 268
Egypt, 8–9, 23, 50, 83, 86–7, 142, 144–5, 148, 220, 268; *see* Karnak, Naucratis, Saqqara
Elaeus, 216
Eleusis 25, 116
Eleutherna, 113
Elis, 50, 186, 257
Enmann Class, 148; *347*
Ephesus, 51, 150
Eretria, 109, 116, 215–6
Erythrae, 144
Etruria/Etruscan, 7, 28, 53, 114, 143–4, 151, 183, 185, 217–22, 265